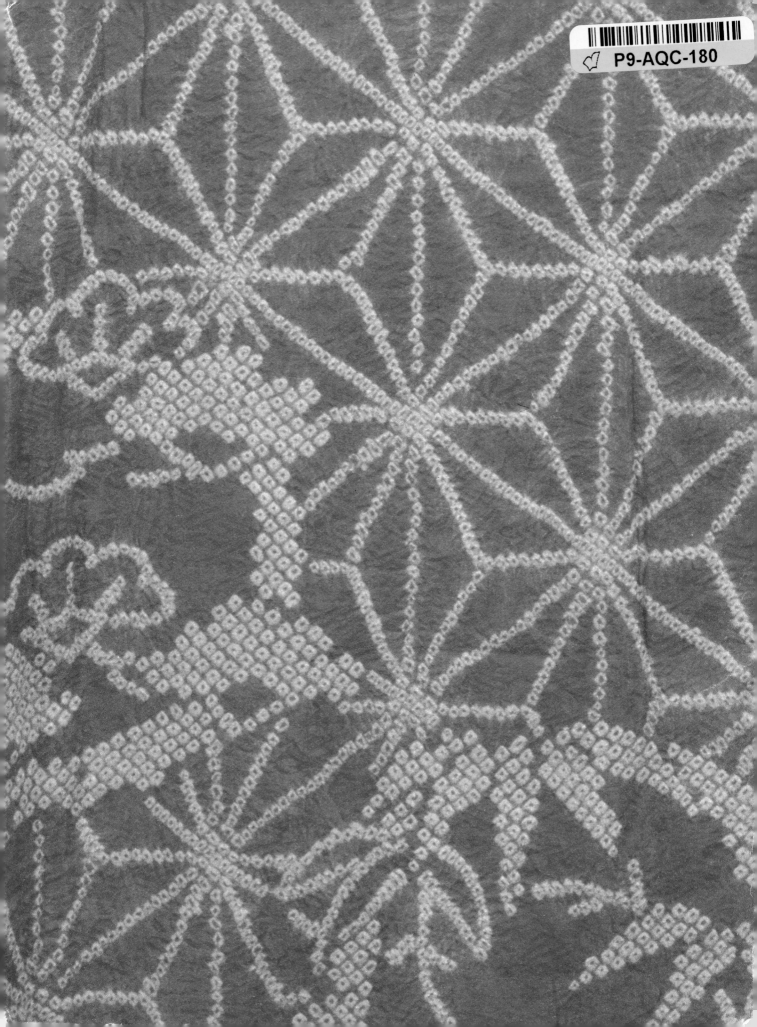

Japanese Art and Design

THE
TOSHIBA
GALLERY

Japanese Art and Design

EDITOR
Joe Earle

TEXTS
Joe Earle · Rupert Faulkner · Verity Wilson
Rose Kerr · Craig Clunas

PHOTOGRAPHY
Ian Thomas

DESIGN
Patrick Yapp

VICTORIA AND ALBERT MUSEUM

Published by the Victoria and Albert Museum
First published in 1986

© Trustees of the Victoria and Albert Museum

Printed in Great Britain by Balding + Mansell Ltd.
Wisbech, Cambridgeshire

ISBN 0 948107 65 0

FRONT COVER: No.*31* Cosmetic box, wood covered in black
and gold lacquer, *c.* 1620

BACK COVER: No.*120* Sword guard, pierced iron, 16th century

REVERSE OF COVER: No.*54* Detail of *kimono*, red and white
tie-dyed silk, late 18th or early 19th century

Contents

Prefaces

We hope that the Toshiba Gallery will provide a greater opportunity to enjoy one of the world's finest collections of Japanese Art and Design and contribute to the strengthening of cultural relations between Britain and Japan.

Shoichi Saba
Chairman of Toshiba Corporation

The Victoria and Albert Museum acquired its first object from Japan in 1852 and remained an avid collector of Japanese artefacts throughout the rest of Queen Victoria's reign. During the early years of the present century there were many gifts from the great English collectors, making the Museum's holdings a memorial to Britain's early fascination with Japan's rich and varied craft traditions. In the last decade the Museum has renewed its relationship with Japan, holding important exhibitions of recent craft and design and making acquisitions of contemporary material which build on its historic commitment to the 'decorative art of all periods and all countries'.

The long search for a home which would do full justice to the Museum's superb Japanese collections ended in 1985 when the Toshiba Corporation of Tokyo offered extremely generous sponsorship towards the creation of a permanent display. The Toshiba Gallery's quality and scope make it a landmark both in the history of cultural relations between our two countries and in the Museum's programme for the transformation of all its displays with the assistance of the private sector.

The V&A is especially grateful to Toshiba for its generosity in not only sponsoring the gallery but also supporting the publication of this magnificent commemorative volume which offers for the first time a permanent record of the fruits of one hundred and thirty years of collecting.

The Lord Carrington KG
Chairman of the Board of Trustees of the Victoria and Albert Museum

I am delighted to send a message of congratulations to the Victoria and Albert Museum on the occasion of the opening of the new Toshiba Gallery of Japanese Art.

I welcome the establishment of this new Gallery which is being set up with the support of the Toshiba Corporation. It provides room for the first permanent display of Japanese works of art in the United Kingdom. By choosing to establish this gallery in the Victoria and Albert Museum in London, Toshiba is offering to the visitor, not just from this country but from countries all over the world, the opportunity to see and appreciate the Museum's magnificent collection of Japanese art treasures which, until now, had largely been hidden from view owing to lack of display space. The wealth and extent of the collection will surprise even the visitor from Japan.

The Toshiba Gallery of Japanese Art will thus contribute greatly towards the ideal of making known to a wider public the many and varied facets of Japanese art. I congratulate Toshiba on their decision to fund the establishment of the new gallery which will surely play an important role in achieving an even deeper understanding of Japan by peoples of all nations.

His Excellency Mr Toshio Yamazaki
Japanese Ambassador in London

I should like to offer warmest congratulations to the Victoria and Albert Museum on the opening of the Toshiba Gallery and on the production of this superb commemorative publication. The new Gallery will enable many more people to appreciate the richness and breadth of Japan's artistic achievements.

I should also like to take this opportunity of paying a tribute to the Toshiba Corporation for their most generous and imaginative sponsorship and support. The Toshiba Gallery will not only make a great contribution to the wider and deeper understanding of Japanese culture, in Britain and among the Museum's many visitors from Europe and all over the world. It will stand in addition as a symbol of the increasingly close relationship between the people of our two countries, and of the spirit of far-sighted and constructive enterprise on which the sound development of that relationship depends.

His Excellency Sir Sydney Giffard KCMG
British Ambassador in Tokyo

Introduction

LIKE the new gallery it commemorates, this book presents the Japanese collections of the Victoria and Albert Museum for the first time in their 130-year history. A few publications in the past have featured our Japanese ceramics, woodblock prints or *netsuke*, but never before has the full range of material been systematically selected, reproduced and discussed.

In the 1920s and 1930s the V&A followed prevailing fashion and turned its attention from Japan to China. Japanese art suffered further in the 1950s under the Museum's great post-war programme of redisplay in 'Primary Galleries' which, for the first time, grouped the finest works by date and style ('English Baroque') rather than by medium ('Pewter'). No Japanese Primary was ever installed. Instead, the Japanese collection has led a precarious life as a furtive intruder in corners of Chinese displays, or even in exile at the V&A's many outstations. The Museum has now embarked on a second great transformation of its buildings and its displays, dividing the vast collections between galleries of 'Art and Design' and of 'Materials and Techniques'. This time there has never been any doubt that the installation of a new Japanese display would be a high priority, and in 1985 the timely intervention of the Toshiba Corporation ensured that the V&A would be the home of the first major gallery of Japanese art in this country.

The V&A's Japanese holdings are large and important. By usual standards they are also unconventional. Anyone with an appreciation of the complexities of the material past knows that there is no such thing as a 'representative' collection. Nevertheless, the Museum's assembly of Japanese objects may seem more un-representative than most. In comparison with collections in the United States, it is lacking in painting and sculpture, and with a few exceptions its pre-sixteenth-century content will disappoint expectations of thorough historical coverage. These gaps may be accounted for both by the circumstances under which the collection was formed and, more recently, by the adoption of a policy in keeping with the Museum's original intention to concentrate on the acquisition and display of applied rather than fine art.

The aim of the founding fathers of the South Kensington Museum, now the V&A, was the formation of a collection which would 'exhibit . . . the practical application of the principles of design in the graceful arrangement of forms, and the harmonious combination of colours' for the benefit of 'manufacturers, artisans and the public in general.' As is well known, this directly practical policy quickly gave way to a more historicist approach. This was not true, however, of the Museum's treatment of Japanese artefacts. In the case of Japan, there were no spoils of empire and neither the early curators nor other specialists ever saw anything more than about two centuries old. They were thus prevented from forming a longer historical perspective, with the result that by the 1880s there was a widely held conviction that the applied arts had seen their highest development during the Edo period (1615–1868), which had been followed during the Meiji

period (1868–1912) by a drastic decline due to the pernicious influence of contact with the outside world.

Starting as early as 1852 with some porcelain and lacquers, the South Kensington Museum, with important exceptions, mainly collected only very recent or contemporary Japanese artefacts, a policy whose results attracted considerable criticism. During the last years of the nineteenth century, however, the steady decline in more general British enthusiasm for Japanese art was reflected in a greatly reduced flow of acquisitions into South Kensington. This decline coincided with the emergence of a new and better informed generation of specialist connoisseurs who effectively did the Museum's work for it. The collections of Edo period crafts formed by Salting, Tomkinson, Alexander, Hildburgh and others between the 1880s and the 1920s were acquired, mostly by gift or bequest, between 1910 and 1936 and together with the Victorian purchases form the core of the present holdings. These add up to one of the finest assemblies outside Japan of the crafts from the sixteenth century to the end of the nineteenth century, with some important earlier and later material and a huge number of woodblock prints. The re-presentation of this material in a manner suitable to the priorities of the V&A in the late twentieth century has posed formidable problems, making it worthwhile to consider some of the approaches to the collection which have been followed in the past.

The didacticism of the early South Kensington Museum was complemented by a methodology of collection and study which stressed the importance of comprehensiveness. In 1863 the Lords of the Committee of Council on Education opined that 'the aim of the Museum is to make the historical and geographical series of all decorative art complete, and fully to illustrate human taste and ingenuity.' This optimistic policy lasted for a very long time in the case of Japanese artefacts (within the historical limits of the collection) and was still actively pursued at the V&A in the 1930s. It was also an important influence on the collectors mentioned above, and accounts for the impressive quantity of their acquisitions. If they were alive today, there is no doubt that they would expect a new gallery to cover every school of *inrō* maker and every technique of decorative metalwork used during the Edo period. They would also be certain that the great majority of pieces could be very accurately dated. In 1916 Henri Joly, the doyen of British collectors and connoisseurs, regretted that in a few cases his dating of lacquer might err 'by a score or two of years.' Today, like our colleagues in Japan, we can only suggest a century, with perhaps an 'early', 'middle' or 'late'. Greater knowledge of Japanese sources and Japanese collections has caused a decline in confidence about authenticity and date which has coincided in the context of the V&A with changing ideas about museum display.

In the 1920s and 1930s the Japanese displays were intended, consciously or unconsciously, for the benefit of other collectors and specialists and certainly not for 'manufacturers, artisans and the public in general'. The 5,000 sword-fittings, for example, sternly arranged by school and artist, afforded a complete and egalitarian structure for the dating of all other sword fittings. In the 1950s, on the other hand, one of the reasons why no Japanese Primary was planned was the supposed absence of 'masterpieces', judged either by western or by Japanese criteria. Exhibitions and acquisitions in the United States were establishing a new

Japanese aesthetic canon, and only rarely did they include examples of Edo period craft. When such pieces were sent from Japan, they were almost invariably connected in some way with a known individual. Ceramics would be by Kenzan or Mokubei, and lacquers would carry an attribution to the great decorative painter Ogata Kōrin. The work of lesser men, particularly if they were specialist craft practitioners rather than painters involved in the crafts as a sideline, was beneath serious notice, as were the miniature arts of *netsuke*, *inrō* and sword fittings. The undeniable and often-cited Japanese reverence for the 'hand-made', widely known in Britain through the writings of Bernard Leach, can backfire. When the crafts are considered to deserve nothing less than the application of standards formulated in the study of the fine arts of painting and sculpture, there is a natural tendency to select for consideration only those pieces which will respond to the intensive and isolated study implied by such an approach.

One of the aims of the new Art and Design displays will be to avoid both the taxonomic pedantry of the pre-war study collections and the reverent connoisseurship which has characterized some of the post-war Primaries. These early approaches might be illustrated by the ways in which we could present a knife-handle (*kozuka*) signed Hamano Shōzui (*127*), decorated with a *kabuki* actor of the Ichikawa Danjūrō line in the *Shibaraku* role and inscribed with a *haiku* by Kikaku. We might follow the 1930s method and regard it as an example of metalwork extending the coverage of the Hamano school, to be displayed in relation to other works with the signatures of Hamano masters. From the standpoint of connoisseurship, on the other hand, we could attempt to authenticate it as a genuine work of Shōzui, calling on the expertise of Japanese specialists and, if their verdict was favourable, give it star billing in a case on its own with a long story-board detailing Shōzui's life and his other known masterpieces. However, bearing in mind that most such works are the products not of individuals but of workshops and that many signatures on Japanese objects were inscribed with a different intention from their western counterparts, it may be better to view the *kozuka* primarily as evidence of trends in the decorative subject-matter of sword fittings at the beginning of the eighteenth century. The inclusion of a design from the popular theatre and a *haiku* by a man noted as a poet of the common people may be interpreted as part of a change in the self-image of the urban samurai.

This last approach does not have to involve a lot of reading of panels, maps and chronological tables. The point outlined above can be sketched in by a brief caption and communicated by the objects themselves. The design of the gallery, by Paul Williams, is another vital part of the attempt to suggest interpretation and context without boring visitors or taking them away from the all-important business of looking at the exhibits. Above all, it does not pursue some unattainable 'authenticity'. Instead it seeks to recapture, in an idiom which is unmistakably that of contemporary museum display, some of the elements of Edo period domestic architecture. Textures, finishes and colours suggest *tatami*, wood and clay, and the lighting approximates to the paper-filtered daylight by which many of the exhibits would have been seen and used. The idea of modularity based on the dimensions of the *tatami* is conveyed by divisions within the cases which correspond to larger divisions within the gallery as a whole. The overhead structure uniting the cases incorporates panels of *renji*, upright wooden slats arranged

side by side. Although this particular detail comes very close to some well-known classical seventeenth-century interiors, its very simplicity should preclude its being viewed as a pastiche.

As well as being transformed by a new display policy and a design which hints at its original physical context, the collection has recently been given a new balance by means of several important acquisitions. Limited funds concentrate the mind wonderfully. When the Japanese holdings were reassessed during the 1960s, it seemed that it might be possible to purchase some great early Buddhist sculptures, some important Muromachi period ink-paintings or some Momoyama period screens. Since then events have overtaken us. The prices of such things have soared, purchase grants have been cut, and the Museum has been obliged by the weight of public opinion to save western masterpieces from export rather than import eastern treasures. As a result new ways of giving extra significance to the inherited collection have had to be found. The answer has been to buy a small number of high-quality pieces in areas where there is something to build on. The outcome is far more distinctive and far more in tune with the V&A's current commitments than would have been a half-hearted imitation of the great American collections.

The quality and importance of recent acquisitions is reflected in the fact that nearly twenty percent of the pieces selected for this book have entered the Museum during the last fifteen years. In the case of lacquer, for example, three purchases (*31, 32, 42*), two from the early seventeenth century and one from the middle years of the nineteenth century, provide the chronological frame for a remarkable collection of Edo period material. A magnificently rugged storage jar from Shigaraki (*13*) complements the more self-conscious glazed ceramics from the Nagoya region (*11, 12*). Japanese textiles received less attention from the Victorian and Edwardian collectors than other traditional industries and were represented almost entirely by small samples rather than whole garments. Five pieces (*53–57*) bought in the last four years have remedied the situation and are symbolic of a change in emphasis from the academic classification of designs to the appreciation of dress as a vital part of a nation's material culture.

More obviously, there has been a realisation that four minor ceramics donated in the 1930s do not constitute a twentieth-century collection. The Museum's virtual failure to buy anything modern during the years 1910–1970 has left a gap which is hard to fill. The market for pieces from that period (apart from ceramics) is undeveloped even in Japan, but the purchase of a screen by the celebrated textile artist Serizawa Keisuke (*199*) is a step in the right direction. Contemporary work is less of a problem. While it must be admitted that there is at present a serious bias towards ceramics (*200–203*), other materials (*204–205*) have been acquired and it is intended to widen the range in the future. In addition to the contemporary studio pieces included in this book, mass-produced ceramics, lacquers and metalwork have also been purchased. What has to be tackled now is the challenge posed to an orderly collecting policy by the need to extend coverage of contemporary industrial design. Curators trained in the appreciation of the traditional crafts may not be the best people to exercise the extreme discrimination needed in this field if the Museum is to avoid being flooded with desirable consumer goods. Their integration into the wider collections, in terms both of publication and of

display, is another problem. Nevertheless, the very fact that these issues are being addressed augurs well for the Museum's future treatment of Japanese material culture in all its forms.

This is not the place to impose yet another potted history of Japan on the reader. Most of the necessary background is given in the commentaries, but there are a few more general points which should be very briefly made here. Nearly everything reproduced in this book, apart from the pieces in the first three and last three sections, was made during the Momoyama (1573–1615) and Edo (1615–1868) periods. From 1603 to 1868 Japan was ruled by the Tokugawa shoguns. The post of *shōgun* dates back to the eighth century, when it was the title of a general charged by the Emperor with the task of driving the aboriginal inhabitants away from areas occupied by the Japanese. In 1192 it was made a permanent and hereditary political office exercising authority throughout the country, in theory deriving its legitimacy from the Emperor but in practice based on military superiority. The first such shogun, Minamoto Yoritomo (1147–1199), established his headquarters at Kamakura in eastern Japan which gave its name to the Kamakura period (1185–1336), but after his death the government passed into the hands of the Hōjō family of regents. In 1338 Ashikaga Takauji (1305–1358) became the first Ashikaga shogun, ruling from Muromachi in Kyoto which gave its name to the Muromachi period (1336–1573). The Momoyama period saw the gradual unification of Japan, after centuries of increasing political disorder and declining shogunal power, by three great military leaders, Oda Nobunaga (1534–1582), Toyotomi Hideyoshi (1536–1598) and Tokugawa Ieyasu (1542–1616). In 1568 Nobunaga entered the capital Kyoto and in 1573 he deposed the shogun Yoshiaki, putting an end to over two centuries of Ashikaga rule, much of it only nominal.

The Edo period takes its name from the town of Edo, renamed Tokyo in 1868, where Ieyasu established the Tokugawa shogunal government. The beginning of the period is sometimes given as 1600, the year of the great battle of Sekigahara which left Ieyasu master of all Japan, or 1603, when he secured from the Emperor the title of shogun. 1615, the third possible starting date which saw the final defeat of Hideyoshi's son Hideyori, has been chosen here because many of the new elements in Momoyama period art lasted well into the seventeenth century. As explained in the commentary to the armours (p.114), Ieyasu formalised the status of the daimyo and the samurai. The *daimyō*, literally 'great names', were given authority to rule in their fiefs and were ranked according to their income measured in *koku* of rice per annum. All samurai, with the exception of the masterless *rōnin* ('wave men'), were made vassals either of the daimyo or of the Tokugawa family itself. Excluded from agricultural work, they formed a vast army of non-productive retainers whose needs were catered for by the emergent merchant and artisan classes in the great cities of Kyoto, Edo and Osaka.

During the sixteenth century, the development which most affected the future of the applied arts was the shift in economic power from the imperial and shogunal aristocracies of Kyoto to the new military elite and merchant class. The spirit of *gekokujō*, 'the lower overcoming the higher', was apparent not only in the political but also in the artistic arena. Warlords of humble origin sought relief from their bloody struggles by cultivating the art of tea, now brought to a new level of

sophistication by Kyoto aristocrats and merchants from the port cities. Later in the century, Nobunaga, Hideyoshi and their contemporaries built castles and commissioned for their decoration a new type of screen painting combining the brushwork of the Chinese-influenced Kano academy with the brilliant colours of the traditional court style. The desire of the age for immediate and splendid effect is seen in lacquers (*31, 32*) and also in such utilitarian artefacts as sword-guards (*122, 123*), whose decoration was no longer confined to the austere symbolism favoured by earlier warriors.

Zen-influenced restraint and understatement, first felt in the architecture of the Kamakura period warrior class, was mediated through the tea ceremony (*chanoyu*), with its cult of the unaffected and unwrought, to form one of the poles of Edo period taste. At the opposite extreme stand the bold expanses of colour and lavish use of gold typical of the Momoyama painting style. The tension of these two modes informs many of the Edo period artefacts reproduced in this book. Outside the fields of ceramics and textiles, the overall lines of development of Edo period decoration have been little studied except where they come close to comparable trends in painting. Elaboration of technique, a response perhaps to sumptuary regulations restricting expenditure on materials, is a feature of some crafts, reaching a peak in the late eighteenth century. In the middle years of the period, the crafts reflect a growing confidence on the part of the townsmen and a shift of cultural preeminence from Kyoto to Edo, which was less burdened by the weight of tradition. There is a distinct move away from the classical inheritance of literary motifs in favour of material drawn from the popular mythologies of both China and Japan as well as from the experience of everyday life.

No apology is made for the seemingly disparate categories selected for the arrangement of this book. As well as making it possible to adopt a variety of approaches rather than impose a single scheme, they reflect the arrangement of the gallery and the strengths of the Japanese holdings. For example, there are only two areas, Early Ceramics (*9–13*) and Early Metalwork (*3–8*), where the Museum has a rich collection of pre-sixteenth century material. The mirrors illustrate the formative stages of some of the most characteristic design motifs, while the early ceramics set the scene for developments which were to take place at the end of the sixteenth century in response to the formulation of a self-conscious tea aesthetic. Other objects are grouped on the basis of categories which have their origins in Japan. Tea Ceramics (*14–30*) reflect the changing tastes fostered by the tea ceremony (*chanoyu*) over four centuries, while Folk Craft (*155–174*) brings together otherwise miscellaneous items falling within the definition of *mingei* as formulated by the founders of the Folk Craft movement in the 1920s and 1930s.

The study of Japanese design in the Edo period is hampered by the lack not only of obvious regional divisions but also of widely accepted historical phases such as Rococo or Neo-Classical. There are few broad stylistic labels apart from the Rimpa, often mentioned in the text of this book. As a result, much of the material from the Edo period, so well represented in the collection, has been divided according to use or material. *Inrō* and *Netsuke* (*61–103*), two large collections formed with a late nineteenth-century love of completeness, have been put in their proper place as extensions of Dress (*53–60*). Similarly, a selection of the Museum's 5,000 sword-fittings (*115–140*) follows a detailed illustration of the complex assembly (*111*) of which they form a part. Porcelain (*43–52*) includes pieces

destined for use within Japan as well as those made for the European market. Export Lacquer (*149–154*), on the other hand, has been treated as a special category. Apart from its stylistic differences from other Lacquer (*31–42*), it includes three pieces (*149*, *151* and *152*) which must be regarded as the most significant in the Museum's Japanese collection.

Two sections, The Meiji Period (*175–198*) and The Twentieth Century (*199–205*), are purely chronological. The Meiji Period, which saw the end of Tokugawa rule and the restoration of power to the Emperor followed by the emergence of Japan as a modern nation-state, marks such a significant break with tradition in political, social and economic terms that separate treatment is inevitable. Finally, given the severe limitations of the existing collection, the choice of twentieth-century material has been the easiest to make.

As well as those whose names are listed on the title page, many individuals inside and outside the V&A have contributed to the reassessment, restoration and redisplay of a large and neglected collection. At Toshiba International Company Ltd., Sueaki Takabatake and Peter Leeds have been the perfect sponsors, working in close cooperation with Julie Laird and the Associates of the Victoria and Albert Museum on the many financial and administrative aspects of the project. Past and present members of the Far Eastern Department, in particular Carolyn Hopkins, assembled and inventoried some thirty-five thousand Japanese objects which until 1970 had been stored in eight different departments. More recently Catherine Hay, Nicholas Pearce, Amanda Ward and Helen White have prepared close to a thousand pieces for photography, conservation and display, while Amanda Proctor as departmental secretary has borne the brunt of a greatly increased workload. The range of media and techniques represented in the collection has required the involvement of specialists in all the sections of the Conservation Department in the cleaning and repair of nearly every piece, not only the two hundred or so reproduced here but also the majority of those exhibited in the gallery. In the Museum's Works and Exhibitions Sections, Phil Phillips, Garth Hall and Andrew Hiskens handled many of the practical complexities of a technically exacting project. Robert Wood and his colleagues at the Property Services Agency supervised the provision of services and the reinstatement of a magnificent Victorian setting for the Japanese installation, demonstrating a commitment to the preservation of the Museum's unique architectural heritage. Beck and Pollitzer Contracts Ltd. under Tom Morris and Ray Eyres built the display installation, whose standards of craftsmanship have matched the incomparable collection it houses.

From the very earliest planning stages of this project, Paul Williams was the natural choice as designer of the Toshiba Gallery. His unique combination of impressive creative talent with insistent attention to detail has resulted in a display which will rank as the finest in an already outstanding list of achievements.

Joe Earle
Far Eastern Department
May 1986

Map of Japan

showing places mentioned in the text

MAIN ISLANDS

Hokkaido
Honshu
Shikoku
Kyushu

SMALLER ISLANDS

Ryukyu (Okinawa)

NEIGHBOURING COUNTRIES

Korea
China
Taiwan

THE OLD PROVINCES

Dewa
Shimotsuke
Echizen
Mino
Owari
Mikawa
Wakasa
Tamba
Ise
Iga
Bizen
Izumo
Iwami
Higo
Satsuma

THE MODERN PREFECTURES

Aomori
Niigata
Saitama
Ishikawa
Tottori
Fukuoka

LARGER TOWNS •

Edo (renamed Tokyo in 1868)
Yokohama
Nagoya
Kyoto
Osaka
Kobe

SMALLER TOWNS AND VILLAGES ⊙

Akita
Yamanokami
Kirigome
Tsutsumi
Wajima
Nikko
Mashiko
Kanazawa
Kutani
Sekigahara
Kamakura
Sanage
Seto
Atsumi
Tokoname
Shigaraki
Zeze
Nara
Arima
Hagi
Karatsu
Imari
Arita
Nagasaki

REGIONS AND FIEFS

Tsugaru
Tōhoku
Mito
Noto
Hirado

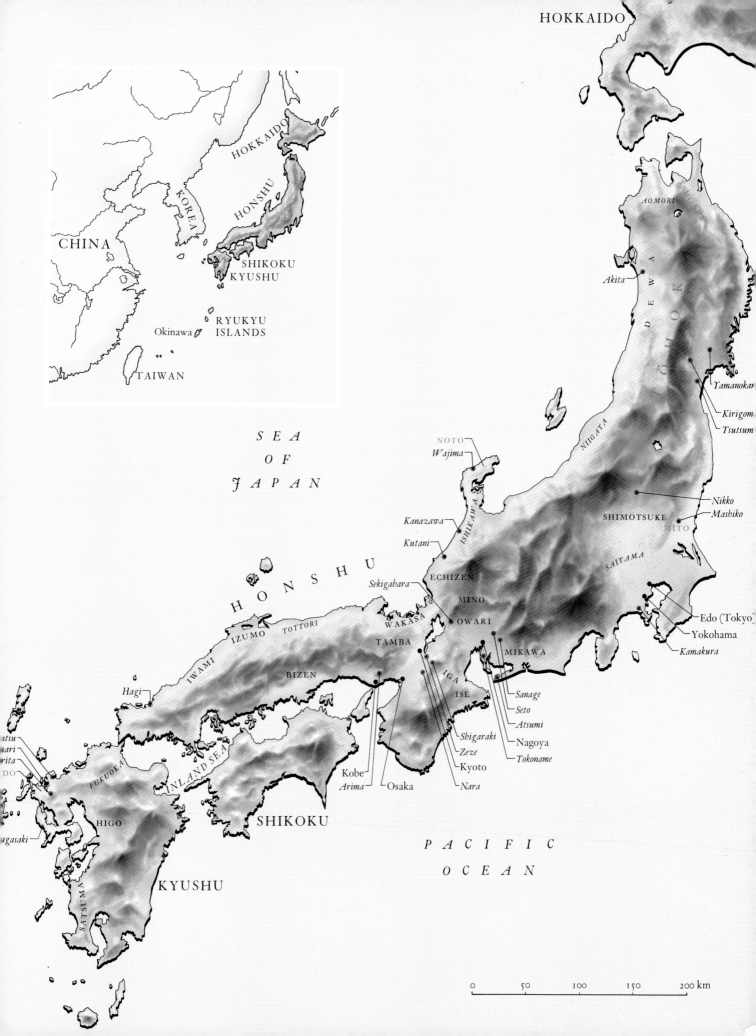

HOKKAIDO

CHINA

KOREA

HOKKAIDO

HONSHU

SHIKOKU
KYUSHU

RYUKYU
ISLANDS

Okinawa

TAIWAN

SEA

OF

JAPAN

AOMORI

Akita

NIIGATA

NOTO
Wajima

Kanazawa

Kutani

ISHIKAWA

ECHIZEN

MINO

SEKIGAHARA

WAKASA

OWARI

TAMBA

BIZEN

IZUMO TOTTORI

IWAMI

Hagi

INLAND SEA

FUKUOKA

HIGO

agasaki

KYUSHU

SATSUMA

SHIKOKU

H O N S H U

IGA

ISE

MIKAWA

Sanage

Seto

Atsumi

Nagoya

Tokoname

Shigaraki

Zeze

Kyoto

Nara

Kobe

Arima

Osaka

DEWA

T
Ō
H
O
K

Yamanokan

Kirigom

Tsutsum

Nikko

Mashiko

SHIMOTSUKE

MITO

SAITAMA

Edo (Tokyo)

Yokohama

Kamakura

atsu
ari
rita
DO

P A C I F I C

O C E A N

0 50 100 150 200 km

Chronology

Chronology of periods mentioned in the text

794 ——— 1185 Heian period

898–1185 Later Heian period

1185 ——— 1336 Kamakura period

1336 ——— 1573 Muromachi period

1573 ——— 1615 Momoyama period

1615 ——— 1868 Edo period

1868 ——— 1912 Meiji period

Buddhist Images

THE Buddhist religion, introduced to Japan during the sixth century, brought with it many aspects of the advanced civilisation of Korea and China on the Asian mainland: a writing system and literature, music and architecture as well as painting and sculpture. Like the monasteries and churches of Europe, the great Buddhist foundations of Japan have stimulated and preserved some of the highest artistic achievements of the Japanese people. The earliest Buddhist images were mostly made of bronze, clay or lacquer, but from the late eighth century carved wood became the commonest medium. In the later Heian period (898–1185) a number of religious sects came into being which emphasized personal salvation through faith in Amida, a form of the Buddha who rules the Pure Land of the Western Paradise. Pure Land Buddhism inspired a revival of the sculptural tradition and this figure (1) is the best example of classic Buddhist art in the Museum's collection. The image is identified as Amida by the tightly interlocking legs, the eyes almost closed in meditation and the hands raised in the gesture for expounding the Buddhist law.

1
AMIDA NYORAI
Carved and lacquered wood
13th century
Height 44.5 cm
FE.5-1972
Given by Sir John and Lady Figgess

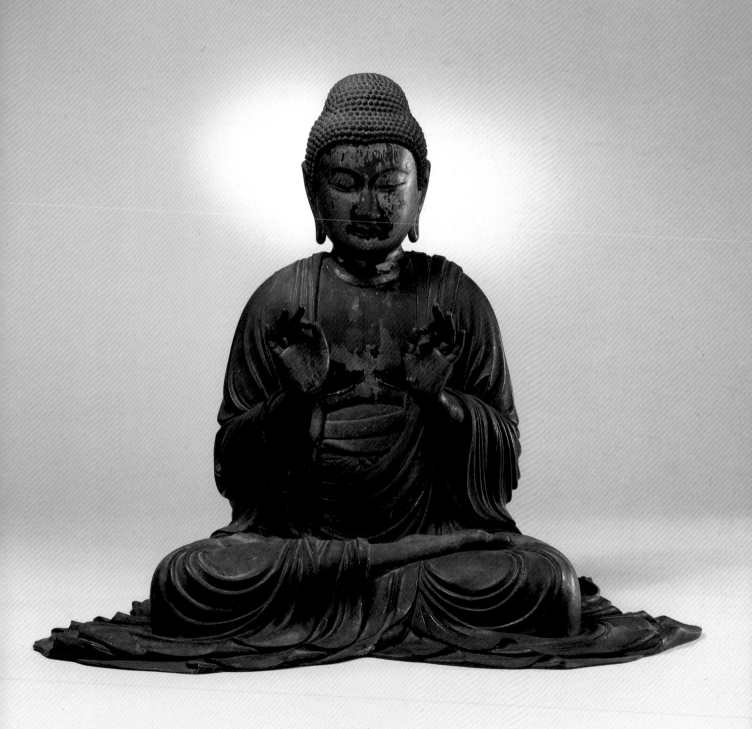

Bodhisattva are beings who have escaped from the cycle of reincarnation and achieved enlightenment but choose to postpone their entry into nirvana in order to work for the relief of suffering mankind. Nyoirin Kannon is a form of the bodhisattva Kannon, who 'listens to the voices of the world', and is distinguished by having six arms, holding a lotus, a wheel of the law of reincarnation and a rosary, as well as by the characteristic pose. Nyoirin's special function is the granting of wishes.

Recent analysis carried out in Japan has shown that the volcanic rock from which this image (*2*) is carved comes from the east of the country. Steles of this kind were often erected as an act of piety in the precincts of unattended wayside shrines and temples, sometimes built as part of a series of thirty-three temples in a particular district, all of them dedicated to different forms of Kannon. Such series of temples were visited in sequence by Buddhist pilgrims.

Most stone images of this type are roughly carved and are normally assigned by contemporary Japanese scholars to the category of 'folk art' (see p.160), but this example is of unusually high quality. JE

2
NYOIRIN KANNON

Carved andesite
Inscribed *made for the lady believer Jōoku Isei on the twentieth day of the seventh month of the eighth year of Empō* [= 1680]
Height 140 cm
A.125-1920
Tata Gift

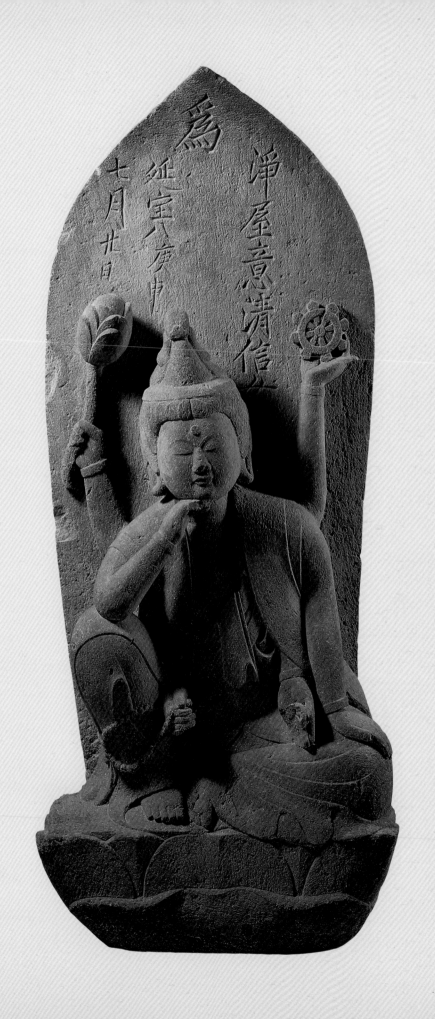

Early Metalwork

3
BELL
Gilded bronze
14th century
Height 17.4 cm
FE.154-1983

BELLS of the type reproduced opposite (*3*), called *gokorei*, were used along with other implements in the rituals of the Tendai and Shingon sects of the Buddhist religion, whose teachings were introduced from China in the ninth century. Their sound is said to symbolize the awakening of the original Buddha-nature in each individual, and to illustrate the relationship between the illusory world and ultimate reality, the sound standing for the transitory nature of phenomena.

The mirrors overleaf are shown with their backs uppermost. Japanese mirrors were cast from bronze. Their faces were polished and, from the eleventh century, made more reflective by applying a thin layer of tin. They were lifted and held by a cord which was passed through a hole in the raised boss in the centre of the back. This boss often took the form of a tortoise.

In Japan, as in the West, although mirrors have an essentially practical function, their property of reflecting whatever is put in front of them has made them objects of veneration. Shinto, the indigenous Japanese religion, endowed mirrors with the numinous quality, *kami*, also associated with natural phenomena such as trees, rocks and springs. The mirror is one of the Three Sacred Treasures of Japan: the Mirror, Sword and Jewel. With the introduction of Buddhism in the sixth century, the religious link was reaffirmed. Mirrors were buried in mounds (*kyōzuka*) containing scriptures and other religious material, inscribed with images of Buddhist deities, placed inside Buddhist sculptures and even, as an act of piety, thrown into ponds in large numbers. In the more secular-minded Edo period (1615–1868) religious beliefs about mirrors survived in proverbial form: 'A cloudy mirror means bad luck, a broken mirror means divorce'.

The first mirrors to be used in Japan were imported from Korea and China and it was not until the fourth century AD that the Japanese began to make their own. At first they were close copies of Chinese and Korean originals, but by the eleventh century mirrors with distinctively Japanese designs were being made. Of the mirrors reproduced on the following pages, (*5*) is the earliest, showing how formal Chinese designs had been replaced by naturalistic subjects. Although there are some motifs on these mirrors, for example the two small birds, which are not found elsewhere, there are many which are often met with on other types of object of the same period, for example autumn plants (*6*) and pines and birds by the sea shore (*4*). The pine and crane motif is especially common in Japanese mirrors from the twelfth century onwards. Derived ultimately from Chinese depictions of the paradise island of Penglai (in Japanese Hōrai), it developed, with the addition of bamboo, into a conventional assemblage of symbols for longevity (*8*). JE

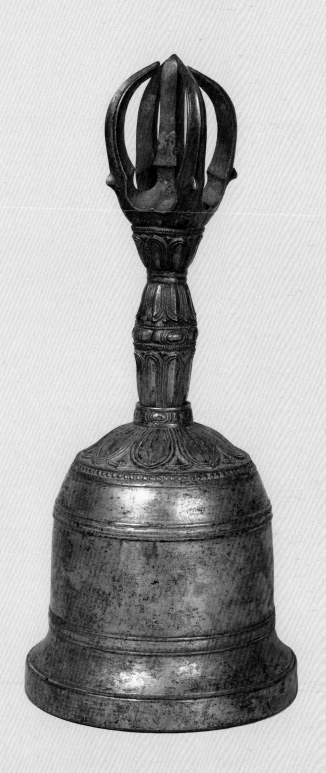

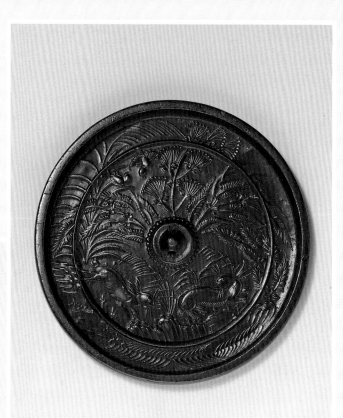

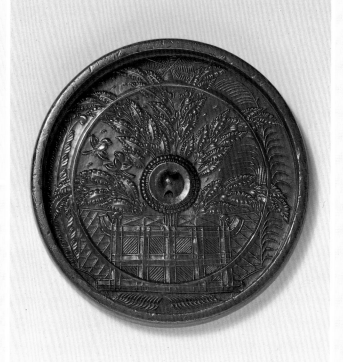

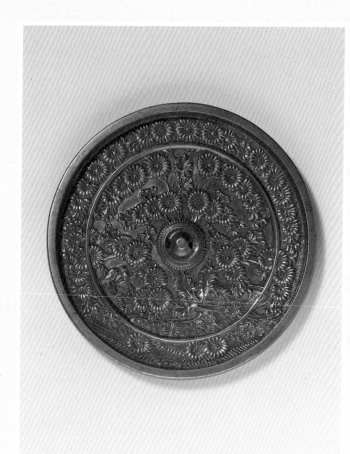

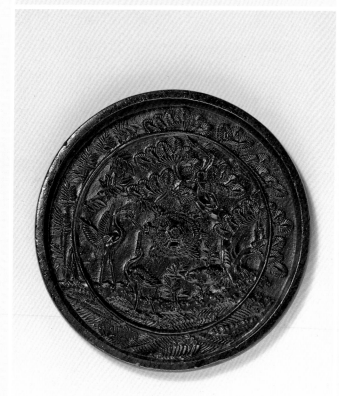

4 *(left)*
MIRROR
Cast bronze
Pine trees by the sea shore, and
two small birds
14th century
12.2 × 10.7 cm
M.61-1928

5 *(centre top)*
MIRROR
Cast bronze
Hares and autumn plants, and
two small birds
13th century
Diameter 11.4 cm
718-1901

6 *(centre bottom)*
MIRROR
Cast bronze
Autumn plants by a fence, and
two small birds
14th century
Diameter 11.4 cm
717-1901

7 *(top right)*
MIRROR
Cast bronze
Chrysanthemum flowers by a
stream, and two small birds
13th or 14th century
Diameter 11.0 cm
FE.81-1982
Given by the Trustees of the
Wellcome Trust

8 *(bottom right)*
MIRROR
Cast bronze
Cranes, pines and bamboo by the
sea shore
15th or 16th century
Diameter 11.3 cm
722-1901

Early Ceramics

Japan's reputation as a ceramic producing nation is justified not only by its activities during modern times. Archaeologists have shown that there were rich traditions of earthenware manufacture in Japan's prehistory, and that stoneware has been made for more than fifteen hundred years. The technical mastery seen in early Japanese pottery was followed by increasingly complex and sophisticated developments which have continued to the present day. Contemporary Japan boasts a large and innovative population of artist potters alongside an extensive industrial base which supplies many parts of the world with quality ceramic goods. The success of Japan in these areas owes much to the corpus of skills acquired by its potters during long centuries of manufacturing experience, and can only properly be understood as the result of an extended historical process.

The Museum's collection of Japanese ceramics does not contain any prehistoric earthenware. The earliest major piece is the sixth-century Sueki jar opposite (9). It was probably intended as a burial accessory for one of the many large tombs built in Japan at that period. Similar vessels with rounded bottoms have been found with tall supporting stands. The marks visible on the exterior reveal that the jar was made by joining together a series of coils of clay which were then beaten into shape with a textured paddle. The flow of air into the kiln in which the jar was fired was controlled in such a way that only a limited amount of oxygen could enter. This resulted in a reducing atmosphere which caused the iron-rich clay to turn a greyish black colour. The deep green splash of glaze which defines the front of the jar is the chance result of flying ash from the wood fuel settling and melting on the pot surface during firing.

The technical features of this jar are characteristic of Sueki wares as a whole, and have their source in methods introduced into Japan from Korea at about the turn of the fifth century AD. The most important aspect of this new technology was the use of single chambered kilns built as narrow tunnels into sloping hillsides. Unlike the bonfires or open pit kilns used for earthenware, these new kilns attained for the first time temperatures up to and above the twelve hundred degrees celsius necessary to produce stoneware. The effectiveness of the tunnel kiln can be gauged by the fact that it was the only type of high temperature kiln to be used in Japan until the sixteenth century. Variations in size and proportions occurred in response to different needs, but the basic design of the kiln remained unchanged.

The second example reproduced (10) is a tall-necked Sueki jar with a liberal covering of natural ash glaze, dating from the late seventh to early eighth century. This was the high point of a period of extensive Chinese influence which affected many aspects of Japanese cultural life. Government was being centralised along Chinese lines, and attempts were being made to assert control over the provinces by means of local seats of power governed by appointees from the capital.

9
ROUND-BOTTOMED JAR
Stoneware with natural ash glaze
and paddling marks
Sue ware
6th century
Height 25.4 cm
FE.8-1972

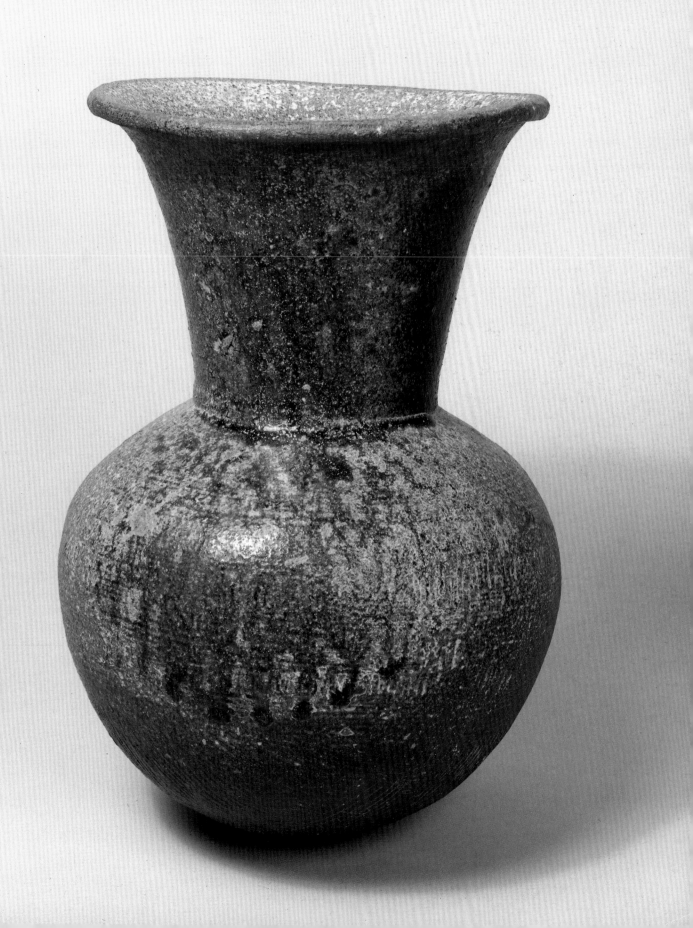

Ceramics of quality were required at these regional centres and Sueki workshops were built accordingly. The dissemination of stoneware technology which had been taking place since the fifth century was complete, and Sueki kilns were active throughout the country. In the meantime the nature of the demand for pottery had undergone considerable changes. At more sophisticated levels of requirement, at least, the need was less for burial accessories, as previously, than for high quality functional wares for official and religious ceremonial purposes. Chinese influence caused changes in kiln distribution and in the overall nature of Sueki manufacture, and was also responsible for the development of several of the new pottery shapes which appeared at the time. It seems that at first the influence came from Chinese metalwork rather than ceramics. The angularity and the sharpness of execution of the Museum's jar is reminiscent of metalwork, and although no immediate prototype is identifiable, it is not unreasonable to suggest that imported Chinese bronzes were the formative inspiration.

There was, of course, also influence from Chinese ceramics. Multi-coloured lead-glazed wares closely modelled on Tang dynasty (618–906) originals have been stored in the Shōsōin treasury in Nara since the eighth century. There was also a variety of stonewares, in particular green-glazed Yue wares from Zhejiang province in southern China, which inspired potters in the large Sueki manu-facturing centre of Sanage, slightly east of present day Nagoya, to experiment with artificial glazing. First attempts were made in the late eighth century, and good results were being obtained not long after. Of numerous changes initiated by the Sanage potters, the practice of using light-coloured clay with a low iron content and the shift from reduction to oxidation firing were the most important. The new wares were so successful and so much in demand that neighbouring kiln groups began to follow Sanage's lead. By the start of the eleventh century the whole Nagoya region was making ash-glazed wares and had disassociated itself completely from the reduction-fired Sueki traditions maintained elsewhere in Japan.

During the twelfth century pottery manufacture became more diversified than before. In the Nagoya region three distinct types of production emerged which were to endure in essentially unchanged form until the end of the sixteenth century. First there were kilns specialising in high-fired but unglazed and rough-bodied bowls and dishes meeting popular demand for ordinary tablewares in the same way as earthenware potteries did in other parts of the country. Next in size of output volume were kilns like those near the coast at Tokoname and Atsumi making large unglazed stoneware storage jars for national as well as regional distribution. The third type of manufacture was of high quality glazed ceramics known as Koseto wares. These were made in the Seto area, northeast of Nagoya and not far from Sanage, in a large variety of shapes frequently modelled after imported Chinese ceramics. The distribution of consumer sites where Koseto wares have been found by archaeologists indicates that they enjoyed a particularly lively market in areas of the country where Chinese ceramics were either unavailable or too expensive to buy.

The two pieces reproduced (11, 12) are examples of Koseto ware dating from the fourteenth century. The first piece (11), a narrow-mouthed bottle, is closely based on contemporary white porcelain examples from kilns in southern China.

10 (*opposite*)
TALL-NECKED JAR
Stoneware with green ash glaze over lightly rouletted bands of dots
Sue ware
Late 7th to early 8th century
Height 27.4 cm
FE.7-1972

11 (*overleaf left*)
NARROW-NECKED FLASK
Stoneware with green ash glaze over impressed roundel decoration
Seto ware (Koseto type)
Mid-14th century
Height 26.7 cm
FE.6-1972

12 (*overleaf right*)
WIDE-MOUTHED JAR
Stoneware with olive brown glaze over combed and impressed floral decoration
Seto ware (Koseto type)
First half of the 14th century
Height 23.5 cm
C.44-1960

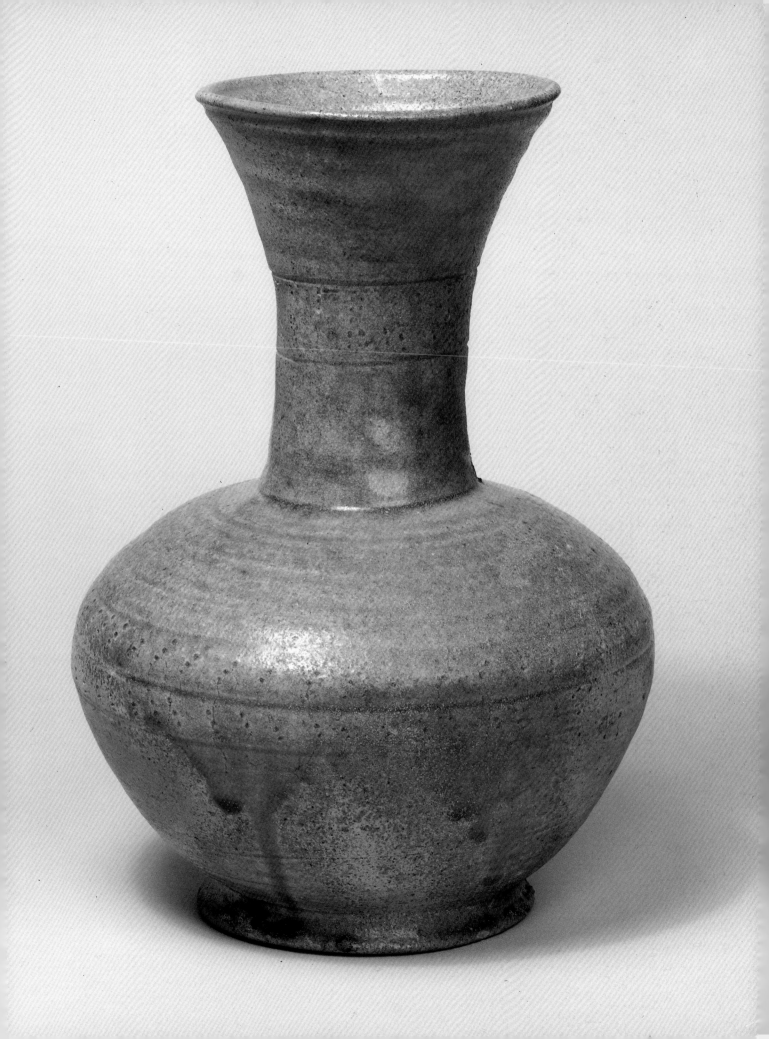

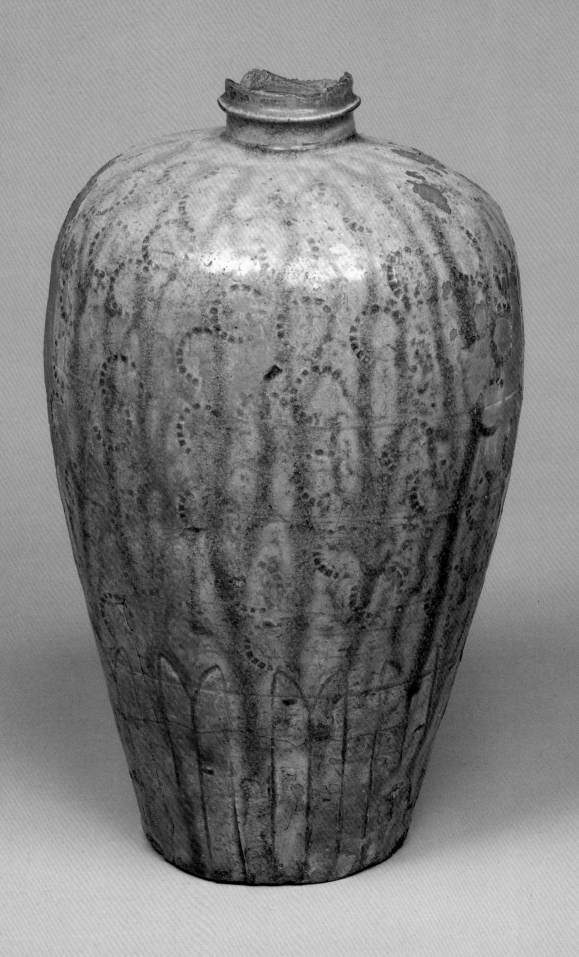

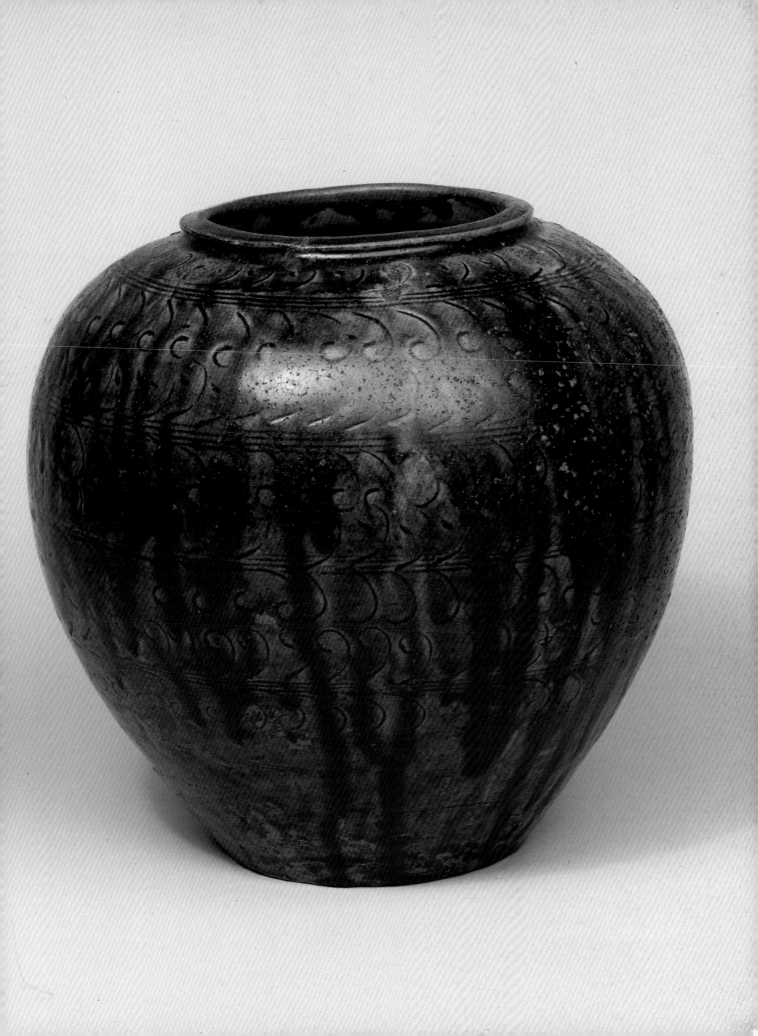

The second piece (*12*), a wide-mouthed jar which may originally have had a lid, also had its prototype in Chinese imports, this time in celadon wares rather than white porcelain. While the makers of these pieces were clearly successful in reproducing the shapes of their models, they failed somewhat as far as techniques of surface decoration and glazing are concerned. The simple stamped roundels on the bottle are a far cry from the intricately incised and combed decoration seen on Chinese equivalents. The decoration on the wide-mouthed jar is slightly more complex but still rather naive. The potters were no more competent in their handling of the glazes. The green glaze on the bottle is a simple combination of clay and wood ash, while the same mixture modified by the addition of iron oxide-bearing material gave rise to the brown glaze of the wide-mouthed jar. In both cases the glazes are unstable and have run quite badly.

It is true not only of these two examples but of Koseto wares in general that while accurately copying the shapes of their models they fail to reproduce the effects of glaze and surface decoration. Possibly the Seto potters had access only to drawings or rough reconstructions of Chinese wares and not to actual samples, since no Chinese ceramics have been found in the vicinity of any of the numerous Seto kiln sites excavated to date. Tentative though this argument is, it would explain why the Seto potters seem never to have attempted a whole-hearted imitation of Chinese techniques, and why they continued to be so charmingly and freely interpretive in their approach.

Outside the Nagoya region the situation was more straightforward. All the thirty or more mediaeval kiln groups which are presently known concentrated on producing unglazed storage jars. Some kiln groups continued locally established Sueki traditions of making dark reduction-fired wares. Others sprang up anew on the strength of oxidation firing technology learnt from the Nagoya region. A third kind combined technology from both traditions but developed in favour of oxidation firing. Shigaraki, the village where the storage jar opposite (*13*) was made, falls into this last category. The jar dates from the fifteenth century and is a particularly striking example of the strength and beauty which can arise from the chance effects of the ceramic process. The rugged contours result from the potter having built up the shape in several stages, while the streak of pale green glaze is another case of flying ash settling and melting during firing. The spontaneity of this jar contrasts quite sharply with the more controlled elegance of the two Koseto pieces. Between them these pots express the range of aesthetic experience which mediaeval Japanese ceramics can provide, and represent the two main directions which potters continued to follow during the sixteenth century. RF

13
JAR
Stoneware with natural ash glaze
Shigaraki ware
15th century
Height 49.5 cm
FE.20-1984

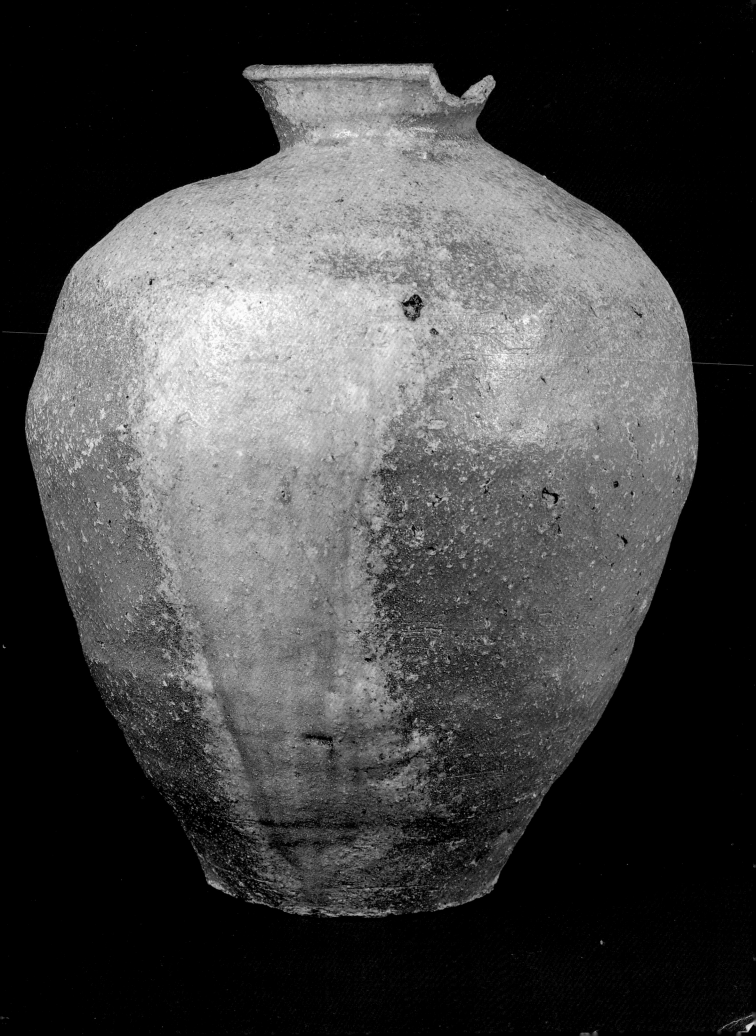

Tea Ceramics

CHANOYU, or the tea ceremony as it is often called, developed into the basic forms in which it is known today during the sixteenth and seventeenth centuries. At the core of *chanoyu* lies the preparation and serving of a type of powdered green tea which is mixed with hot water and drunk like a thin broth. This way of drinking tea originated in China, where it was in vogue during the Northern Song dynasty (960–1127). It is said to have been introduced into Japan in the late twelfth century by Zen Buddhist monks returning from periods of study in China. Powdered tea was initially used in the context of religious ceremonial or for medicinal purposes, but during the thirteenth and fourteenth centuries it came to be drunk by increasingly wider sections of the populace. By the fifteenth century tea drinking had become a prominent part of various modes of social entertainment prevalent among the urbanised military aristocracy. These included lavishly organized tea tasting competitions combined with notoriously drunken banquets and sometimes communal bathing parties. Tea drinking also played a role in meetings of more literary and artistic intent. The origins of the practice were reflected in the utensils used, notably the brown, black and green glazed ceramics from southern China in which the tea was stored and served. More sophisticated devotees began to codify their interests in a formal manner, on the one hand classifying and recording tea utensils in especially compiled catalogues of art treasures, and on the other laying down rules as to the correct procedures by which tea should be prepared and served.

The late fifteenth and early sixteenth centuries were a period of widespread political and social upheaval. Provincial warlords vied with each other in a constant struggle for power, and Buddhist monks armed themselves to join the fray while a newly risen class of wealthy merchants asserted their control in the numerous emergent urban centres. It was among the last of these groups that *chanoyu* as we know it today first evolved. Existing customs were combined and modified, making the actual procedure of tea drinking and the connoisseurship of utensils a cultural activity in its own right. Of particular significance was the evolution of the tea room, a small space some nine feet square specifically set aside for the pursuit of *chanoyu*. Tea rooms were designed in such a way that colours, textures and filtered daylight could be modulated to provide a suitable physical setting for the use and appreciation of the utensils and an atmosphere conducive to interaction between guests and host.

Throughout the history of *chanoyu* Chinese ceramics of the traditionally respected type such as Longquan celadons and Jian *temmoku* wares have enjoyed high status. During the first half of the sixteenth century, however, there was a gradual broadening of the aesthetic horizon so that ceramics which had never previously been considered of any merit were taken up as worthy of serious appraisal. These included more ordinary Chinese ceramics, Korean tea bowls

14
VASE IN THE SHAPE OF A
DRUM
Stoneware with yellow glaze
Mino ware (Yellow Seto type)
End of the 16th century
Height 19.4 cm
176-1877

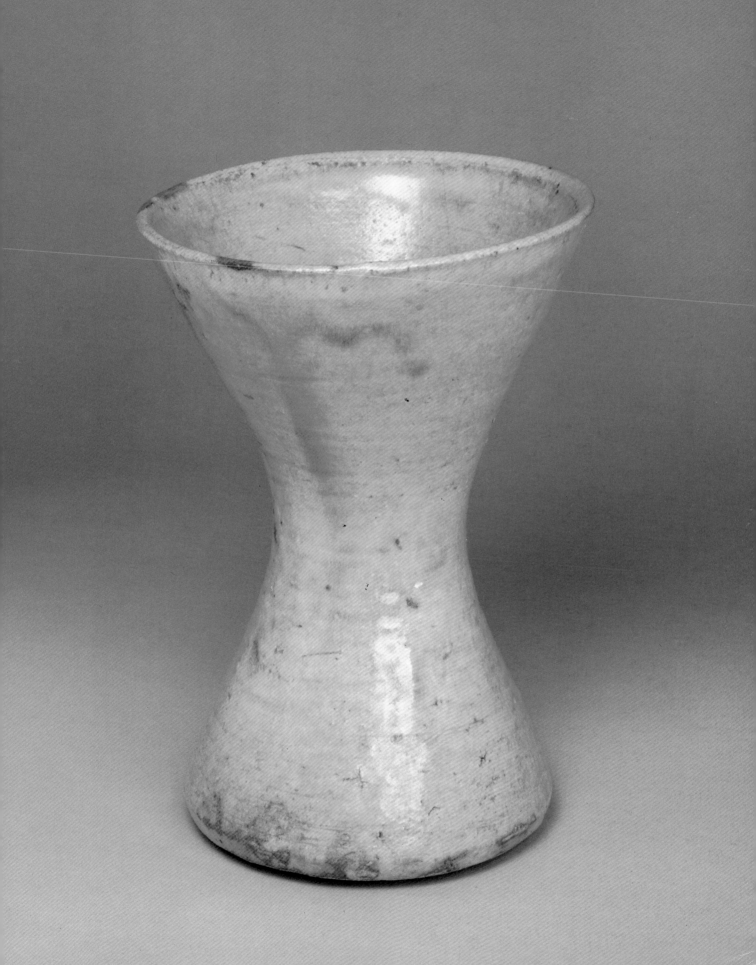

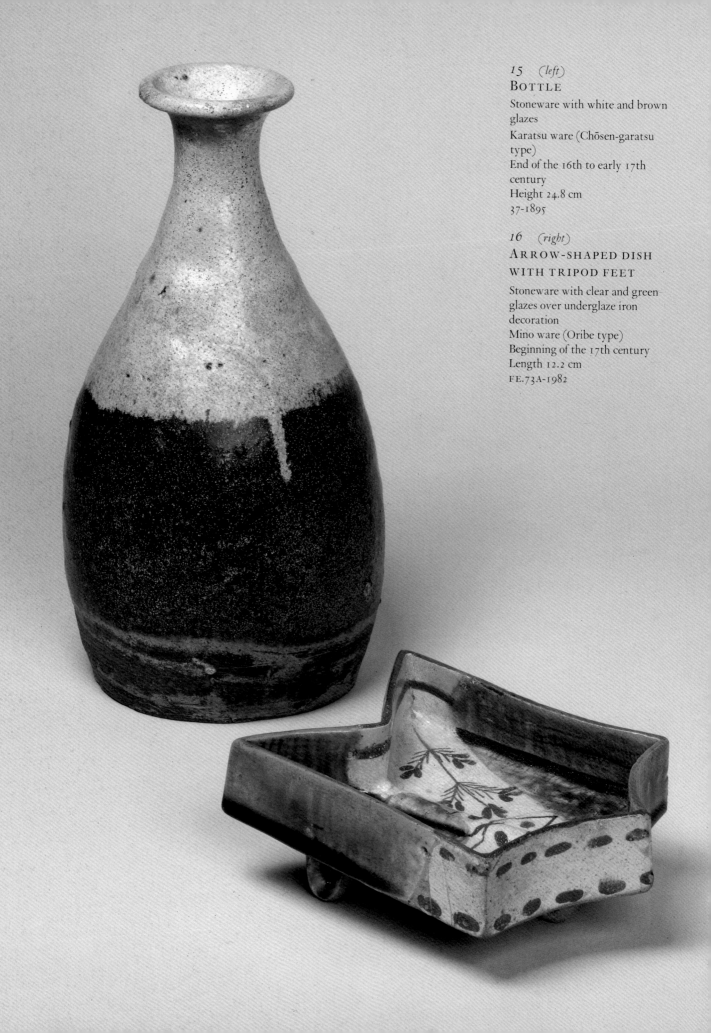

15 (left)
BOTTLE
Stoneware with white and brown glazes
Karatsu ware (Chōsen-garatsu type)
End of the 16th to early 17th century
Height 24.8 cm
37-1895

16 (right)
ARROW-SHAPED DISH WITH TRIPOD FEET
Stoneware with clear and green glazes over underglaze iron decoration
Mino ware (Oribe type)
Beginning of the 17th century
Length 12.2 cm
FE.73A-1982

17 *(left)*
SQUARE FOOD VESSEL
Stoneware with clear white glaze
over decoration incised through
iron slip
Hanging branches
Mino ware (Grey Shino type)
End of the 16th century
Height 9.2 cm
C.633-1923

18 *(right)*
EWER WITH TRIPOD
FEET
Stoneware with clear white glaze
over floral decoration in
underglaze iron
Mino ware (Decorated Shino
type)
End of the 16th century
Height 15.2 cm
C.648-1923

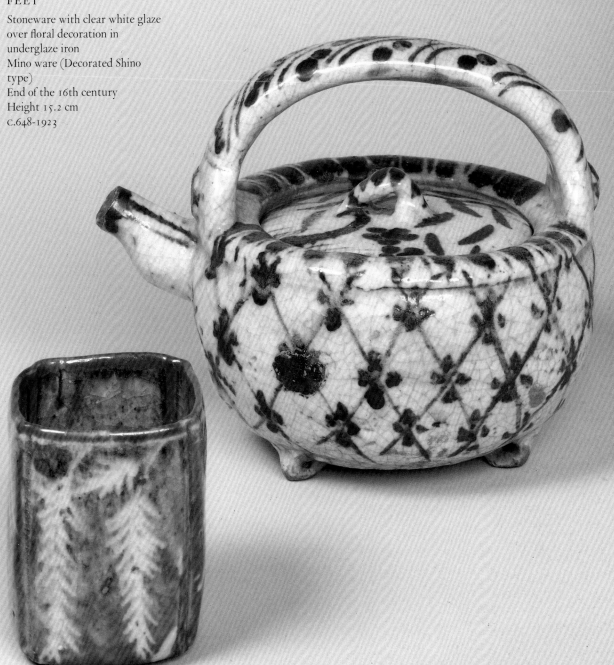

which in their country of origin were sold as humble peasant utensils, and obscure products from the south seas. Such wares entered Japan by way of the port cities where many of the merchant devotees of *chanoyu* lived, and were eagerly seized upon. Native Japanese ceramics were also collected for the first time. Wares with the rough naturalistic qualities of the Shigaraki jar (*13*) were juxtaposed with elegantly formed Chinese ceramics in a mood of profound sensibility tempered by a somewhat wry sense of humour. The discovery and adaptation of objects from unlikely sources has always been one of the more creative aspects of *chanoyu*, and until the 1580s was the only way in which the repertoire of tea utensils was increased. By this time a knowledge of *chanoyu* had become a standard requirement for social acceptability. Urban merchants were still fully involved, but many of the leading exponents now came from the controlling military classes. The increased need for tea utensils together with the desire for new forms created a demand for purpose-made wares.

The first kilns to respond to this demand were in Seto and Mino. Seto had a long tradition of making glazed wares going back to the days of Koseto ware production (see p.32), and glazing had evolved in neighbouring Mino with the introduction of Seto technology in the fifteenth century. During the sixteenth century both areas continued to make glazed wares imitating Chinese ceramics, and were thus closely in tune with changes in taste among the wealthy and influential. Experimentation with new shapes and glazes began in the late 1570s, but it was not until the following decade that tea ceramics proper were made. The Yellow Seto vase (*14*) is one of only a few known examples of its kind. Its peculiar shape is based on the wooden hand-drum used by musicians in the *Nō* theatre. It would have been displayed in the *tokonoma*, the small raised alcove of the tea room, containing a simple arrangement of flowers. The distinctive yellow colour which gives the ware its name derives from the oxidation of a recipe containing small additions of iron oxide in an otherwise simple ash glaze mixture. More common than Yellow Seto wares but no less brilliantly conceived are the various kinds of Shino ware with their characteristically thick white feldspathic glaze. The two examples reproduced (*17*, *18*) are both types of tableware and would have been used in the so-called *kaiseki* style of meal served before the tea drinking part of a *chanoyu* meeting, or in contexts not necessarily related to *chanoyu* but influenced by its tastes. From a technical point of view Shino wares were important as the first kind of Japanese ceramics to have painted decoration. In the case of the ewer (*18*) the decoration was executed in underglaze iron oxide. On the food vessel (*17*) a reverse kind of technique was used. The pot was first covered in iron oxide-bearing slip which was then incised with a sharp tool so that the white clay would show through from below. Its square shape was achieved by using a mould, another innovation of the late sixteenth-century Mino kilns.

The Momoyama period (1573–1615) saw an expansion of ceramic production throughout the country, coupled with the high degree of inventiveness which was displayed in so many other areas of the arts. In Mino the flavour of the age is epitomized by the exuberant shape and colour of Oribe wares (*16*). The irregular form and division of the pot surface into areas of contrasting colour echo contemporary trends in textiles and lacquerware. Even more expressive work was being carried out at kilns which during the mediaeval period had specialised in unglazed stoneware storage jars. The Bizen ware tea caddy and fresh-water jar

19 (*left*)
TEABOWL
Raku ware with black glaze, partially scraped away
Kyoto, attributed to Hon'ami Kōetsu (1558–1637)
Early 17th century
Diameter 12.7 cm
247-1877

20 (*centre*)
FRESH-WATER JAR
Stoneware with off-white glaze
Karatsu ware (Plain Karatsu type)
End of the 16th to early 17th century
Height 10.6 cm
FE.10-1972

21 (*right*)
TEA CADDY WITH IVORY LID
Stoneware with natural ash-glaze and firing marks
Incised mark on base
Bizen ware
End of the 16th to early 17th century
Height 7.3 cm
189-1877

22 (*overleaf left*)
FRESH-WATER JAR WITH LUG HANDLES
Stoneware with natural ash glaze, firing marks, and incised decoration
Impressed seal on inside bottom and incised mark on base
Bizen ware
End of the 16th to early 17th century
Height 20.3 cm
191-1877

23 (*overleaf right*)
VASE WITH LUG HANDLES
Stoneware with natural ash glaze over incised and impressed decoration
Iga ware
End of the 16th to early 17th century
Height 20.3 cm
205-1877

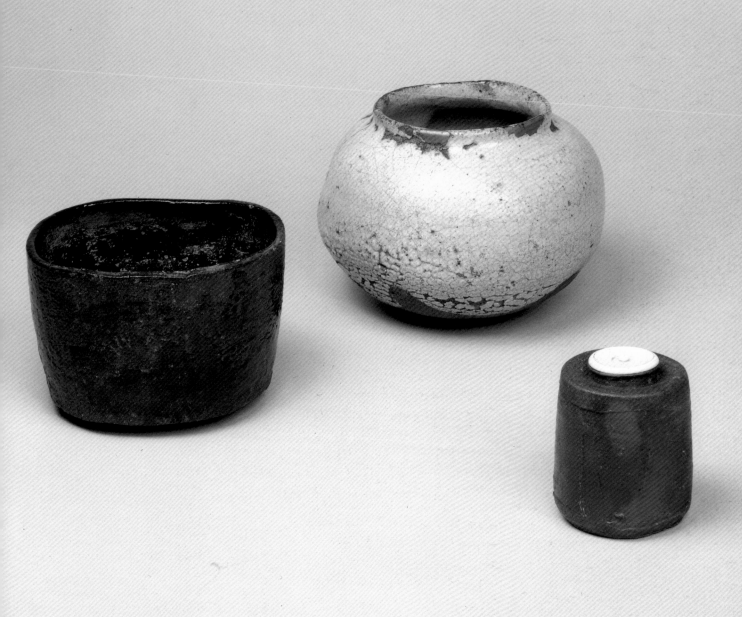

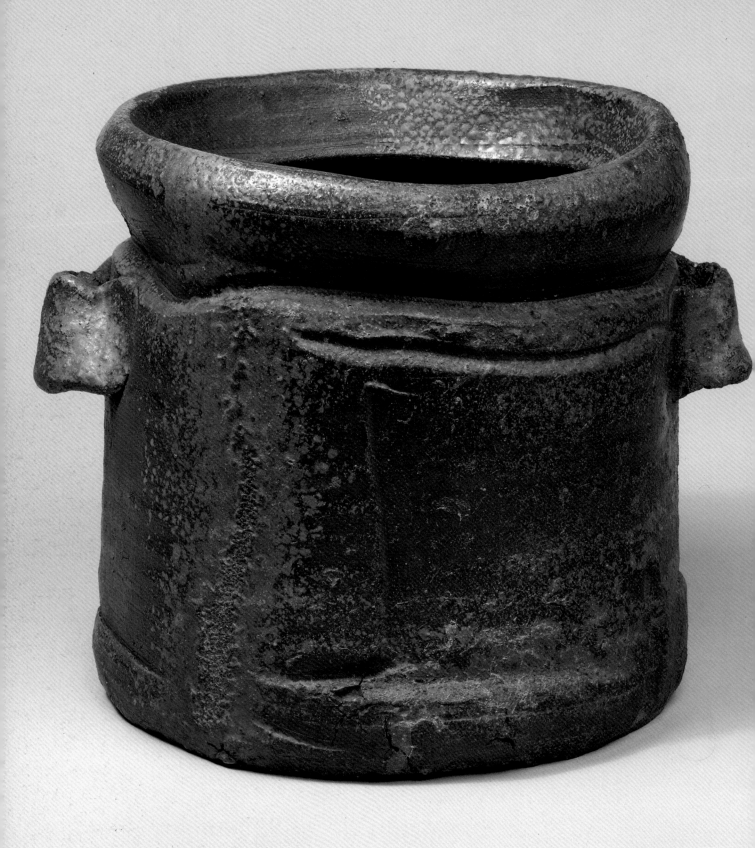

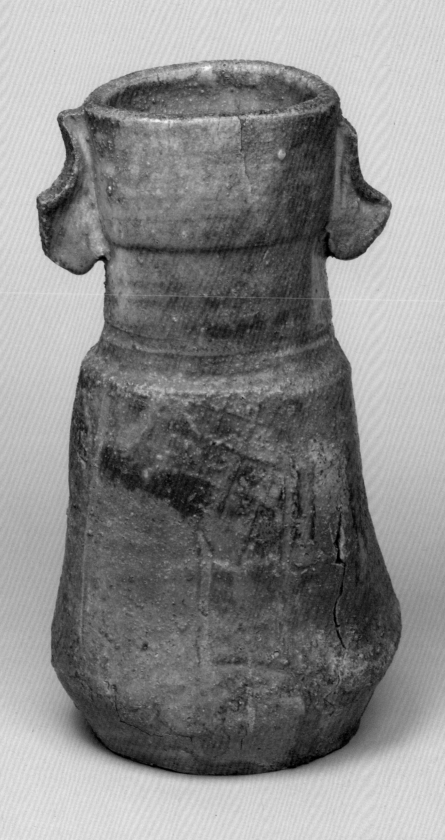

(*21, 22*), the Iga ware vase (*23*) and the Tamba ware fresh-water jar (*25*) are some of the finest examples in the Museum. The Iga vase would have been used in the same way as the Yellow Seto example described earlier. The other pieces would have been used in the types of combinations shown on pages 43 and 47. The tea caddy would have held the powdered tea before it was poured into the tea bowl and mixed with hot water, while water would have been ladled from the fresh-water container to refill the cast-iron kettle in the hearth as successive bowlfuls of tea were made. The split walls, scorched base and natural ash glaze of the Iga vase result from its having been fired and fired again until the potter was satisfied that it could be improved no further. Again the scarred surfaces and burnt reddish brown tones of the two Bizen pieces are as controlled as they are effective. On the Tamba piece a striking contrast is obtained between the loosely modelled form and the obviously artificial application of glaze. It is one of the most difficult challenges in ceramics to blend artifice and naturalism to the advantage of both, but in all of these pieces the potter has been altogether successful in emphasizing the inherent qualities of his materials in forms which are both individualistic and strongly sculptural.

Another group of ceramics whose appeal lay more in qualities of material and form than in decorative brilliance were the various glazed wares made in western Japan at kilns established near the end of the sixteenth century by *émigré* potters from Korea. The most important of these were the Karatsu kilns, two pieces from which are reproduced (*15, 20*). The tea bowl (*24*) is an example of a similar sort of ware made at Hagi. Karatsu is said to have an older history than other western kilns, but at all events it was not until Japan's invasions of Korea in the 1590s (see p.150) and the bringing back of large numbers of Korean potters that any of the kiln groups became seriously active. Their products showed many of the features which the Japanese had found appealing in Korean ceramics imported earlier in the sixteenth century. Looseness and spontaneity of form, texture and colour of body, and subtlety of glaze were the admired qualities, all of which are well exemplified by these pieces. The Karatsu fresh water jar and bottle are especially pleasing in this respect. Although they are both now treated as tea utensils, neither of them were necessarily intended as such when they were made. The former is a little too small and the latter larger than one would normally expect. They show how the process of discovery and adaptation continued to operate even after purposely made tea wares had begun to appear. The Hagi tea bowl, on the other hand, was clearly made as a tea utensil. While it remains a fine piece of pottery, its flattened side and rather self-consciously notched footring reflect some of the stiltedness which crept into tea ceramics during the Edo period (1615–1868).

Kyoto, the capital of Japan from 794 until 1868, was another important place to develop glazed ceramics during the Momoyama period (1573–1615). It is one of those peculiarities of history that during Kyoto's previous eight centuries it had never had a sophisticated pottery industry. The first of the new Kyoto ceramics were Raku wares. They evolved in close association with *chanoyu*, and the great majority were tea bowls (*27, 28*). Raku wares were hand-formed rather than thrown on the wheel and were fired individually in purposely designed kilns. The inherent immediacy of the process is reflected in the subtle and intimate effects achieved. The bowls (*28*) and (*27*) were made by the fifth and seventh generation

24 (*left*)
TEABOWL WITH
NOTCHED FOOTRING
Stoneware with crackled pinkish grey glaze
Hagi ware
Probably 18th century
Diameter 14.0 cm
219-1877

25 (*centre*)
FRESH-WATER JAR
Stoneware with greenish brown glaze over incised vertical striations
Tamba ware
17th century
Height 15.2 cm
208-1877

26 (*right*)
TEA CADDY WITH IVORY LID
Stoneware with mottled brown glaze
Zeze ware
Possibly 17th century
Height 7.9 cm
211-1877

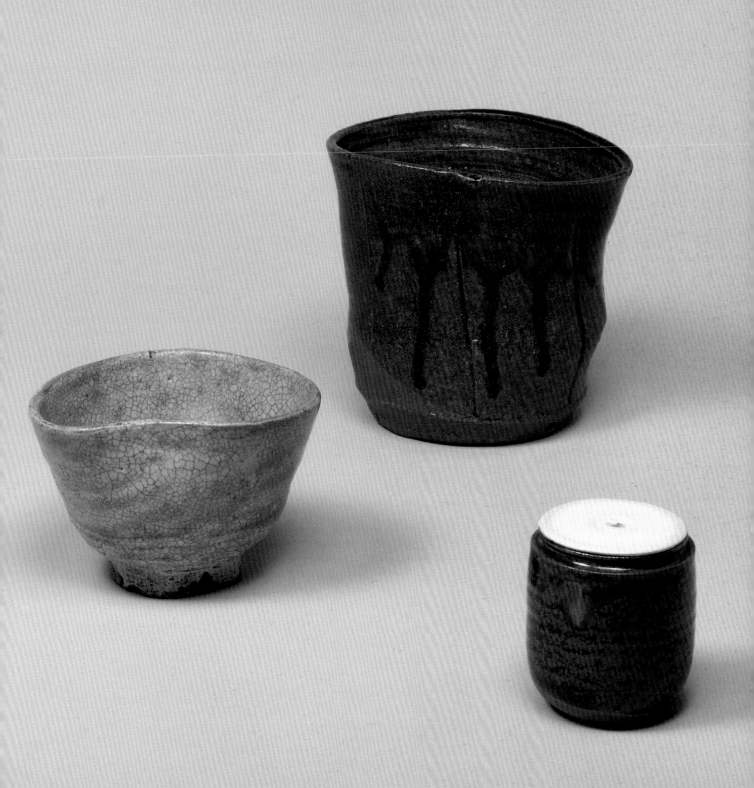

27 *(left)*
TEABOWL

Raku ware with red glaze and
broadly incised band around sides
Mark *Raku* impressed on base
Kyoto, attributed to Raku
Chōnyū (1714–1770)
Mid-18th century
Diameter 12.4 cm
242-1877

28 *(right)*
TEABOWL

Raku ware with black glaze
Mark *Raku* impressed on base
Kyoto, attributed to Raku Sōnyū
(1664–1716)
End of the 17th to early 18th
century
Diameter 11.4 cm
240-1877

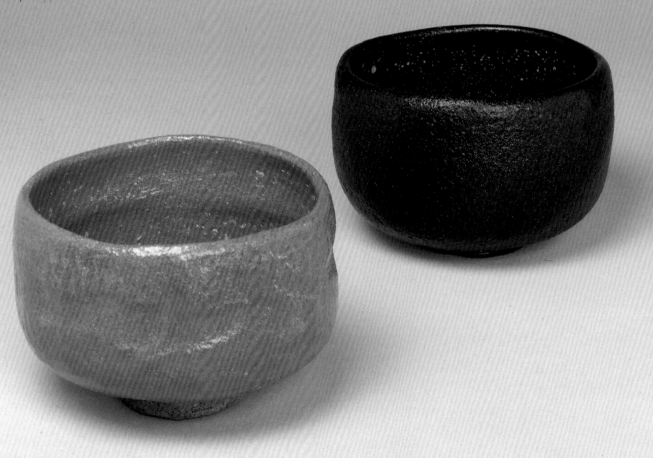

29

INCENSE BURNER IN THE FORM OF A CONCH-SHELL

Stoneware with clear glaze and
stippled underglaze iron
decoration
Mark *Ninsei* stamped on inside of
upper section
Kyoto, probably by Nonomura
Ninsei (*c.* 1574-1660/6)
Mid-17th century
Length 27.3 cm
260-1877

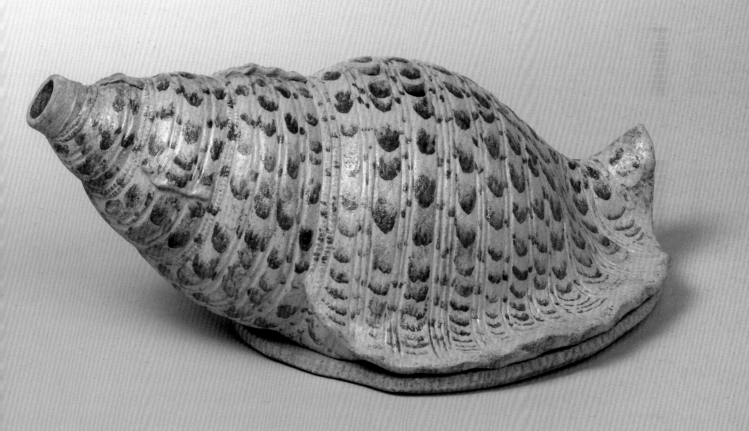

potters of the Raku family, the traditional makers of the ware bearing their name. Raku wares were also made by other people who would not usually have become involved in ceramics, largely because the equipment needed was minimal and results were immediate. One of the great amateur Raku potters was Hon'ami Kōetsu (1558–1637), to whom the tea bowl (19) is attributed. The severity of its almost cylindrical form is extreme, yet it will sit comfortably in the hand and allow the warmth of the tea to be slowly transmitted through its walls. The sharpness of the front of the rim is relieved by a smooth rounded section at the rear. The glaze, which would otherwise have turned out even and shiny, was scraped away in patches to add richness of tone and texture.

Important though Raku wares were, they are not representative of the bulk of Kyoto ceramics which developed in the Momoyama and early Edo periods. Evidence suggests that the earliest of mainstream Kyoto ceramics were copies of existing styles of ware popular at the time, and that technology was introduced from a diversity of sources. The tea caddy (26) was made in Zeze, not far from Kyoto, at kilns established under influence from Seto and Mino. The carefully executed shape and perfectly controlled glaze reflect the early Edo period's preoccupation with technical and stylistic refinement. The incense burner (29), which is attributed to Nonomura Ninsei (c. 1574–1660/6), is a splendid example of mid-seventeenth-century Kyoto ceramics. Ninsei was responsible for the development of a style of overglaze enamel decorated pottery which was to characterize Kyoto ceramics for much of the seventeenth and eighteenth centuries. This particular example has painting in underglaze iron oxide, but it can be seen that decorative effect is the paramount concern and that honesty to the qualities of the ceramic medium has been turned almost on its head in the representation of a very different material.

From Ninsei's time onwards Kyoto flourished as a major source for tea ceramics. By the early eighteenth century when chanoyu had become fashionable among the culturally active and by then very numerous townspeople of Kyoto and elsewhere, increased demand ensured a lively progression of new styles and forms. A further market was also generated by a different kind of tea drinking which became current in the late Edo period as part of a refound interest in Chinese culture, in particular the ideal of the 'literati' artist-scholars. Sencha, as this new style of tea drinking was called, involved the preparation of infused tea with a special combination of utensils in a somewhat exotic array of Chinese styles. The tiered food-box (30), with its minute decoration of popular Taoist symbols, is a good example of its kind. It is attributed to Aoki Mokubei (1767–1833), a central figure in the Japanese 'literati' movement, and shows that some of the more creative work in early nineteenth-century ceramics was being carried out in the context of sencha rather than chanoyu. RF

30
TIERED FOOD BOX
Porcelain with decoration in overglaze enamels
Fruits, and scenes from Chinese mythology
Kyoto, attributed to Aoki Mokubei (1767–1833)
Early 19th century
Width 14.9 cm
C.1324-1910
Salting Bequest

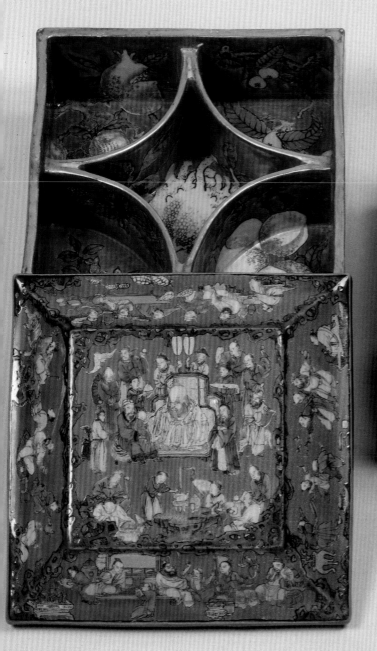
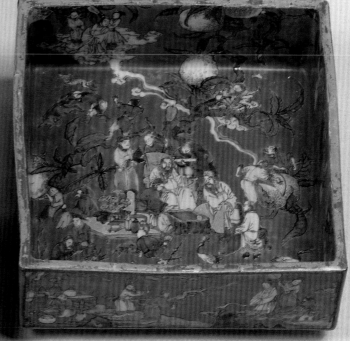

Lacquer

LACQUER is the sap of a tree, *Rhus verniciflua*, and has been tapped in Japan from at least the sixth century AD. After filtration and evaporation of excess water, lacquer is applied to a carefully prepared base of wood, paper or other materials. It can be coloured, but only black (from iron) and red (from mercury sulphide or iron oxide) are commonly used on most pieces of higher quality. The illusion of polychromy is achieved by sprinkling metal dusts, most often gold and silver, onto still-wet lacquer, a technique called 'sprinkled picture' (*maki-e*).

The main types of *maki-e* are *togidashi-e* (see p.68), *hiramaki-e* and *takamaki-e*. In all three cases metal dust is applied to a ground made from many coats of lacquer, usually black, which have been painstakingly applied, dried and polished. In the simplest *maki-e* technique, *hiramaki-e* ('flat *maki-e*'), the design is painted in lacquer which while still wet is sprinkled with metal powder from a bamboo tube fitted with a cloth filter. After the lacquer has dried a further protective coat of transparent lacquer is usually applied and polished. In *takamaki-e* ('high *maki-e*'), the lacquer is mixed with powdered charcoal or clay, so that it can be built up in relief before metal dust is applied.

During the Muromachi period (1336–1573) these techniques were brought to a very sophisticated level, but they were too slow and elaborate either to satisfy the increase in demand for decorated lacquer during the sixteenth century or to incarnate the bold and innovative spirit of Momoyama period (1573–1615) culture. The three pieces reproduced on the following pages (*31–33*) show some of the means by which seventeenth-century artisans brought a new expressiveness to their ancient craft.

The box with willow decoration (*31*) is decorated in *hiramaki-e*, further simplified by the omission of the final protective coat of lacquer. Details within the design showing in black against gold, for example the divisions between crossing branches, are sometimes done by scratching away the gold-sprinkled lacquer while it is still wet instead of carefully reserving certain areas when the lacquer is first painted on.

The box with a design of long-tailed birds and camellias (*32*) is particularly close in technique to a group of lacquers, much admired in Japan today, which are known as *Kōdaiji maki-e* from the name of a temple where several examples are preserved. A characteristic feature of *Kōdaiji maki-e* is *e-nashiji*, '*nashiji* in the design'. *Nashiji*, 'pear skin', refers to irregularly shaped flakes of gold which are suspended in clear lacquer. This technique is normally confined to backgrounds, but here it is used as a contrasting texture to articulate the design. Rubbed areas of the gold decoration show no signs of the usual underpainting in red lacquer, suggesting that the design may have been drawn freehand. Both examples are typical of Momoyama and early Edo period lacquer in their close observation of nature and their skilful use of the whole surface.

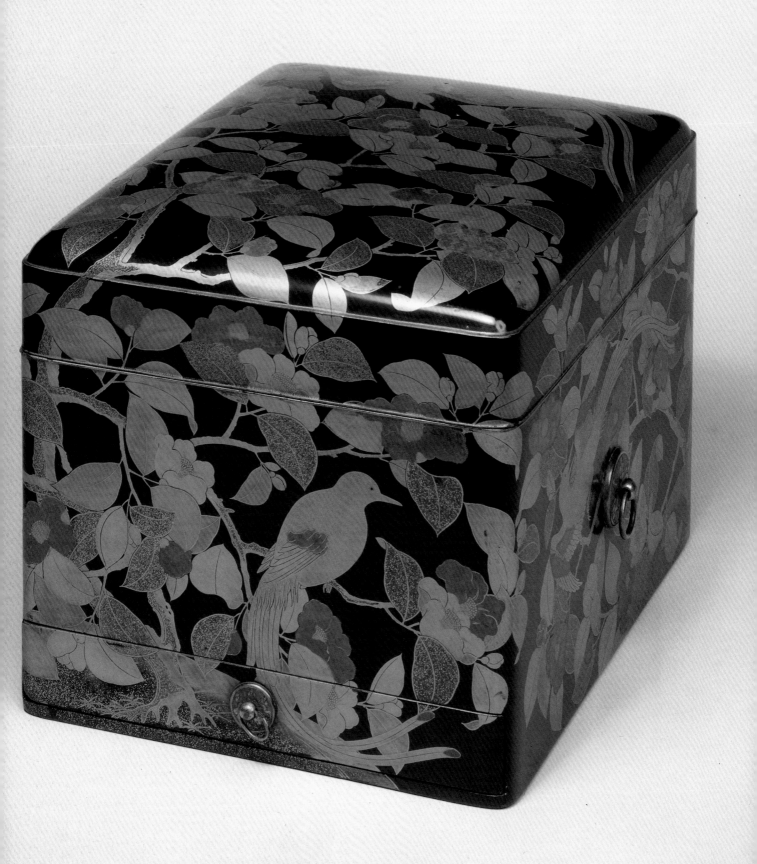

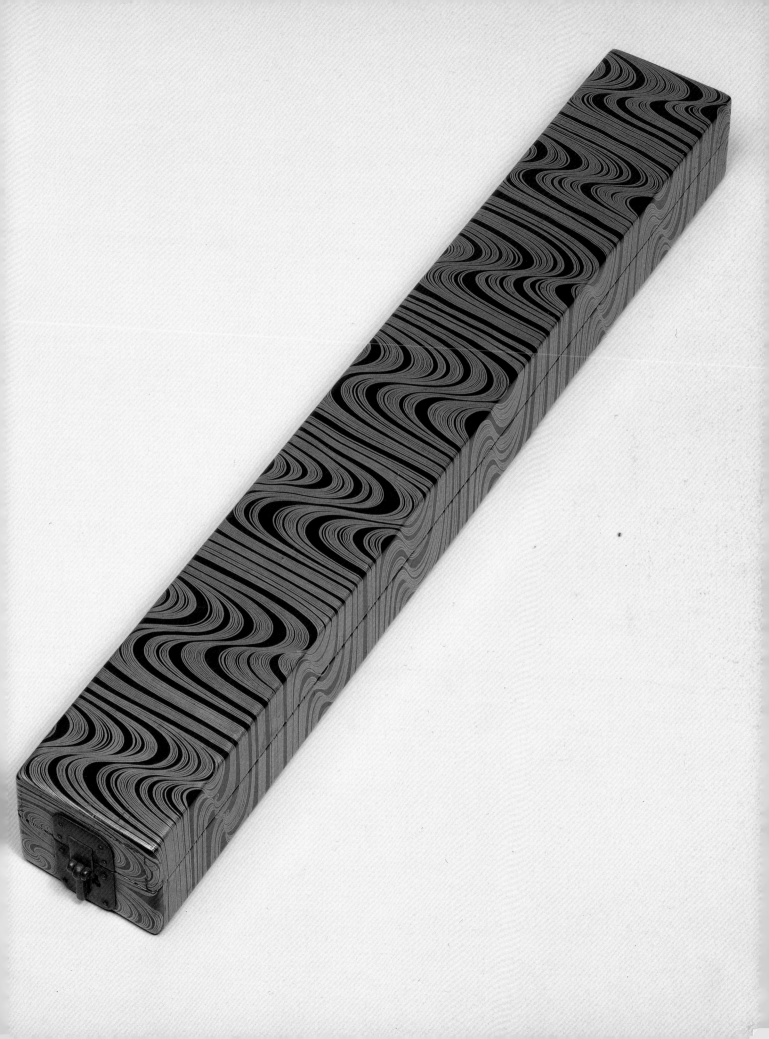

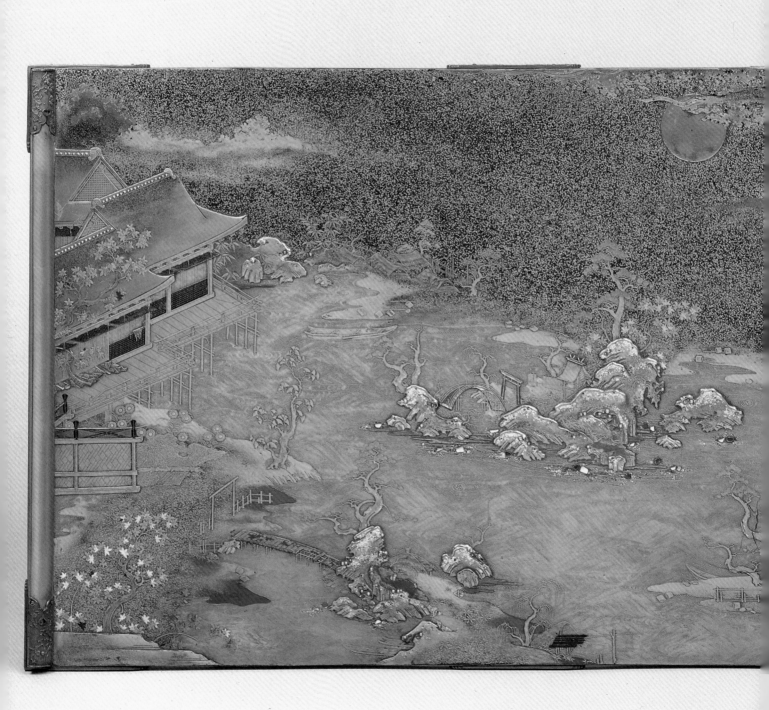

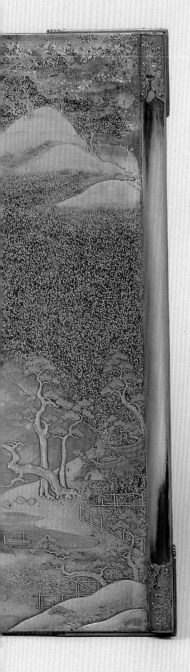

34
WRITING TABLE
(*bundai*)
Wood, covered with gold and
silver *takamaki-e* and *nashiji*
lacquer with gold and silver
details; silvered metal fittings
A deserted palace by the sea
c. 1620
8.9 × 59.7 × 35.0 cm
W.339-1916
Alexander Gift

The scroll box (*33*) is an example of the Rimpa style founded by Hon'ami Kōetsu (see p.50). Kōetsu brought to lacquer some of the ideas which he and his collaborator Tawaraya Sōtatsu (died *c.*1643) had applied to painting and calligraphy, in particular the revival of motifs from the later Heian period (eleventh to twelfth centuries) in a form more directly visual than literary in its appeal. The abstract wave pattern, the sole decoration of this box, was a favourite with Rimpa lacquerers.

This writing table (*34*) exemplifies a mode of lacquer decoration in which elements of the design allude to themes from classical literature. In the earliest, thirteenth century, examples the connection between literary theme and lacquer motif is highly explicit and is often reinforced by the inclusion in the design of words from poems, but in time fewer direct hints were provided and the reference became more complex and suggestive.

In contrast to pieces in a demonstrably Momoyama period (1573–1615) style like (*31*) and (*32*), it is difficult to date such a technically conventional example as this. It is probably correct, however, to suggest that the table was made around the beginning of the Edo period (1615–1868), although it could be thirty or more years earlier. Either way, its manufacture followed more than two centuries of sophisticated versification in the form known as 'linked verse' (*renga*), and lacquer artists were able to assume an unprecedented degree of subtlety in their patrons' appreciation of poetry and motifs drawn from poetry.

Originally, *renga* were thirty-one syllable lyric poems (*waka*) composed by two people instead of one. Later the form developed into 'serious' (*ushin*) *renga* in the form of a hundred or more links governed by explicit rules. There seems to be a close connection between *renga* and the literary mode of lacquer decoration, both of which reached a peak of sophistication in the fifteenth and sixteenth centuries. The lacquers reproduce in pictorial form some of the commonest devices of *renga*, most importantly the reworking of a famous earlier poem (or, in lacquer, earlier image) and *engo*, word (or image) association.

This writing table is best seen as a pictorial *renga* sequence based loosely around the theme of loneliness and separation. Close similarities with a writing box in Kyoto National Museum which has the word *Sumiyoshi* hidden in its design establish that the building on the island is the Sumiyoshi shrine in the present-day city of Osaka. Sumiyoshi is close to Suma, a place famous for salt-making and well-known from the early ninth century as a place of exile and loneliness. Saltburners' huts, especially deserted ones, were the subject of innumerable poems. The broken bridge is the Nagara bridge, used in poems from the great *Kokinshū* imperial anthology, compiled *c.* 905 AD, as an image of separation (by analogy with the gaps between the planks and between lovers' meetings) and decay. Another *Kokinshū* poem, on Suenomatsuyama, the island topped by a pine tree (which is far distant from Sumiyoshi in a purely geographical sense), compares the possibility of the waves rising and engulfing the island with the likelihood of a lover's change of affections. The dilapidated palace, like the deserted salt-burners' huts, calls to mind a whole range of verses on appropriate themes, while the chrysanthemums by a fence refer to a Chinese poem first used in Japanese lacquer in the thirteenth century. The poem, by Tao Yuanming (365–427), is a celebration of the Chinese ideal of withdrawal from the world.

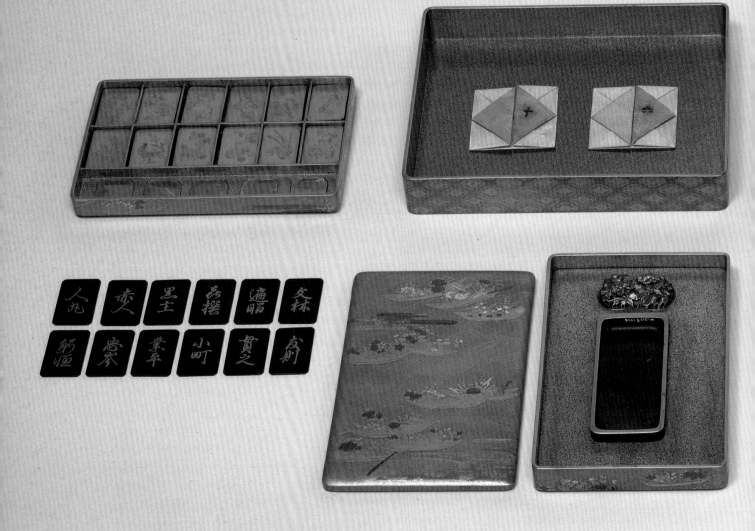

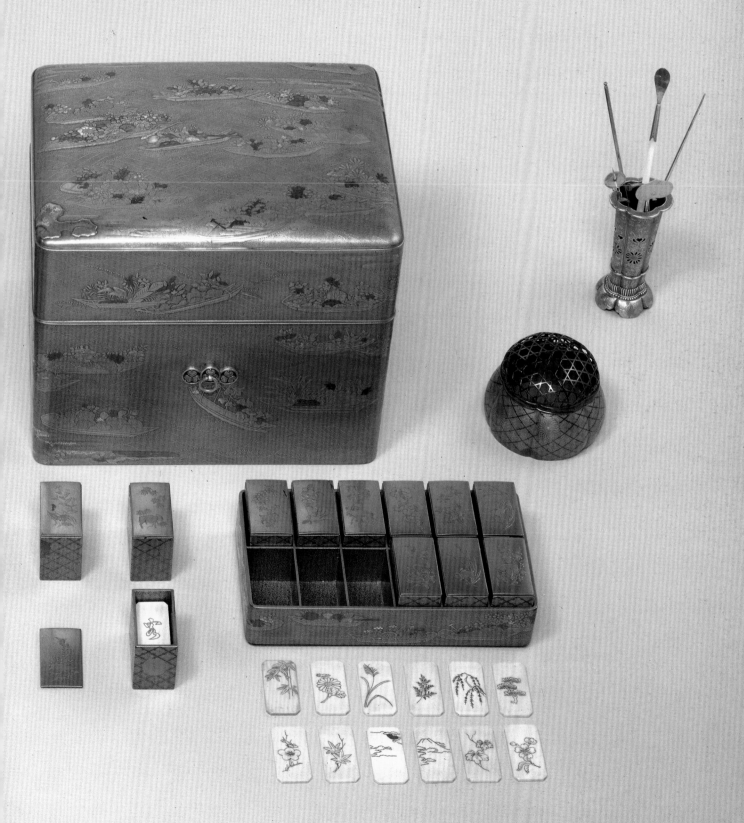

A brief examination can only reveal a few of the possible patterns of reference which the lacquer artist intended. Poetic composition and appreciation in the fifteenth and sixteenth centuries was a highly esoteric activity and it is unlikely that modern scholarship will ever be able fully to unravel the complex web of literary and visual associations which were woven in the mind of a sophisticated aristocrat or merchant.

Knowledge of incense first reached Japan from the Asian mainland during the eighth century and already by the tenth century incense was the object of connoisseurship among the Kyoto aristocracy. The development of incense appreciation into an elaborate social activity on a par with *chanoyu* (see p.38), flower arrangement and *renga* composition took place during the Muromachi period (1336–1573). In the fourteenth century luxury imports from the mainland of Asia included rare incense woods which were avidly collected by enthusiasts. The appreciation of these woods was made easier towards the end of the century by the introduction of silver-rimmed slivers of mica to separate the incense from the burning charcoal on which it was placed. The incense cult reached a peak under the patronage of the shogun Ashikaga Yoshimasa (1435–1490) and detailed records of elaborate incense gatherings exist from the late fifteenth century.

Although during the Edo period (1615–1868) literary associations were still important, the competitive element which had been present from earlier times was given greater emphasis. In a typical version of the Edo period game, four incenses are selected, but only three are burnt at first. Using a small hand-held burner the guests take turns to smell all four incenses and attempt to match them with those which were burnt, or the one which was not burnt, at the beginning. They indicate their guesses by placing a specially marked wood or ivory counter in a cylindrical box with a slot in the top. The guesses are then recorded and a small writing box is included for this purpose in the present set (*35*). The 144 ivory counters are contained in twelve boxes, each decorated in lacquer with one of the twelve zodiac animals. Every counter in each set of twelve carries on one side the character 'guest' (standing for the incense which is not burnt at the beginning) or one of the numbers 'one', 'two' or 'three' (standing for the three incenses which are burnt), and on the other side one of twelve seasonal motifs. A separate set of sixty wood counters, apparently intended for a more literary version of the game, have the names of twelve celebrated early poets (as reproduced here) on one side, and on the other either one of the twelve zodiac animals or one of four characters which occur in the introduction to the *Kokinshū* poetry anthology.

The poem card game is a typically Momoyama period (1573–1615) fusion of native and foreign elements, combining the traditional shell-matching game with European playing cards. In the most popular Edo period form, there are two hundred cards, half of them bearing an imaginary portrait of one of the 'Hundred Poets' and the beginning of one of their poems, and the other half with the remainder of the poem.

The decoration of this box (*36*) makes very unambiguous reference to two well-known themes from classical literature. The top is inscribed with the full text of a poem by Fujiwara Teika (1162–1241), himself the compiler of the list of the 'Hundred Poets': 'Reining in my horse, no shelter to wipe my sleeves/snowy twilight at the Sano crossing.'

35 (*previous pages*)
TIERED CABINET (*kōbako*), WRITING BOX, INCENSE BURNER AND TOKENS FOR THE INCENSE GAME
Wood, covered in gold *nashiji* lacquer with gold *hiramaki-e* and *takamaki-e* lacquer and gold and silver foil; gilded *shakudō* fittings
Flower-filled boats
Late 17th or early 18th century
Tiered cabinet:
18.5 × 22.0 × 18.0 cm
W.319-1916
Alexander Gift

35a (*previous page extreme right*)
SET OF UTENSILS FOR THE INCENSE GAME
Silver, one with an ivory handle
Signed on the base of the container *Tomoharu*
18th or 19th century
M.427-1910

36 (*opposite*)
BOX FOR PLAYING CARDS (*karutabako*)
Box and liners: wood covered in black lacquer with gold and silver *hiramaki-e* lacquer and foil, with gold *nashiji* lacquer interiors
Tiered card boxes: silver with gold and copper inlay
The box decorated with a horseman at the Sano crossing, a poem and (on the sides) the Eightfold Bridge and irises
The liners and silver boxes decorated with autumn plants
18th century
11.6 × 15.8 × 10.2 cm
W.311-1921
Sage Memorial Gift

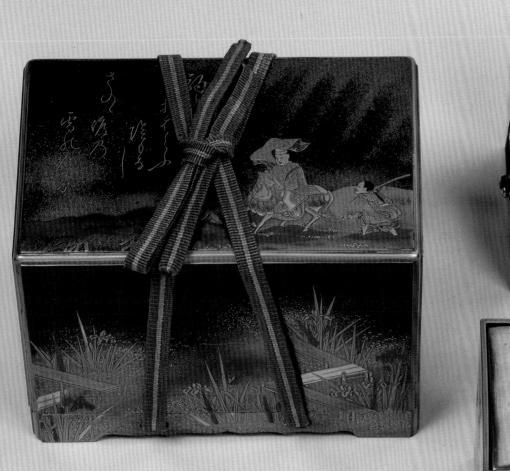

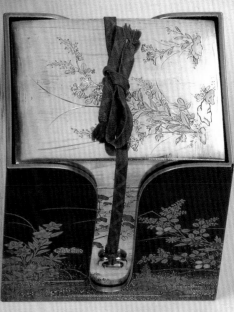

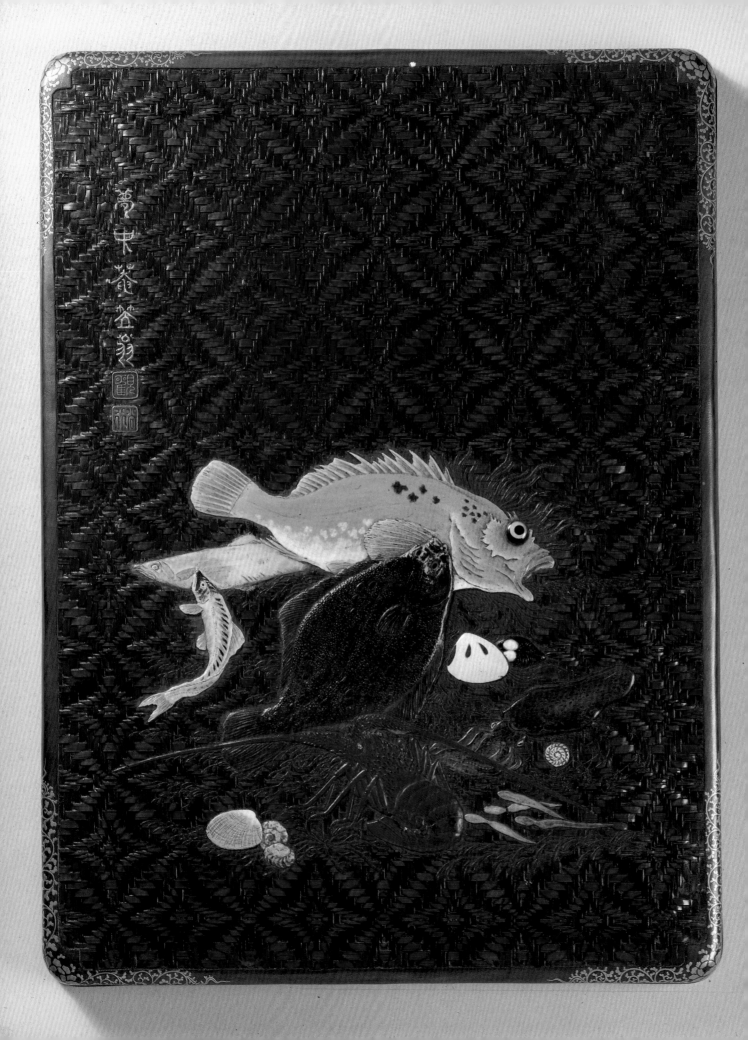

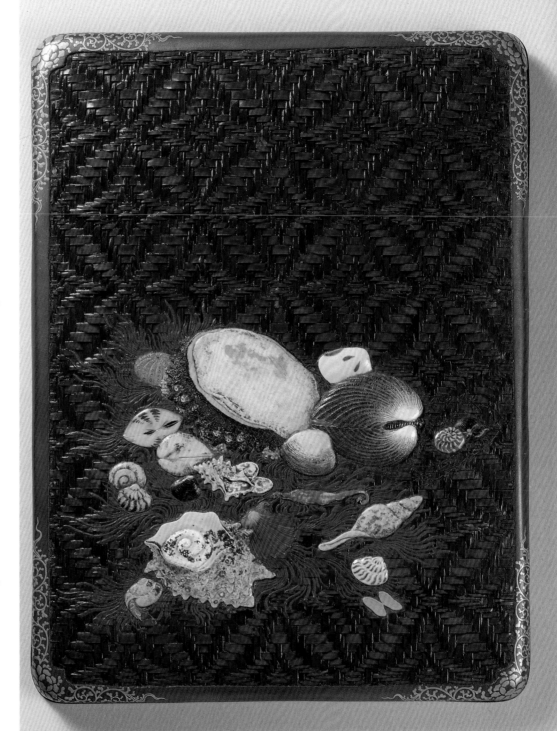

37
PAPER BOX (*ryōshibako*)
AND BOX FOR WRITING
UTENSILS (*suzuribako*)
Wood covered in woven bamboo
decorated in lacquer, enamelled
pottery and horn
Sea creatures
The paper box with the signature
Muchūan Ritsuō and seals *Kan* and
Shōkō of Ogawa Haritsu
(1663–1747)
18th century
Paper box 9.9 × 28.1 × 37.5 cm
Writing box 5.1 × 18.5 × 24.1 cm
W.56/57-1922
Tomkinson Memorial Fund

The Eightfold Bridge motif on the sides of the box is the subject of a famous passage in the tenth-century *Tales of Ise*. In the ninth chapter the poet Narihira comes to the Eightfold Bridge in Mikawa province, a spot noted for its irises, and composes a poem using the syllables of the world *kakitsubata*, 'iris', as the first syllable of each of its lines.

The straightforward message of this box is in striking contrast to the involved pattern of allusion made by the design of the writing table (*34*) and attests to a pronounced shift in patronage.

In the early Edo period there were three basic categories of decoration in high-quality lacquers destined for the domestic market: the traditional manner inherited from the Muromachi period (*34*), the Kōdaiji group of techniques (*31, 32*) and the Rimpa style (*33*). Until the second half of the seventeenth century the subject-matter of lacquer remained largely conservative, even in more popular forms such as *inrō* (*64, 67*). In the late seventeenth and early eighteenth centuries bold new techniques and subject-matter which gave expression in lacquer decoration to the values and culture of the prosperous townspeople were introduced by Ogawa Haritsu and his contemporaries like the *togidashi-e* specialist Shiomi Masanari (1647–1722).

A man of samurai origins, Haritsu moved to Edo early in his adult life and was associated with several masters of the miniature *haiku* poem. Himself an accomplished *haiku* poet, he shared with the great poet Kikaku (see *127*) a love of curious Chinese learning and made, for example, many *inrō* which imitate the form and decoration of late Ming dynasty (1368–1644) inkcake designs. His lacquers are characterized by unexpected subject-matter and exotic materials, in particular applied pottery, along with more conventional *maki-e* decoration. Although the imitation of one material by another is not an invention of Haritsu's, he did much to popularise it, and in this example (*37*) the surface of the enamelled pottery pieces is carefully textured to capture the appearance and feel of fish-skin and shell.

This set of boxes carries Haritsu's studio-name *Muchūan*, 'hut of dreams', deriving from his favourite Chinese Taoist work *Zhuangzi*, and the name *Ritsuō*, 'old man in a straw hat', which Haritsu adopted in 1712 and by which he is best known in the West. In spite of the very high quality of this set, it should be borne in mind that Ritsuō had many pupils and successors. In fact, works in this style were produced for much of the later Edo period under the name *Haritsu zaiku*. In our present state of knowledge about this artist, who has yet to be studied seriously in Japan, the attribution of this masterpiece of invention and craftsmanship is best left open, just as it is with most unsigned lacquers as well.

Although the writing box (*suzuribako*) which holds inkstone (for grinding solid ink with water), brushes and other implements was used in Japan from at least the twelfth century, it was not until the Edo period that it became the favoured vehicle for large-scale lacquer decoration. The example opposite (*38*) reflects the influence of the Rimpa style (see p.57), with its penchant for abstract treatments of natural subjects, on lacquers decorated in traditional workshops. Its largely conventional decoration is offset by two bold bands of cloud executed in a mosaic of minute squares of gold and silver (*kirikane*) which are individually positioned using a wooden skewer.

38

BOX FOR WRITING UTENSILS (*suzuribako*)

Wood, covered in gold and silver *nashiji* and *takamaki-e* lacquer with gold and silver *kirikane*

Pines, rocks and clouds at the sea shore

Second half of the 17th century

4.5 × 21.0 × 22.4 cm

W.151-1910

Salting Bequest

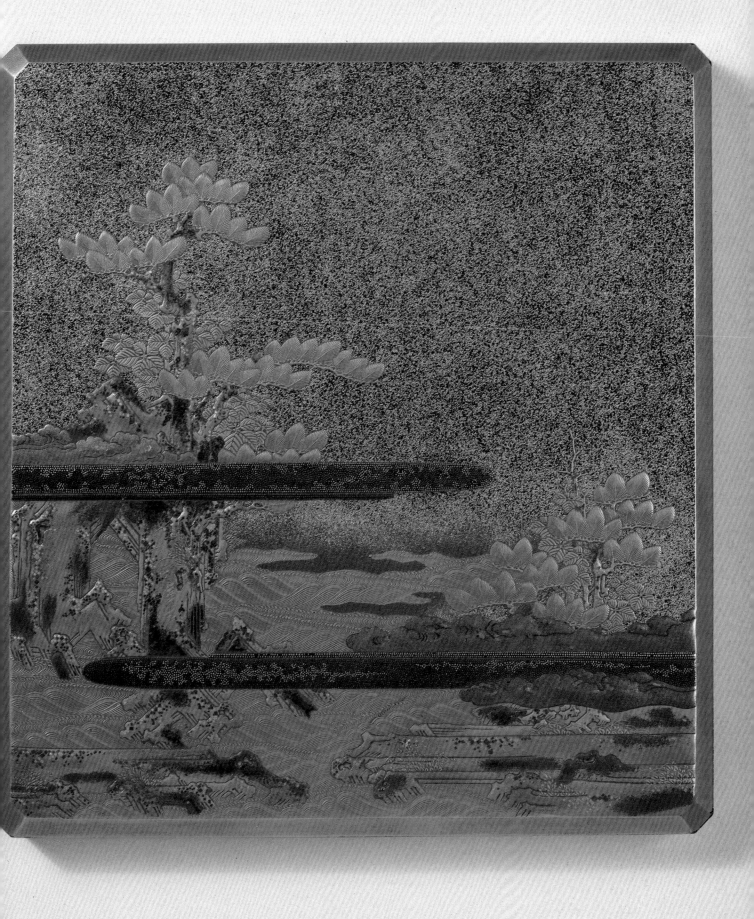

During the fourteenth century the Kyoto townspeople's increasing involvement with aristocratic culture lent a new practicality and utility to architecture and artefacts. This concern with function led to the invention of a range of forms in lacquer, a Kyoto craft *par excellence*, in response to changes in lifestyle. In the history of Japanese food, the sixteenth century is noted as the time when a mid-day meal was added to the existing routine of a morning and evening meal, and the picnic set was probably first developed in the early Momoyama period. Later on, it transcended its purely practical origin to become a decorative object particularly associated with urban excursions into the countryside to view spring cherry-blossoms, the summer moon or autumn maple foliage. Picnic sets were essentially a phenomenon of the urban merchant and artisan class; they are rarely seen, for example, in the great sets of furniture which were made for the trousseaux of daimyo brides.

Later picnic sets usually consist of a pair of bottles, a tiered box, a number of trays, and small saucers for drinking *sake* (rice wine), often stored in a drawer underneath the bottles. The components of the set are carried in a frame with a handle, giving the whole assembly its name of 'tiered box for carrying' (*sagejūbako*). This example (*39*) is decorated with rural motifs celebrating the end of the rice harvest, an activity carried out almost entirely for the benefit of town-dwellers, since Edo period peasants only very rarely ate rice and had to content themselves with humbler grains such as millet. The sheaves of rice straw hung out to dry, the sprouts growing in the stubble and the wind-powered clappers to frighten away scavenging birds establish the season as autumn, a popular time for rural excursions.

The frame is signed on one side *Koma Kyūhaku*, followed by the cursive monogram called *kaō* or *kakihan*. The first Kyūhaku died in 1715 and is credited with establishing the reputation of the Koma family. He was succeeded throughout the eighteenth and nineteenth centuries by many artists of the same name whose exact genealogy is unknown, so that the signature does not provide any evidence for the set's date. The Koma are famous principally for their *inrō* (*68*), and the decoration here comes close to *inrō* in its freedom from traditional subjects and styles. The presence of a Koma family signature underlines the set's function as a vehicle for the appreciation of the countryside by sophisticated townsfolk.

39

PICNIC SET (*sagejūbako*)
Wood covered in black lacquer with gold *hiramaki-e* lacquer; saucers in red lacquer with gold *hiramaki-e* lacquer; silver handle and stoppers
Rice fields with birds, drying rice-sheaves and bird-scarers
Signed *Koma Kyūhaku*
19th century
Frame: 32.5 × 32.7 × 18.8 cm
Circ. 235-1922

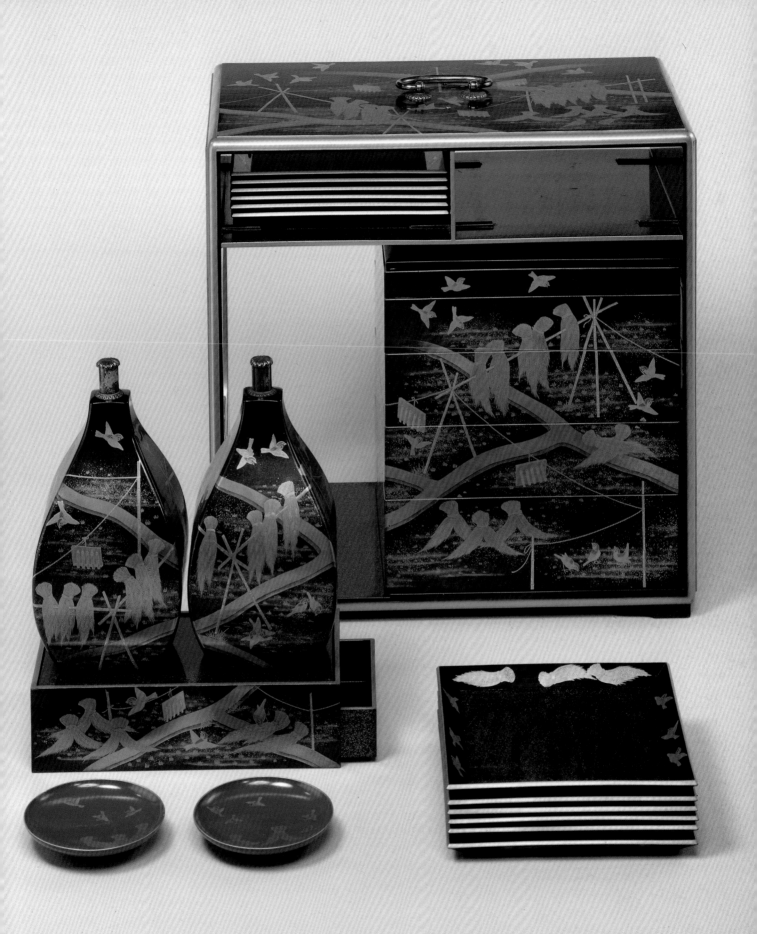

'Polished-out *maki-e*' (*togidashi maki-e*, usually shortened to *togidashi-e*) was the first of the three *maki-e* (see p.52) techniques to be used in Japan and is also the most complicated. In *togidashi-e* the design is first executed in *hiramaki-e* and then covered over with several layers of lacquer of the same colour as the background. These layers of lacquer are then polished away until the design reappears, flush with the new background. During the eighteenth century, the technique became, in a very much more sophisticated form than its eighth-century precursor, the principal mode of decoration for many lacquerers, particularly those catering for the tastes of the urban merchant and artisan class. It is closely associated with the miniature *inrō* (68, 70, 71), but a number of larger pieces were made for the same clientele.

Prominent among these more ambitious exercises in *togidashi-e* is a group of writing boxes and other pieces which take their designs from illustrated books, particularly those of the great Kyoto designer Nishikawa Sukenobu (1671–1751). Sukenobu's books were much reprinted in the century following his death, so they do not help us to date the lacquers. It seems certain that some of them base their colour schemes, as opposed to their designs, on polychrome woodblock prints, which were not widely produced until the mid-1760s. The present design (*40*) comes from Sukenobu's *Ehon Makuzugahara*, first published in 1741, and was used on at least two other pieces.

40
BOX FOR WRITING
UTENSILS (*suzuribako*)
Wood covered in black, red, gold and silver *togidashi-e* lacquer
A firefly watching party, after Nishikawa Sukenobu, *Ehon Makuzugahara* (1741)
Early 19th century
4.4 × 21.6 × 24.1 cm
W.354-1921
Tomkinson Memorial Gift

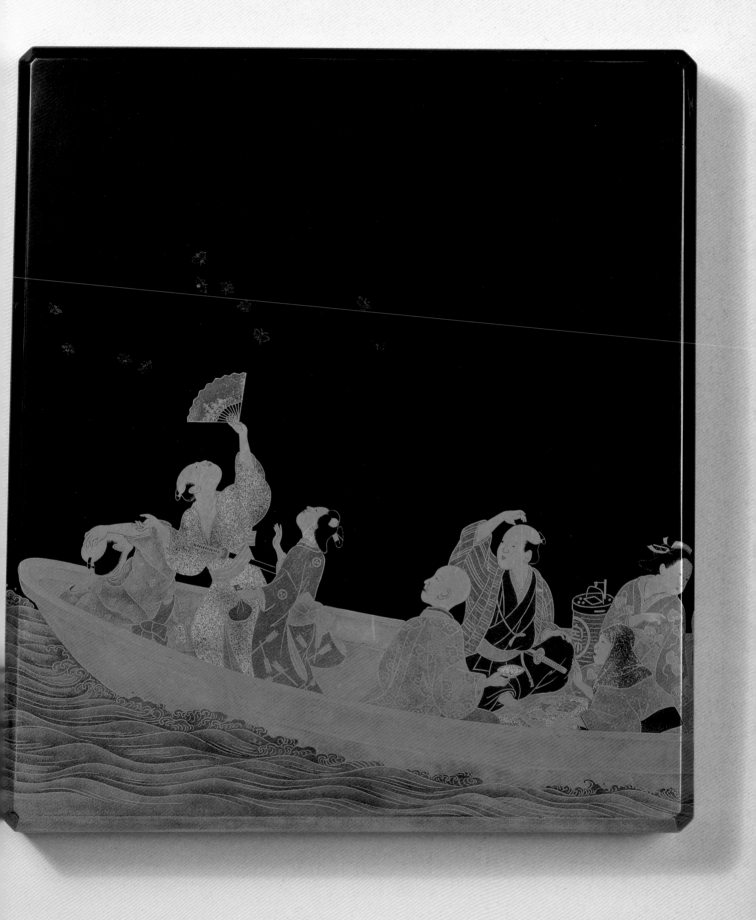

The small size of this box (*41*) and its distinctive mounts and fittings make it close in style to the lacquers of Nakayama Komin (1808–1870), in whose workshop it was probably made. Komin and Shibata Zeshin (*76–87*) are seen as the two great exponents of lacquer in mid-nineteenth-century Edo; Komin's work is unadventurous in style and tends towards the mannerism much decried by contemporary Japanese critics as a fault of later Edo period lacquer. In this instance, the challenge of depicting in lacquer and shell a lacquered and shell-inlaid incense table offered the artist an irresistible opportunity to show off his virtuoso technique.

The paper box and writing box (*42*) by Ikeda Taishin (1825–1903), probably made shortly after the artist achieved independent status in 1859, sum up many of the achievements of Edo period lacquer. The imagery is seasonal. Spring (on the smaller writing box) is represented by dandelions, horsetail and horseradish (*wasabi*), and autumn (on the paper box) is represented by some of the 'seven grasses' (*nanakusa*) of autumn (pampas grass, valerian and arrowroot vine), while a bamboo irrigation pipe cuts across the design. The exaggerated graining of the wood, probably achieved by abrasion with hot sand leaving the harder year-rings in relief, attests to an esteem for rough textures which is seen in the work of Haritsu (*37*) and goes back beyond the Edo lacquer tradition to the aesthetic insights of the tea masters (*14–28*). The bold use of sheets of pewter for the arrowroot leaves on the paper box, an inheritance from the seventeenth-century Rimpa style (see p.57), is balanced by delicately traced pampas grasses which identify the boxes as examples of the revived form of Rimpa initiated by the painter Sakai Hōitsu (1761–1828). The striking treatment of the very traditional autumn grasses theme, which has been celebrated in literature and art since the eighth century, can be compared with the conventional approach adopted by the Komin workshop (*41*) for the *togidashi-e* decoration of the interior of its writing box. Taishin's association with Zeshin (*76–87*), his master for twenty-five years, is reflected in the love of technical variation and ingenuity for its own sake, although the interior of the writing box is relatively restrained. A rich *nashiji* ground is interrupted only by two butterflies and part of a Rimpa-esque stream, executed in meticulous *hiramaki-e*, *takamaki-e* and *togidashi-e*. JE

41

BOX FOR WRITING
UTENSILS (*suzuribako*)
Wood, covered in black, gold, red and silver *takamaki-e* lacquer over shell
A table for burning incense
The interior with a black, gold and silver *togidashi-e* design of autumn plants
Gold and silver water-dropper in the form of a chrysanthemum
Probably from the workshop of Nakayama Komin (1808–1870)
c. 1860–1870
2.5 × 15.2 × 16.7 cm
W.313-1921
Sage Memorial Gift

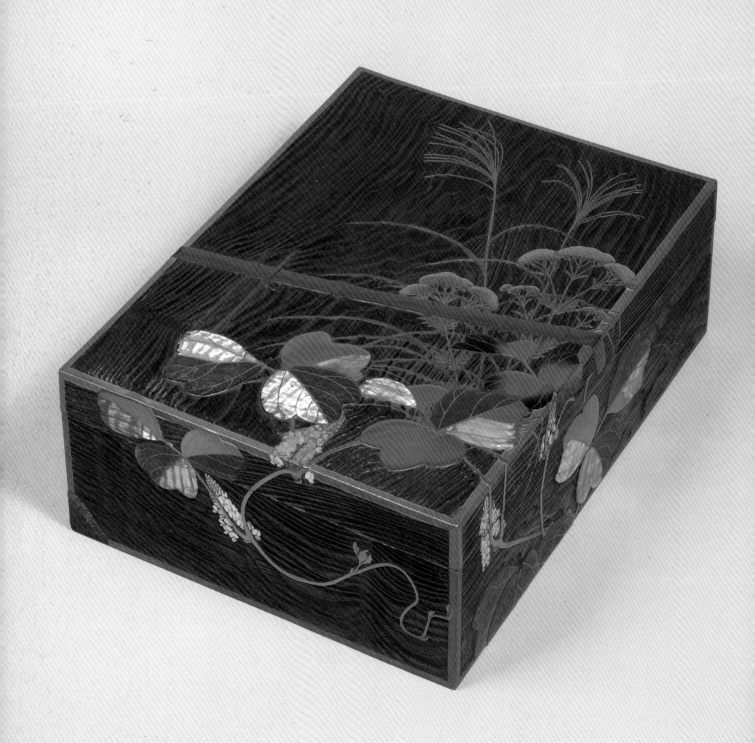

42
PAPER BOX (*ryōshibako*)
AND BOX FOR WRITING
UTENSILS (*suzuribako*)

The interior of the writing box
and lid: wood covered in gold and
silver *nashiji*, *takamaki-e* and
togidashi-e lacquer
Butterflies by a stream
Water-dropper: silver, in the
form of a butterfly
The exterior of the writing box:
grained wood with gold *takamaki-e*
lacquer and shell
Dandelions, horsetail, horseradish
and butterfly
The exterior of the paper box:
grained wood with gold, silver
and coloured lacquer, pewter and
shell
Autumn plants and a bamboo
irrigation pipe
Signed *Taishin* with a seal *Koma*
(Ikeda Taishin, 1825–1903)
c. 1860
Paper box 14.6 × 32.5 × 43.7 cm
Writing box 4.6 × 18.1 × 25.0 cm
FE.6-1984

Porcelain

PORCELAIN was first made in the early years of the seventeenth century at kilns in and around the town of Arita in the northern part of the western island of Kyushu. The making of porcelain marked a break with the earlier ceramic traditions of Japan, and both the use of the material itself and the way it was decorated owe much to the influence of Korea and China.

The hard, white-bodied porcelain was made from crushed volcanic rock, to which a smaller proportion of clay was added. Both materials were local, for the Arita region was rich in suitable china stone and china clay. It was fired in long multi-chambered kilns of a type also used in south China and Korea; in fact, tradition states that the first porcelain makers were Koreans, brought back to Japan after the attempted invasion of Korea in 1597–8. The earliest pieces were decorated in styles inspired from the mainland, and consist mainly of blue and white wares, with a smaller number of green and brown glazed examples. They were initially made for the domestic market, but after 1650 production increased and a large part of the industry became involved in making pots for export to Europe.

The reason for this change was the temporary collapse of Chinese overseas trade. After the Ming dynasty fell in 1644, political and economic factors conspired to reduce the volume of ceramics exported from China. The supply of porcelain was affected for a period of about forty years, and during this time the potteries at Arita benefited. The Directors of the Dutch East India Company (the most vigorous trading company, and the only one with a trading post already in Japan, see p.152) had anticipated events, and started to buy porcelain from Japanese kilns in 1650. By the 1660s they were ordering and obtaining almost the same quantities (some tens of thousands of pieces a year) as they had previously bought from China.

The tankard (44) was clearly destined for Europe, and is in one of the most popular of export shapes. Its decoration is standard, and the picture of figures in a fantastic landscape was probably drawn by a Japanese following a Dutch design after a Chinese original. Tankards were almost always mounted in pewter or silver, and a preformed hole in the handle served for the attachment of lid and thumbrest. The silver-gilt lid on this particular piece is not Dutch but German, and has an inset coin commemorating John Ernest, Duke of Saxe-Weimar, and his seven sons. The coin was struck in 1616, and the lid has a punched date of 1664. However, it was probably not fitted to the pot before the nineteenth century.

German stoneware jugs were common household utensils in Holland in the seventeenth century, and the jug (43) derives its shape from them. Dutch orders for Chinese porcelain in the 1630s had already included such jugs, which were copied either from turned and painted wooden models or from stoneware originals. The flower sprays round the neck of this piece are not unusual for the

43 (*left*)
JUG
Porcelain with decoration in underglaze blue
Arms of the de Graeff family
Arita ware
c. 1665–1675
Height 21.3 cm
C.65-1963
Ionides Bequest

44 (*right*)
TANKARD WITH GERMAN SILVER-GILT MOUNTS
Porcelain with decoration in underglaze blue
Figures and landscape
Lid incorporating a German coin dated 1616
Arita ware
Third quarter of the 17th century
Height 24.9 cm
C.416-1918
David Gift

45 (*overleaf left*)
DISH
Porcelain with underglaze blue decoration on interior, and floral scrolls in yellow enamel on exterior
Arita ware
Second half of the 17th century
Diameter 54.0 cm
C.130-1963
Scott–Taggart Gift

46 (*overleaf right*)
BOTTLE
Porcelain with decoration in overglaze enamels
Floral sprays
Arita ware (Kutani type)
Second half of the 17th century
Height 42.5 cm
C.70-1953

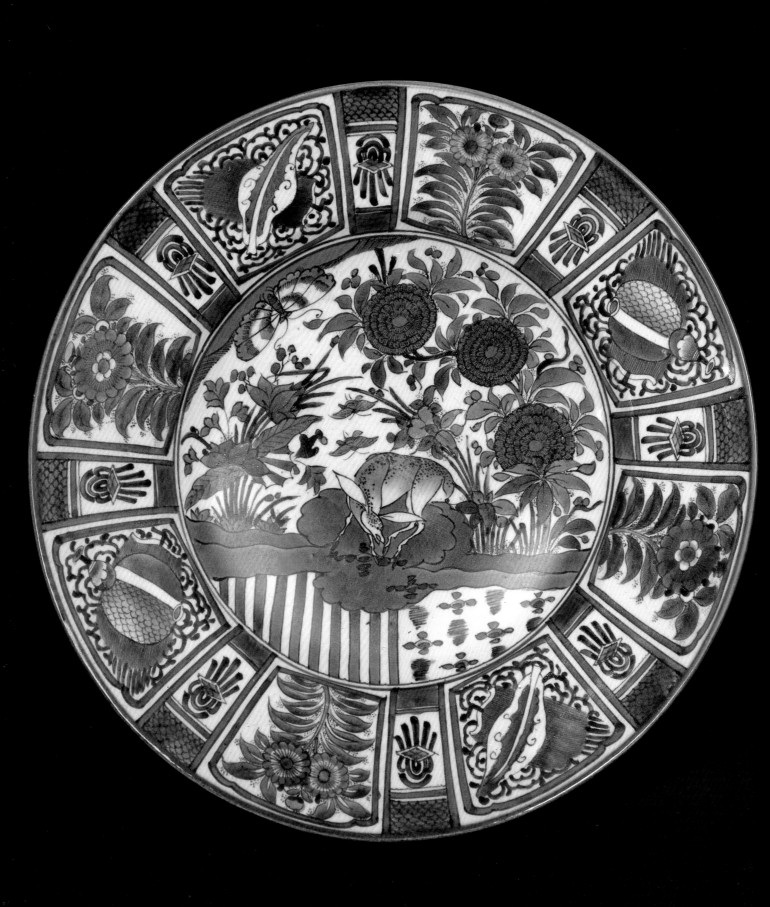

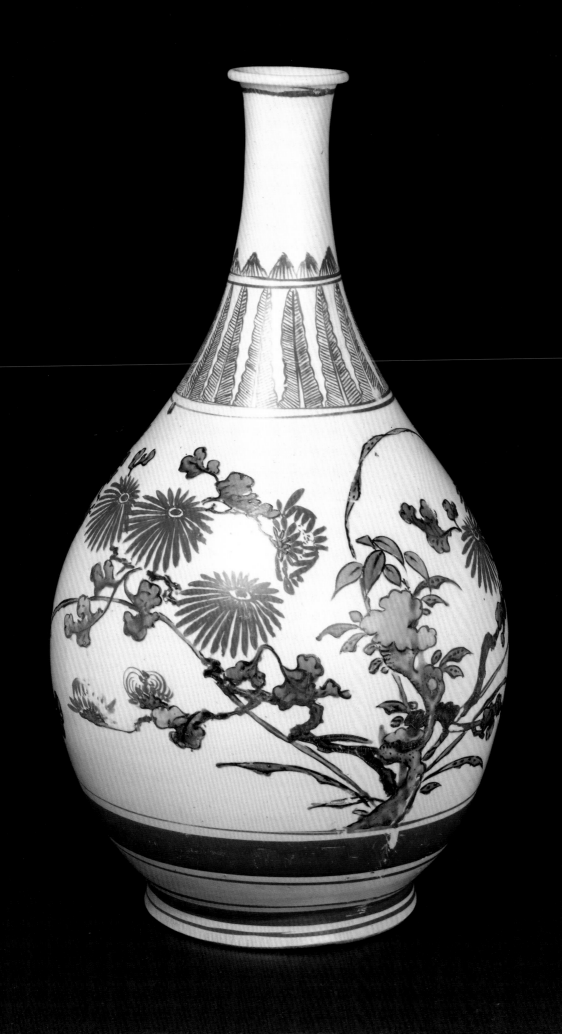

type of ware, but the coat of arms reveals that it was a special order. They are the arms of the de Graeff family, and were probably painted for Pieter de Graeff (1638–1707) who became a Director of the Dutch East India Company in 1664 on the death of his father Cornelis, who had become a Director in 1636.

Plates and dishes formed the bulk of imports into Europe from both China and Japan. The most popular decoration for these pieces was of the sort shown on the large dish (45), with a central scene and panelled design on the rim. *Kraak* porcelain, as the Dutch called this kind of ware, was produced in China for a long period of time, from about 1570 to 1650. Some state that the name comes from the Dutch term for a Portuguese merchant ship, the carrack, while others believe that it refers to the chimney embrasure shelves where porcelain was habitually displayed in Dutch homes. Japanese examples are similar to those from China, but tend to be larger and more sturdily potted and have a brighter shade of cobalt blue pigment under a thicker glaze. The low proportion of clay in the body led to warping and meant that large pieces had to be supported in the kiln on small supports or spurs. On the bottom of this dish there are the remains of five spur-marks. The decoration follows Chinese prototypes, but it lacks their unity of style and the central design of a deer in a landscape is somewhat eccentrically painted.

Many Japanese porcelains were decorated over the glaze in coloured enamels and fired a second time. The first firing baked the body and clear glaze at a high temperature, while the second fused the glass-like colours at a lower temperature. Overglaze enamelling started at Arita in about 1640, and used a palette containing black, red, yellow, green, purple, turquoise and blue. Blue enamel was actually used at Arita some fifty years before it appeared on Chinese porcelain, and is thus one technique to have originated in Japan.

Like blue and white wares, enamelled porcelain was manufactured for two destinations, the home market and the export trade. Some of the best known examples produced in Japanese taste were those decorated in so-called 'Kutani style'. The bottle (46) and the dish (48) are both of this kind. Kutani is the name of a small village in the western central part of the main island of Honshu. Kilns in this locality made pots for a short time in the seventeenth century, and production was revived there in the early nineteenth century. However, most early ceramics in 'Kutani style' are believed to have been made in Arita, in spite of the fact that they differ greatly from other porcelains produced there. They vary widely, but most have a matt glaze over a rather unrefined clay body which is rough and off-white. No two examples are the same, as one would expect with mass-produced wares, and this fact coupled with their large size suggest that they were specially ordered as display pieces, probably by members of the merchant class. Their great attraction lies in their fluid, calligraphically painted decoration carried out in a range of rich, deep colours.

The dish (47) is an example of Nabeshima ware, which was made for the Nabeshima clan of daimyo at kilns about five kilometres north of Arita. The factory was founded in the seventeenth century, and business has continued down to the present day (see p.208). Nabeshima porcelains are characterized by an extremely high standard of both potting and decoration, and, because they were reserved for private use, were virtually unknown in the West before the late nineteenth century. The dish follows a lacquer shape with its high foot and curved sides, and bears a characteristic 'comb teeth' (*kushide*) pattern round the foot in

47 (*opposite*)
DISH
Porcelain with underglaze blue and overglaze enamel decoration
Two varieties of rhododendron
Nabeshima ware
Early 18th century
Diameter 20.3 cm
352-1877

48 (*overleaf left*)
DISH
Porcelain with decoration in overglaze enamels
Rocks, a fir tree, and bamboo
Mark *Fuku* in overglaze enamels on base
Arita ware (Kutani type)
Second half of the 17th century
Diameter 41.9 cm
309-1877

49 (*overleaf right*)
COVERED JAR WITH LOBED BODY AND KNOB IN THE SHAPE OF A LION-DOG
Porcelain with decoration in overglaze enamels
Landscapes
Arita ware (Kakiemon type)
Late 17th century
Height 44.5 cm
FE.24-1985

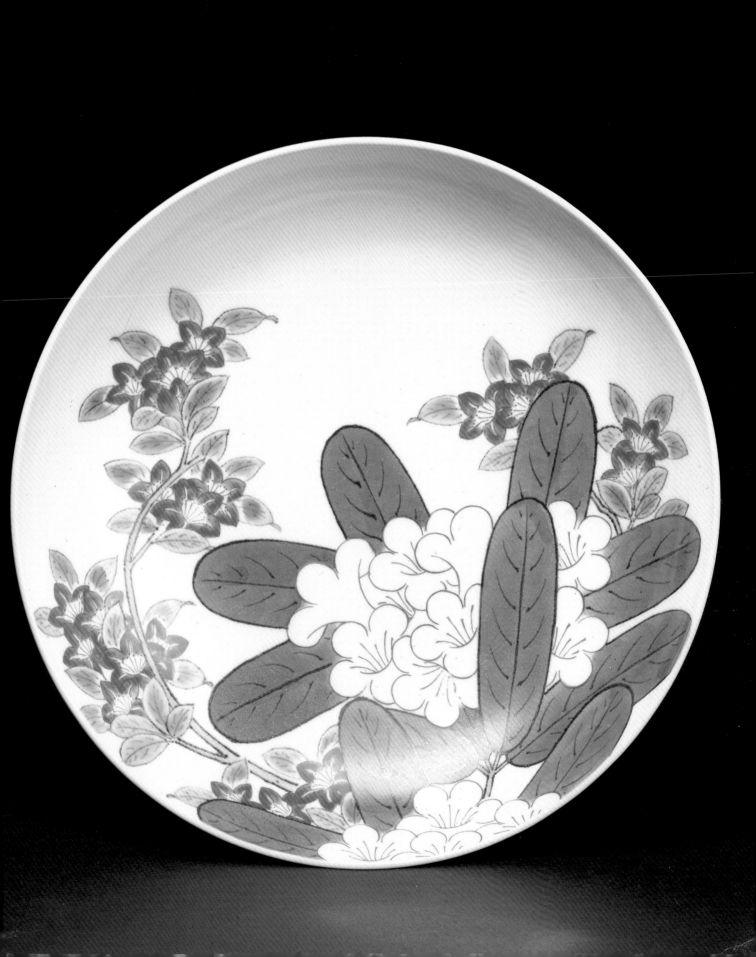

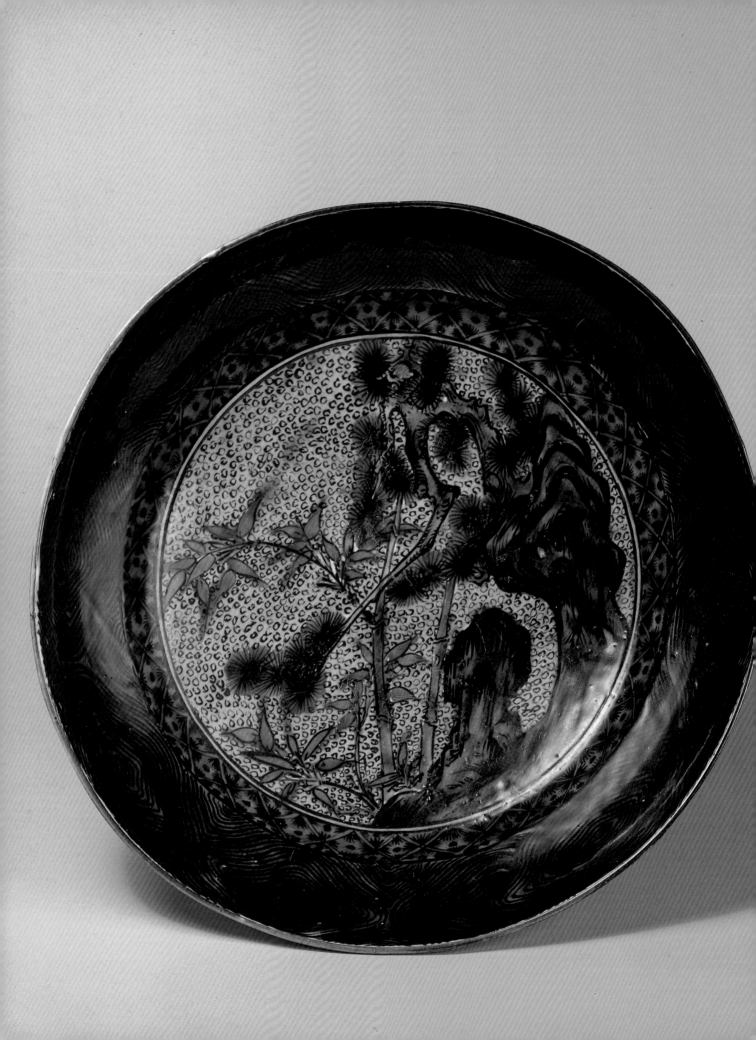

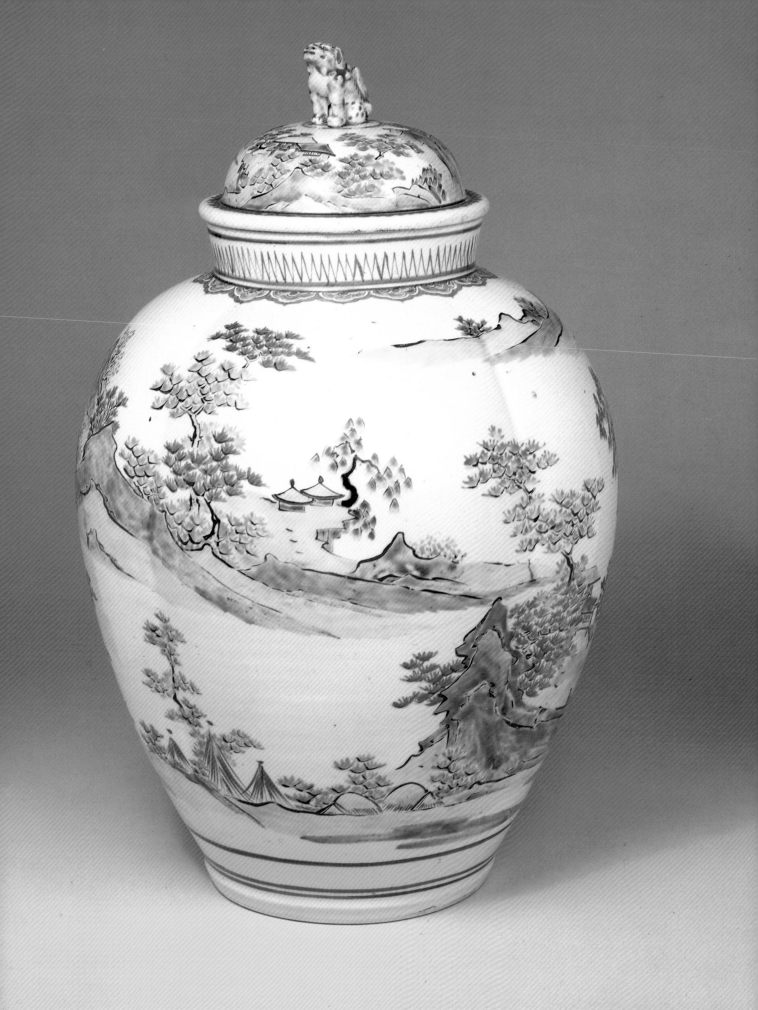

underglaze blue. The front is painted with elegantly stylized depictions of two varieties of rhododendron.

Two kinds of enamelled porcelains were commonly exported, those known as Kakiemon and Imari wares. Kakiemon is the name of a potter, the first of many generations of a family which has worked in the Arita area. The traditional tale is that the first of the line, Sakaida Kakiemon, learnt the skill of overglaze enamelling from a Chinese in Nagasaki in the early seventeenth century. While it is not possible to authenticate the story, nor indeed to attribute wares to a specific Kakiemon kiln, it is certain that by the 1660s enamelling was in general practice at a number of potteries. Kakiemon wares from the 1680s onwards are readily distinguishable on stylistic grounds by virtue of their superior milk-white paste and their fine coloured decoration. A striking cerulean blue and a soft coral red predominate over transparent primrose yellow, grass green and turquoise, and are complemented with touches of brown and gilding. The painting is often witty, and is executed in a skilful fashion. Although designs like those on the jar and the bottle (49, 50) derive from Chinese prototypes, in terms of sense of colour and handling of line they are unmistakably Japanese. Kakiemon wares were much admired abroad, and had more influence on European ceramics than any other kind of multi-coloured oriental porcelain. They were copied at factories in Holland, France, Germany and England.

Imari wares are named after the seaport from which they were exported. Dutch traders were restricted to the tiny island of Deshima, which lay in the shallow harbour opposite Nagasaki, and thus had no opportunity to travel to the area where porcelain was actually made. As a result they incorrectly identified this very popular style of ware with the port through which it was shipped, giving rise to the name still used today. Imari wares are identified by decoration in underglaze blue, red enamel and gilding; other coloured enamels are often present in this scheme. They were produced in at least eleven kilns, and varied greatly in quality. Imari wares came to be one of the most common of exported ceramics, and were copied by manufacturers in both China and Europe. There was a revival of the style in Japan in the nineteenth century, and these later wares were once again welcomed in the West. In fact, many modern ceramic designs still follow the pattern.

Imari wares were made in a range of shapes which reflected their foreign destination. These included large platters and sets of vases, as well as forms copied directly from European patterns and models. The dish (51) has no less than twelve spur marks on its base, where there also appears a Dresden inventory mark, indicating that the piece came from the collection of the Elector Frederick Augustus I of Saxony, 'Augustus the Strong', who died in 1733. The vase (52) is one of a garniture of five large vases and beakers which were bought in Holland in the nineteenth century. Sets like this were common export items, for Europeans liked to stand them on shelves, under cabinets, at the top of stairs, or, in summer, in their fireplaces.　RK

50　(opposite)
GOURD-SHAPED BOTTLE
Porcelain with decoration in overglaze enamels
Chinese sages among trees and flowering plants
Arita ware (Kakiemon type)
Late 17th century
Height 43.2 cm
C.197-1956

51　(overleaf left)
DISH
Porcelain with decoration in underglaze blue, overglaze enamels and gilt
A woman and her attendants in a garden
Inscribed inventory mark of the Royal Saxon Collection on base
Arita ware (Imari type)
c. 1700
Diameter 46.7 cm
C.1513-1910
Salting Bequest

52　(overleaf right)
VASE AND COVER FROM A FIVE PIECE GARNITURE
Porcelain with decoration in underglaze blue, overglaze enamels and gilt
Flowers and landscapes
Arita ware (Imari type)
c. 1700
Height 76.2 cm
C.1523-1910
Salting Bequest

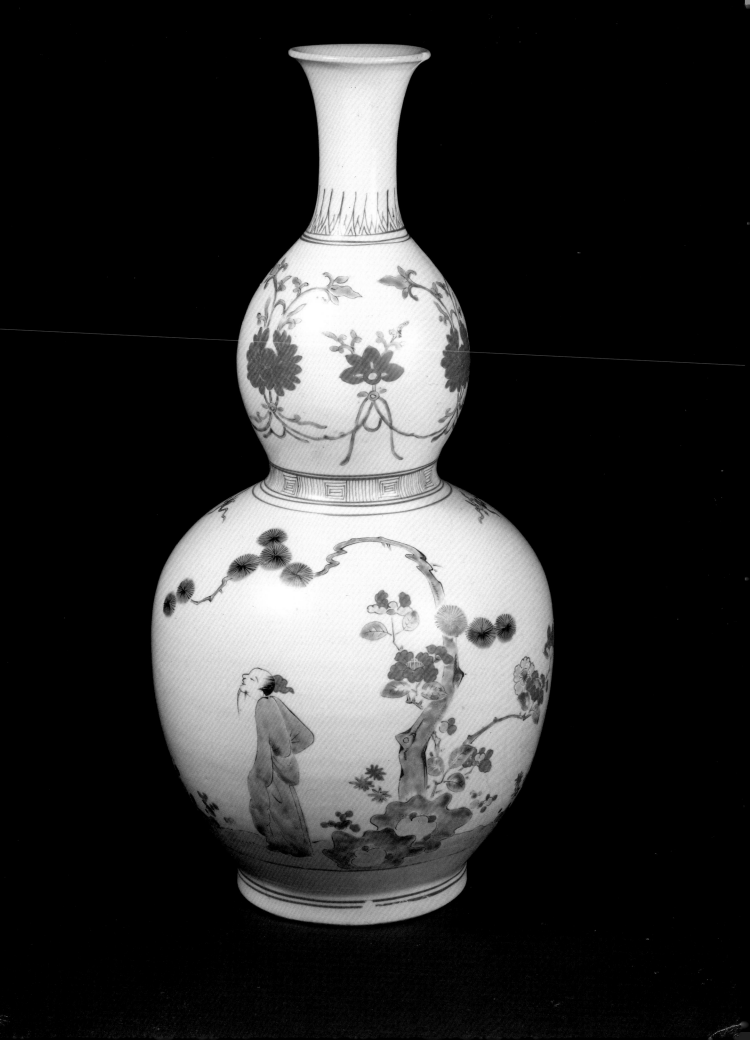

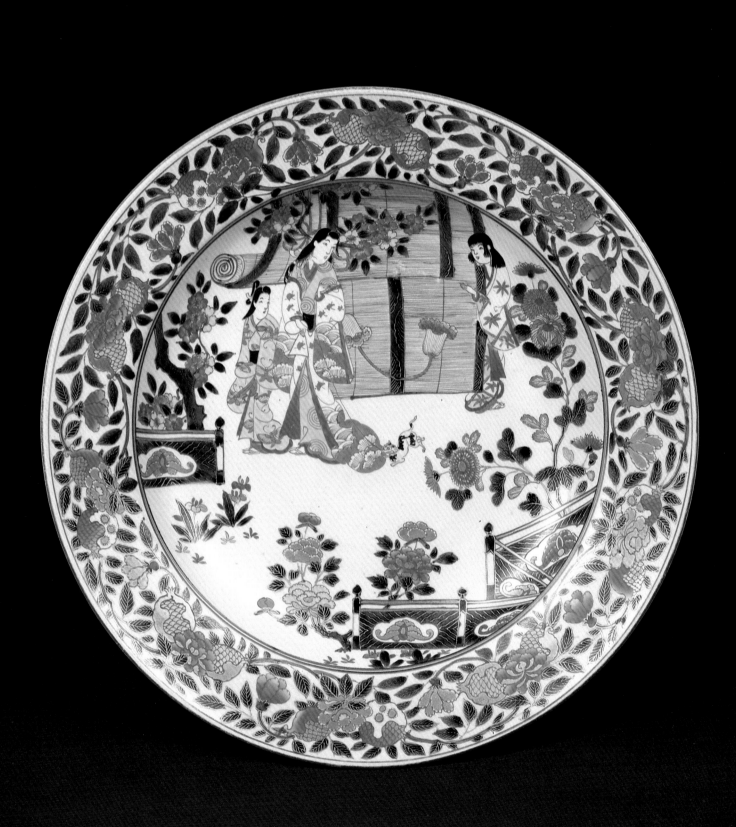

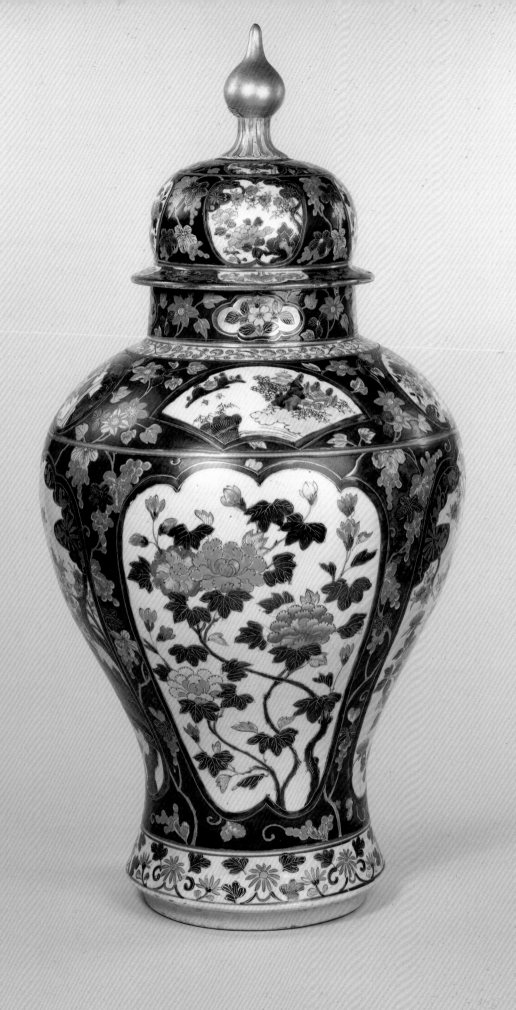

Dress

LOOSE straight-seamed garments worn crossed-over in front from left to right are the traditional clothes of Japan for both men and women. The term used for them is *kimono*, which translates as 'the thing worn', and although trousers, jackets and other garment types play a part in Japan's clothing traditions, *kimono* in their varied shapes form the focus of our attention. It should not surprise us that in museum displays and photographic reproductions *kimono* are rarely shown on life-like models, since they tend to conceal the human form and are interesting primarily for their surface decoration. However, it is clear from the evidence of Japanese woodblock prints that fashion was a matter not only of decoration but also of cut. This was less a question of accentuating or flattening a particular part of the body than of emphasizing the drape of the robe at collar and hem. The feminine neck could be made to appear more slender and graceful than it might be by carefully arranging the *kimono* neck band and by styling the hair in upswept piles.

The length of women's *kimono* is often remarked on as being far too extreme for the human figure, but from colour prints and other pictorial sources we note that they often swept the ground. In addition, Japanese women sometimes wore elevated wooden pattens (*geta*) on their feet when out of doors, not so much to protect their hemlines from mud as to make their appearance grander. The woman's *kimono* shown opposite (*53*) is of the type called 'small sleeves' (*kosode*) after the size of the wrist openings. It has a horizontal tuck taken across the garment just above waist level, the accepted method of adjusting the length to suit each individual wearer. Although this fold, which would not always have been sewn down as here, has cut through the arching bamboo design, this section of the garment would in any case have been hidden beneath a sash which provided the necessary secure closure.

From the second half of the eighteenth century the sash gained greater prominence as an indicator of fashion; methods of tying it were much elaborated and its width increased considerably. Consequently, *kimono* from that time on were patterned in such a way as to minimise the interruption of the design by the sash. On the *kimono* reproduced here the design falls into two sections. The longer lower part is filled with bamboos, while the shoulders and sleeves also have characters and *kana* syllables scattered across them, a mode of decoration often found on Edo period (1615–1868) textiles. The use of literary material on textiles is usually more straightforward than on lacquers (*34*) and sometimes all the characters from a single poem are given. In this case, however, the words come from a number of different poems in the 'Poems of Congratulation' section of the *Kokinshū* anthology (see p.57), including wishes for long life and the auspicious crane and tortoise.

The flat, symmetrical nature of the *kimono* lent itself to inventive decoration. While theatre costumes and court robes were for the most part fashioned from

53
KIMONO FOR A WOMAN
White figured satin with embroidery, brushed black ink and red-brown stencilling to imitate tie-dye
Bamboo and characters
Late 18th century
180 × 130 cm
F.E.106-1982

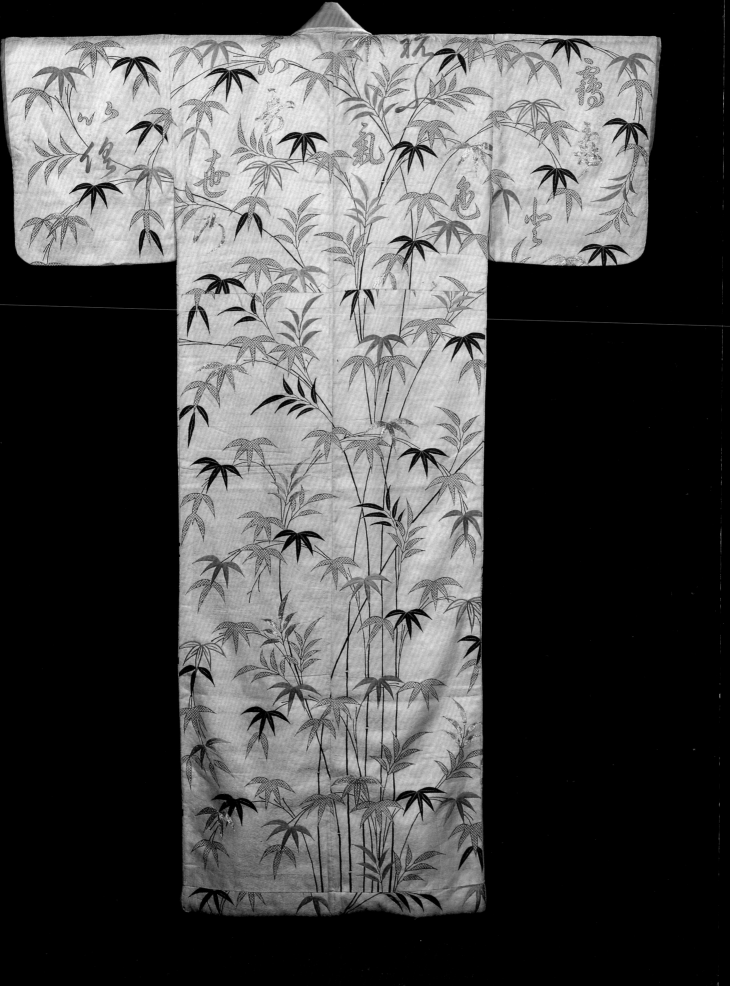

heavyweight fabrics patterned on the loom, *kimono* for well-to-do women were made from loom widths of softer self-patterned or plain silks which were then dyed, painted and embroidered by a different set of craftsmen from the weavers. From the second half of the seventeenth century these artisans could make use of ready-made patterns published in book form. These *kimono* design catalogues, in which black and white woodblocked garments appear one to a page, gave some measure of choice to the fashionable consumer. Today, these illustrated books, while providing the dress historian with information about the disposition of the design across the silk's surface, give less guidance as to colour and techniques. For this we must turn to the surviving garments.

The overall hemp leaf and hemline roundel design on the Museum's red and white *kimono* (54) is seen to consist of many hundreds of small spots. The crimped texture further reflects the unrelenting demands of the technique, which consists of gathering up the silk along the pattern lines and tightly binding small sections with thread. Each spot on the finished garment represents one section bound during manufacture. When the prepared fabric is put into the dye bath, the colour does not penetrate the wrapped part and so the protected silk remains white. The exposed silk takes up the dye which in this case is red and forms the background colour. Christopher Dresser (1834–1904), the designer and theorist who was sent to Japan as a representative of the South Kensington Museum (the former name of the V&A) to report on Japanese art manufactures, observed this tie-dye process applied to fabrics which he called scarves but were more likely under-sashes. He was not able to recommend the exacting method of producing 'conical eminences' to English manufacturers, although he much admired the 'coarsely-granulated character' of the fabrics. He suggested that some arrangement of revolving spindles could do away with laborious hand knotting. The red and white *kimono* shown opposite, entirely patterned by the tie-dye technique, would have been made long before Dresser's visit in 1876. It is of the type called 'swinging sleeves' (*furisode*) which despite their length have small wrist openings. Many other *kimono*, like the black example (55), combined the tie-dye technique with other methods of patterning. Clusters of small circles characteristic of tie-dyeing are here used to represent paper gift ornaments folded in the shape of butterflies. Sometimes only the outline is picked out in this technique and sometimes the whole butterfly is composed of spots. Buds and half-open plum flowers are embroidered in white silk while branches are executed in light brown. The satin stitch shows off the glossy surface of the untwisted embroidery thread to best advantage. Fully opened flowers are filled with coiled gold laid work secured down with orange stitches. Gold work and polychrome embroidery in untwisted silk is also used on the striking green over-*kimono*, intended to be worn without a sash (56), which is unsurpassed in quality by any other Japanese embroidery in the Museum's collection.

54 (opposite)
KIMONO FOR A WOMAN
Red and white tie-dyed silk
Overall hemp leaf pattern with roundels of pine, bamboo and plum across the hem and sleeve ends
Late 18th or early 19th century
132 × 123 cm
FE.32-1982

55 (overleaf left)
KIMONO FOR A WOMAN
Tie-dyed and embroidered silk
Flowering plum and paper gift ornaments in the shape of butterflies
Early 19th century
179 × 124 cm
FE.28-1984

56 (overleaf right)
KIMONO FOR A WOMAN
Green satin-weave silk
Floral and foliage roundels embroidered in satin-stitch and laid work in various metallic colours
Gold family crests of paulownia leaves across the shoulders
19th century
189 × 124 cm
FE.11-1983

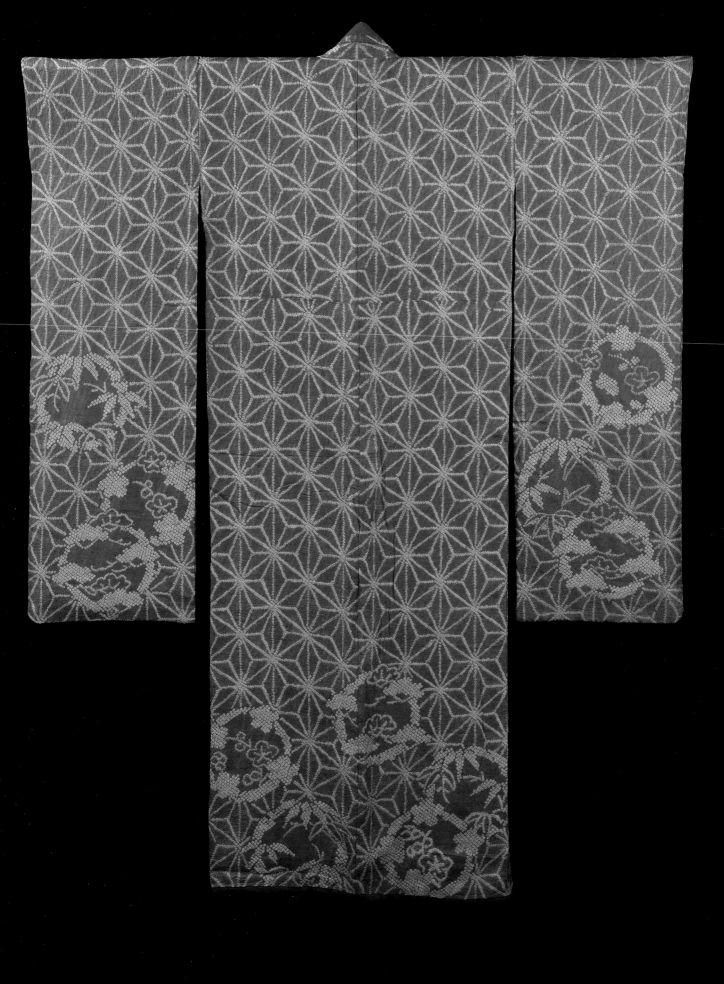

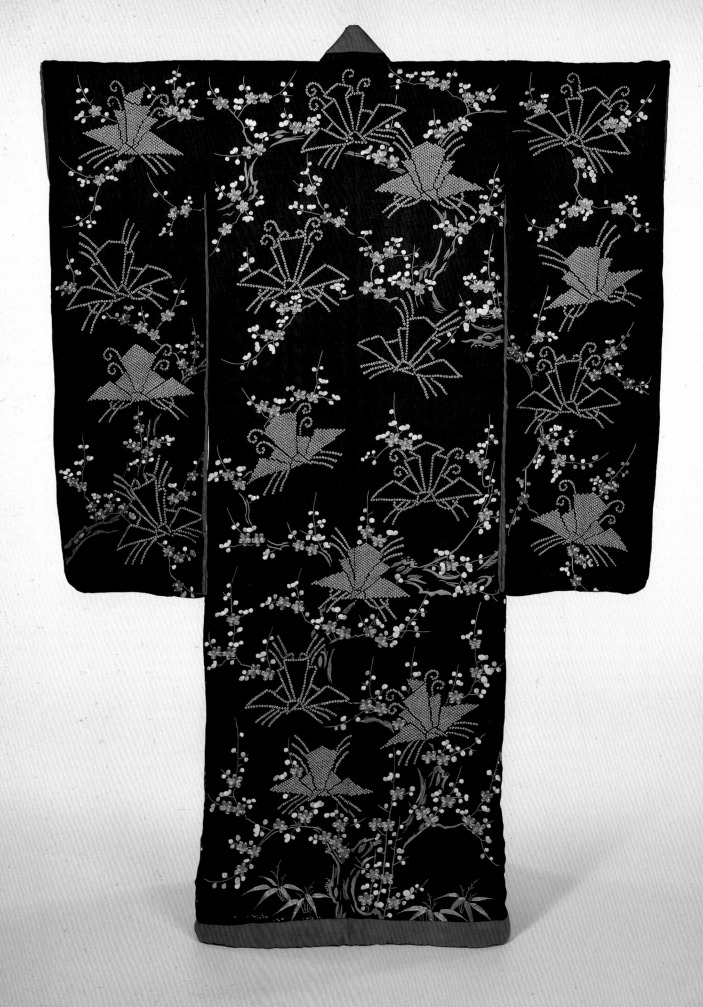

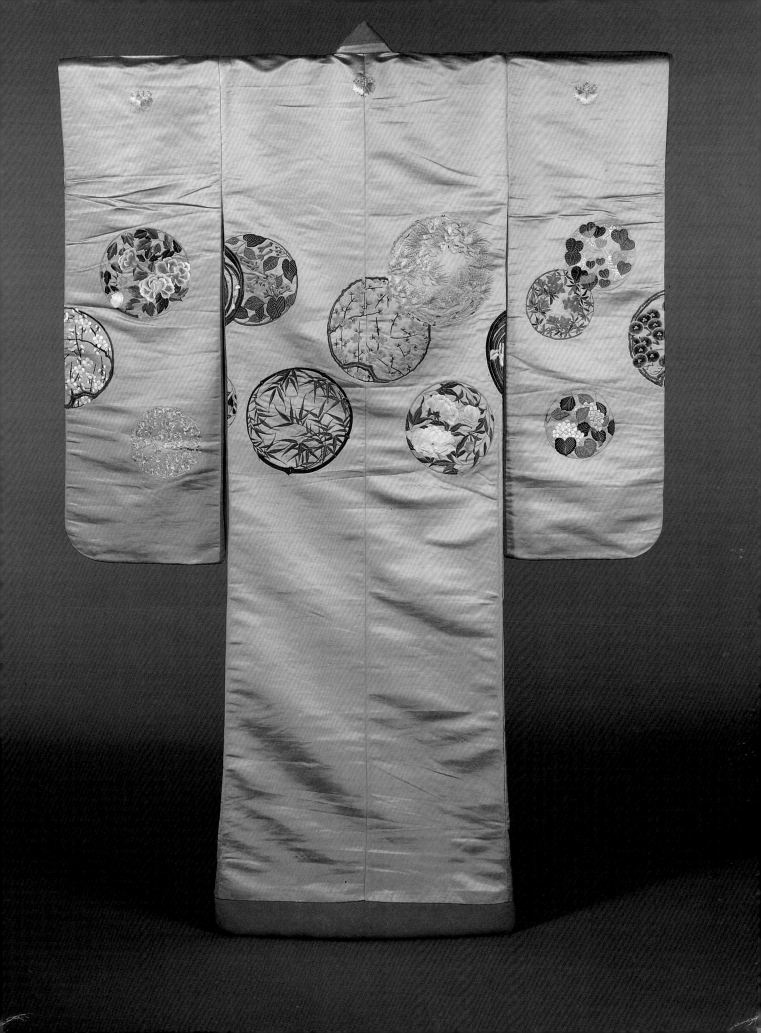

As well as embroidered and pattern-dyed *kimono* for women of the leisured class, the Museum's Japanese dress collection includes Buddhist vestments and a small number of costumes and accessories associated with the *Nō* drama. Most kinds of *Nō* robes echo garments once worn in ordinary life and until the end of the fifteenth century actors were supplied with their stage clothes from the personal wardrobes of their patrons. Later on, however, *Nō* costumes were especially made as such and were distinguishable by their heavy, stiff silk and emphatic designs, as well as by less immediately obvious nuances of tailoring. The glinting, sculptural quality of the costumes befits the deliberate, stylized movements of the *Nō* drama which is acted out by masked male performers on a stage virtually bare of scenery. By the Edo period it was no longer an entertainment for the military aristocracy alone but was enjoyed by the affluent merchant class, the sophisticated women of the latter group sometimes choosing designs for their own *kimono* which alluded to *Nō* themes. The Japanese name for the costume (57) shown here, *kariginu*, is literally translated as 'hunting silk' and this type of tunic was originally worn by courtiers. The narrow body, completely open at the sides, and the double-width sleeves loosely joined to the shoulders with green silk cord lacing ensured freedom of action. However, prolonged rapid movement is not a feature of *Nō* performances, and these tunics were more important for the contribution they made to the overall glittering spectacle, their open seams revealing the contrasting rich silk garments worn beneath.

The mantles worn by Japanese Buddhist monks clearly do not conform to the same clothing conventions as *kimono* and *Nō* robes. These garments are draped diagonally under the right arm and over the left shoulder, their style reflecting certain dress traditions of South Asia, where Buddhism itself originated. In Japan these bordered and vertically seamed mantles (*kesa*) did not provide sufficient body covering alone and were arranged on top of a *kimono*-style robe. As well as marking out the wearer as belonging to a religious order they also specifically identified the monk or nun with the ascetic teachings of the Buddha because the patchwork nature of the *kesa* symbolized rags of poverty. From the two examples reproduced (58, 59), it can be seen that fabrics very far removed from rags were utilised for these mantles. The rich silks were, it is true, sometimes secondhand in that some of them may have originally formed secular garments or theatrical costumes presented to a temple and then remade as *kesa*. During the Edo period a wide range of technically complex woven silks, often enhanced with shining metal thread and displaying a variety of designs not necessarily connected to Buddhist motifs, were made for *kesa*. The tapestry-woven *kesa* (59) is not panelled in the usual way, the mosaic inset effect of the weaving technique serving to produce the patched impression.

57 (*opposite*)
COSTUME FOR NŌ
DRAMA (*kariginu*)
Green silk ground with large scale gold hexagon design
Stylized chrysanthemums and three-comma motifs
18th or 19th century
124 × 140 cm
FE.8-1984

58 (*overleaf*)
MANTLE FOR A
BUDDHIST MONK (*kesa*)
Patterned silk with repeating leaf medallions and flower scrolls
Additional blue patches representing the four kings of heaven and the two attendants of Buddha
19th century
183 × 102 cm
T.84-1927
Clarke-Thornhill Gift

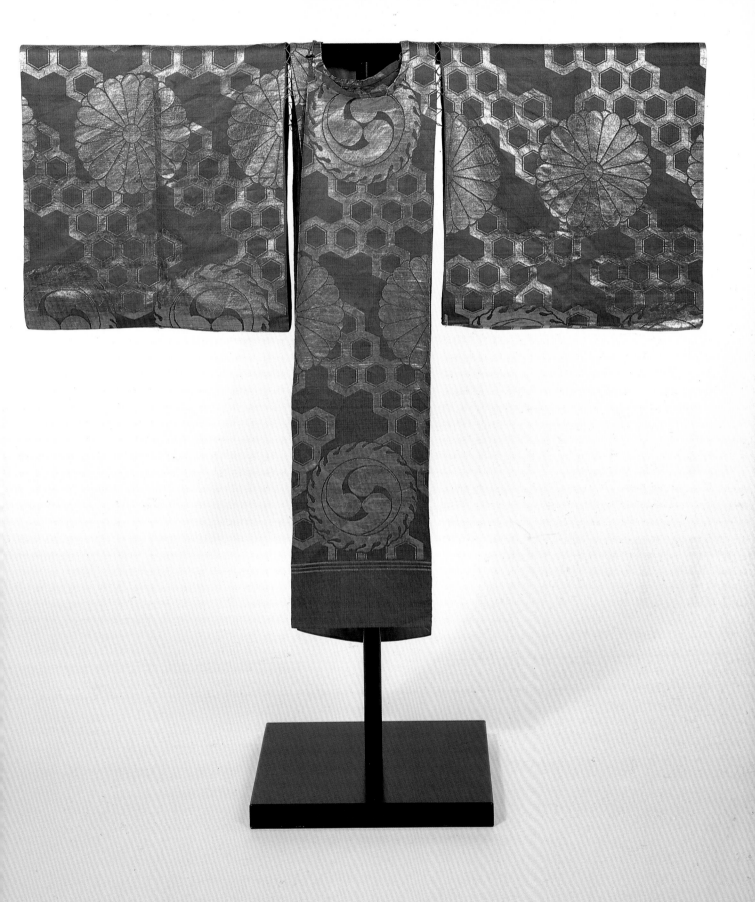

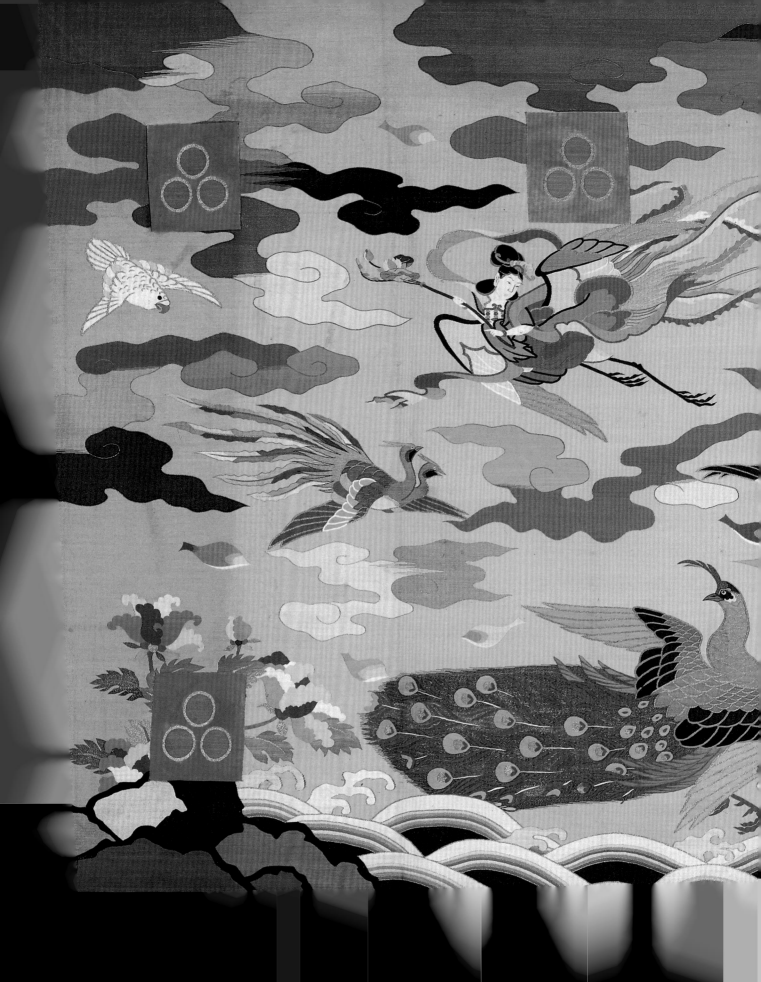

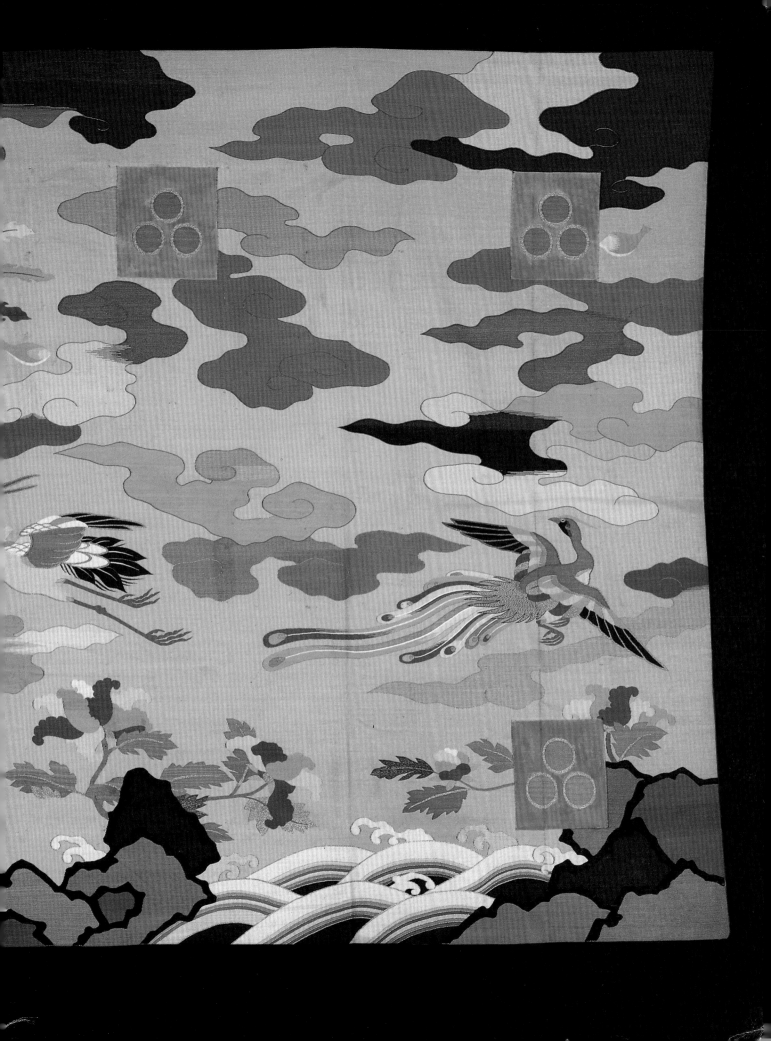

In the urban centres of Edo Japan, the exchange of gifts became a ritualised display of wealth, and textile gift covers played an important part in present-giving courtesies. These lined silk cloths, about the size of a European woman's head-scarf, were laid over the boxed gift, both cover and box being returned to the donor after they had been suitably admired. Because the cover was in no way wrapped or tied around the present the woven or embroidered design on the silk was easy to see and the messages inherent in the pictures, carefully chosen to suit the occasion, were immediately comprehensible. For example, a cover depicting the shell matching game would have been appropriate for a marriage gift, the motif congratulating the couple on their good match. A combination of pine, bamboo and plum blossom sent greetings for the New Year, as did a laden treasure ship. The gift cover reproduced here (60) shows the seven herbs and vegetables eaten on the seventh day of the first month and must have been used at that particular New Year festivity. The motifs are delicately embroidered in a limited but effective colour range onto a shiny white satin-weave ground. The red crepe lining and border is reminiscent of that found at the hem and sleeve openings of *kimono* and serves the same purpose of setting off the main design. The tassels provide a necessary means of picking up the cover without having to touch the white silk. The Museum's collection of gift covers includes some with a family crest emblazoned on the lining and others where the crest is incorporated into the front design. On a few the picture is not confined by the edges of the cover but continues round on to the back. Many are executed in gold and coloured em-broidery, both dark and light blue satin-weave silk being popular backgrounds in the nineteenth century. Paste resist-dyed examples also exist and there are others in the Museum's collection executed in tapestry weave. V W

59 (*previous pages*)
MANTLE FOR A
BUDDHIST MONK (*kesa*)
Silk tapestry weave
The Buddhist Western Paradise
with mythical birds
19th century
203 × 119 cm
T.91-1913

60 (*opposite*)
GIFT COVER (*fukusa*)
Embroidery on satin-weave silk
Plants traditionally associated
with the seventh day of the New
Year: turnip, bee nettle,
chickweed, shepherd's purse,
Japanese parsley, cottonweed and
radish
18th century
77 × 72 cm
Circ. 169-1927
Clarke-Thornhill Gift

Accessories to Dress: Inrō

INRō are small containers made from a number of interlocking sections which were used during the Edo period to carry a personal supply of medicine. The method of closure of the compartments of an *inrō* was considered particularly effective in keeping the contents fresh, a feature which is mentioned by more than one writer. *Inrō* (61–63) were hung from the sash by a cord which passed through holes on each side of each section. The cord was pulled tight by a small bead pierced with a single hole (*ojime*) and tied at its upper end to a toggle (*netsuke*). The *netsuke* hung over the top of the sash and the cord was passed behind it. The bead (*ojime*) and *inrō* hung below the belt. *Inrō* were most usually made from a combination of very thin leather, wood or paper which was elaborately embellished in lacquer utilising many of the techniques described above (pp.52, 68).

The word *inrō* means literally 'seal-basket' and thanks to recent research it is now possible to trace the process by which the word came to designate the small decorative containers which are illustrated on these pages. The earliest written references to *inrō* are found in records of the fourteenth to sixteenth centuries and it is clear from the brief descriptions given that all of them were of Chinese origin and probably, as the name suggests, actually intended for holding seals. Most of them were made from lacquered wood and many were tiered, but they were considerably larger than the standard five to ten centimetre height which is typical for Edo period *inrō*.

By 1625 the term *inrō* was applied to a lacquered article hung from the belt of 'a young priest about town', but it is clear that throughout the seventeenth century containers of this type could carry a number of things other than medicine. For example, a 1660 miscellany records that *inrō* might hold paper prayers or alms to give to beggars. A record of 1686 gives a detailed account of their developing use, explaining that in spite of changes the term *inrō* is still retained. At the beginning of the eighteenth century it seems that medicine-carrying was the most usual purpose. By 1732, the date of a guide to merchandising and industry, the *Bankin sugiwai bukuro*, there was apparently a good deal of sophisticated interest in *inrō*. The number of forms available was already large and 'unlike that of the traditional *inrō*.' The guide gives a detailed account of the lacquer techniques seen on *inrō* from which it is clear that all the available methods familiar on larger seventeenth-century pieces had already been transferred to this miniaturist medium. In 1777 a work on samurai customs, the *Shikigusa*, reported that even common people wore *inrō*, but not for carrying medicine. The excellent condition of many apparently eighteenth-century *inrō* in western collections bears out the suspicion that many *inrō* were not used for carrying medicine, and some were only rarely worn.

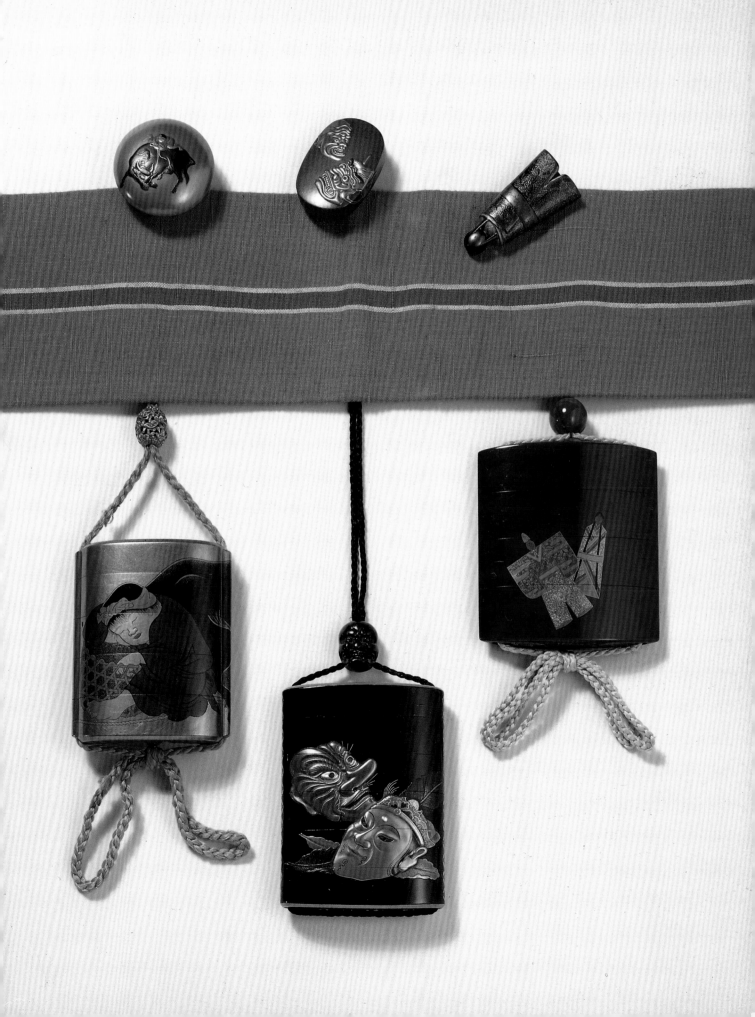

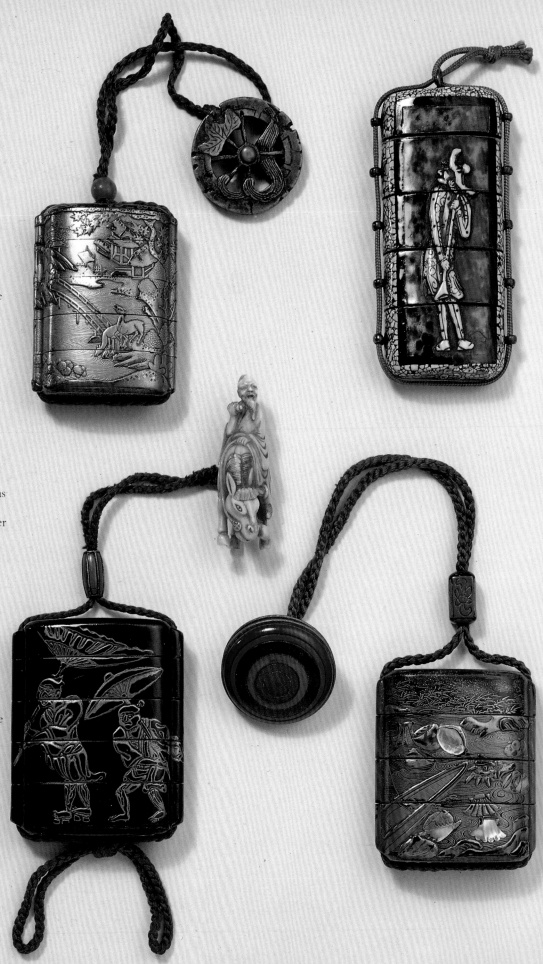

64 *(top left)*
INRŌ

Black lacquer with gold
filings and *hiramaki-e*
Autumn landscape with
deer
c. 1650–1750
Ojime of stained ivory
Netsuke of stagshorn: a
broken wheel
Height 6.3 cm
W.353-1916
Alexander Gift

65 *(top right)*
INRŌ

Tortoise shell with bone
and eggshell mosaic
A Dutchman holding a
flageolet
17th century
Height 11.4 cm
W.356-1922
Pfungst Gift

66 *(bottom left)*
INRŌ

Black lacquer with gold
takamaki-e
Two men with umbrellas
17th century
Ojime of copper and silver
Netsuke of ivory: the
Chinese sage Rōshi on a
donkey
Height 7.0 cm
W.180-1922
Pfungst Gift

67 *(bottom right)*
INRŌ

Black lacquer with gold
takamaki-e, gold foil and
shell
Boat and seashells by the
shore
c. 1650–1750
Ojime of carved lacquer
Netsuke of carved and
lacquered wood
Height 6.3 cm
W.364-1916
Alexander Gift

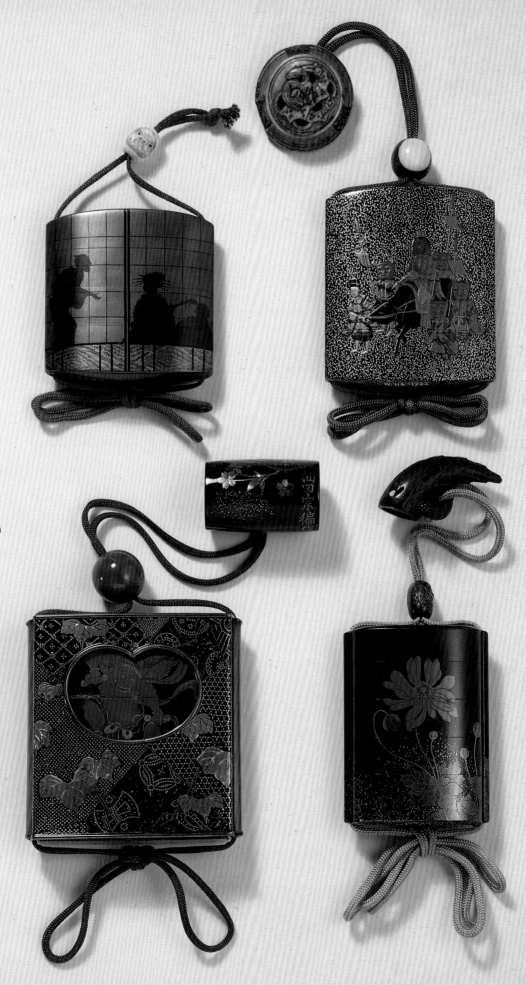

68 *(top left)*
INRŌ

Gold lacquer with *togidashi-e*
Dancers and musicians seen
through a paper screen
Signed *Koma Kyūhaku*
Early 19th century
Ojime of ivory: the face of
Daruma, founder of Zen
Buddhism, signed *Dōraku*
Height 6.3 cm
W.164-1922
Pfungst Gift

69 *(top right)*
INRŌ

Gold *nashiji* with *takamaki-e*
The autumn mask ritual at
the Ōsake Shrine in Kyoto
Signed *Koma Yasutada*
c. 1800
Ojime of wood and ivory
Netsuke of stagshorn: a
squirrel
Height 7.0 cm
W.116-1922
Pfungst Gift

70 *(bottom left)*
INRŌ IN SHEATH
FORM

Inner part black lacquer with
gods of wind and thunder in
togidashi-e
Sheath with geometric
designs in shell and gold foil
Signed *Yamada Jōka after a
design by Hokkyō Kōrin*
Early 19th century
Ojime of red agate
Netsuke signed *Somada Sōhen,
aged 90*
Height 9.5 cm
W.238-1922
Pfungst Gift

71 *(bottom right)*
INRŌ

Black lacquer with *togidashi-e*
Poppies
Signed *Toshihide*
Early 19th century
Ojime of metal: ducks and
weeds
Netsuke of wood: bamboo
shoot, signed *Miwa*
Height 7.6 cm
W.236-1922
Pfungst Gift

It seems to have been during the eighteenth century that the number of *inrō* makers greatly increased and the original function of *inrō* as containers for medicine gave way to their use as purely decorative accessories. According to the author of a diary entitled *Morisada nikki*, by the middle of the nineteenth century every samurai wore something hanging from his belt at all times and it was usually an *inrō*. The *inrō* reproduced on page 101 all have *netsuke* of closely related design. Many of the *inrō* in western collections are either without *netsuke* or only with inferior ones, as good examples have been traded and collected separately from *inrō*.

The study of *inrō* continues to be bedevilled by an unproductive obsession with signatures and schools. Many names of *inrō* makers were used by several generations of artists and in the absence of detailed biographical or other information about these men it seems more fruitful to consider *inrō* from the point of view of their overall development within the context of Edo period urban culture. Apart from progressive technical improvements and the increasing use of luxurious and time-consuming methods such as shell inlay and *togidashi-e* (see p.68), the history of *inrō* is best seen as a progression from the use of motifs characteristic of larger Muromachi, Momoyama and early Edo period pieces (for example *31–35*) to the development of a special range of subject matter which reflects the Edo period townsman's delight in the connotations of the minutiae of everyday life. The same shift occurs in the world of literature. The classic thirty-one syllable *waka* poem gave way as a vehicle for original literary expression during the sixteenth and seventeenth centuries to the seventeen-syllable *haiku* which like the *inrō* is a finely-crafted miniature celebration of the everyday, with a penchant for unusual subjects and humorous treatment.

72 (*top left*)
INRŌ

Carved ivory with horn and shell
Chinese lion (*shishi*) training its
young
Signed *Shibayama*
c. 1850
Height 7.6 cm
W.318-1922

73 (*top right*)
INRŌ

Carved wood
A cicada
19th century
Ojime of wood: monkey and young
Netsuke of wood: a cicada
chrysalis, signed *Gyokushi*
Height 10.8 cm
W.385-1922
Pfungst Gift

74 (*bottom left*)
INRŌ

Black lacquer inlaid with shell
Landscape with figures and
buildings
Probably made in the Ryukyu
Islands (see p.172)
c. 1750–1850
Ojime of copper and gold
Netsuke of black and red lacquer: a
dog
Height 10.4 cm
W.32-1923
Hearn Gift

75 (*bottom right*)
INRŌ

Carved red lacquer
Kōsekikō receiving his shoe from
Chōryō
19th century
Height 8.9 cm
W.248-1910
Salting Bequest

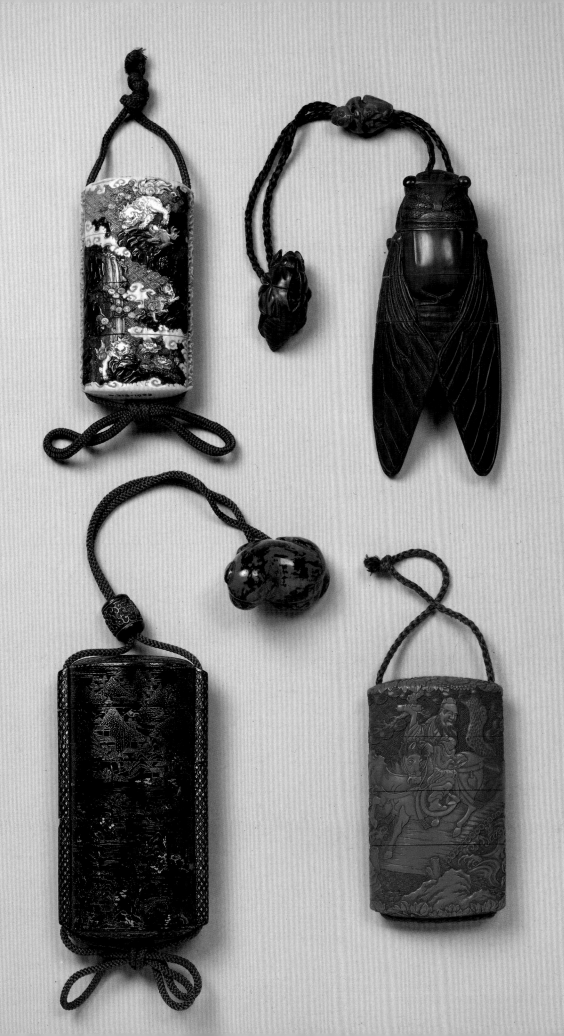

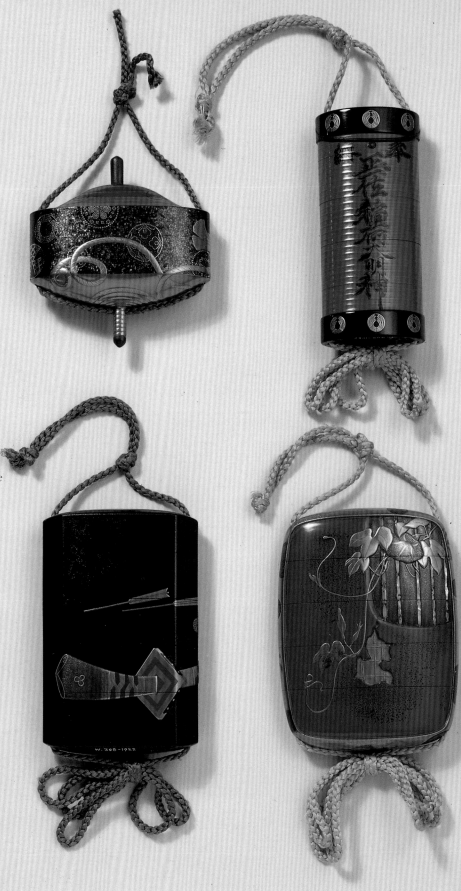

76–87

**SET OF TWELVE INRŌ
FOR THE TWELVE
MONTHS**
BY SHIBATA ZESHIN
(1807–1891)
Heights 7.6 to 12.7 cm
W.301/312-1922
Pfungst Gift

(Top row left to right)

76

First month. In the form of a
spinning top. The New Year
was traditionally a time of
holidays and festivals, and
both adults and children
participated in a number of
games.

77

Second month. In the form of a
lantern inscribed *to the great
god Inari* for the festival on the
first day of the month. Inari is
a rice god who takes the form
of a fox, and banners or
lanterns with this inscription
were set up outside houses
and Inari shrines. Signed on the
back *Zeshin the suppliant*.

78

Third month. In the form of a
box for the shell game, a
popular women's pastime in
the Edo period. The *inrō*
alludes to the Girls' Festival
on the third day of the month.

79

Fourth month. Silk moths and
cocoons. Silk thread was first
drawn from silkworm cocoons
in the fourth month.

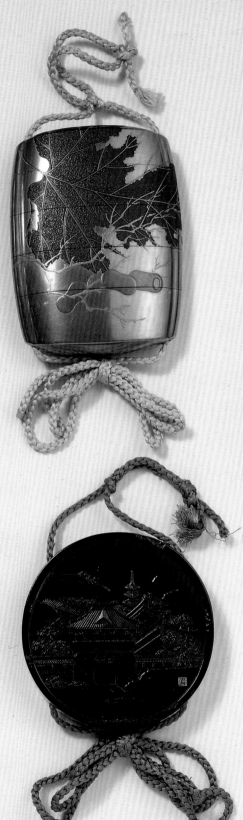

(*Bottom row left to right*)

80

Fifth month. A toy sword and arrows, standing for the Boys' Festival on the fifth day of the month.

81

Sixth month. Morning glory by a window in a broken wall. The Morning Glory Fair took place at this time and was especially popular in the very late Edo period.

82

Seventh month. In the form of a silk winder. The seventh day of the month is the time of the Tanabata festival, celebrating the one day of the year when the Herd Boy and the Weaving Girl are allowed to meet. The composition of poems by women, especially on mulberry leaves, is associated with the Tanabata Festival.

83

Eighth month. In the form of a chipped ink-cake with a design of the Capital of the Moon. The fifteenth day of the month is the most popular time for viewing the full moon, which is also symbolized by the unusual shape of the *inrō*. Zeshin refers here to the work of his great predecessor Haritsu (*37*), who made a speciality of *inrō* in the form of curiously decorated Chinese inkcakes.

The set of *inrō* by Shibata Zeshin (1807–1891) reproduced on the previous and opposite pages (76–87) was originally contained in a box (now lost) stating that it was finished in the fourth month of 1865. The twelve *inrō* offered the greatest lacquer artist of his time a perfect medium for the display of an extremely versatile technique. Zeshin's artistic character is typical of the inhabitants of nineteenth century Edo in its love of the spirited, the chic and the exotic. His choice of subject-matter for each of the twelve lunar months favours popular deities, urban festivals and customs rather than the literary themes so often found in lacquer decoration. JE

84 (*top left*)

Ninth month. Chrysanthe-mums and waves. The chrysanthemum is one of the seven plants of autumn and the Chrysanthemum Festival takes place on the ninth day of the month.

85 (*top right*)

Tenth month. Gong and striker. During this month all the gods of Buddhism and Shintō are summoned to the Great Shrine at Izumo by the beating of a gong.

86 (*bottom left*)

Eleventh month. Gourds for *sake*, prunus blossom and, on the back, oranges. During this month *sake* from the year's rice harvest is offered to the gods. At the Bellows Festival on the eighth day, the smiths of Edo throw oranges from the rooftops down to the children in the street.

87 (*bottom right*)

Twelfth month. Sheath *inrō*. The sheath is in the form of a thatched hut through whose window we see the gods Ebisu and Daikoku feasting. Daikoku is associated with rice, which features prominently in the New Year celebrations. In addition, the form of the *inrō* may be an allusion to the name 'Division of the Seasons' (*Setsubun*) by which the New Year Festival is known.

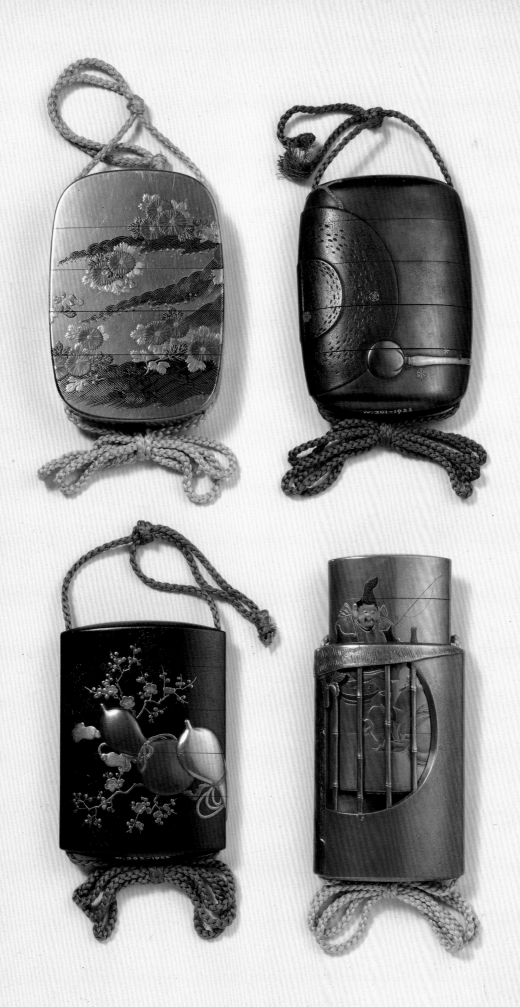

Accessories to Dress: Netsuke

NETSUKE (the name means no more than 'root-fix') are toggles used to hang *inrō* or other articles from the belt (*61–63*). All *netsuke* incorporate a channel for the hanging-cord, either as an integral part of the carving or specially drilled. The date of the first use of *netsuke* in Japan is uncertain, but it is clear from the evidence of paintings that they were already popular by the beginning of the Edo period (*1615–1868*).

In the same way that nineteenth-century Japanese landscape prints (*145, 146*), whose style owed much to European influence, were worshipped by a generation of French painters, the *netsuke*, a late arrival on the Japanese scene with a partial and remote western origin, has been admired since the nineteenth century as the quintessence of oriental ingenuity. The origins of *netsuke* may be traced to sixteenth-century Fujian province in south-east China, where an ivory carving industry grew up stimulated by demand from Iberian traders and missionaries for Christian images. Soon the Chinese carvers were producing images of indigenous deities such as the 'star gods' of good fortune and wealth, who were often depicted in an affectionately humorous way. Early Japanese *netsuke* strongly reflect their western-inspired Chinese origins. The great majority of them are of figure subjects, in particular unusual Chinese demigods such as Gama Sennin (*90*) or foreigners (*91*), who were especially appropriate to the exotic new medium. The Kannon in a Cloud (*92*) closely follows Chinese carvings of the same deity whose designs are taken from popular woodblock-printed albums. The early Mother and Child (*89*) reflects in her iconography and her close-together facial features the remote influence of the European ivory Virgin and Child of some three centuries earlier. She conceals beneath her *kimono* some superfluous anatomical detail which may be derived from the mildly pornographic Chinese ivory female nudes, themselves a development of Christ-child images carved for the westerners. The influence of China is felt again in the penchant for animal subjects among *netsuke* carvers of the later eighteenth and nineteenth centuries. Some of the earliest animal *netsuke* take the form of personal seals surmounted by Chinese-style lions and other mythical beasts. These developed into the minutely observed naturalistic studies which are among the pieces most admired by contemporary western collectors. Although *netsuke* have yet to achieve full recognition in Japan, they are gradually coming to be seen as important manifestations of middle and late Edo period urban culture. JE

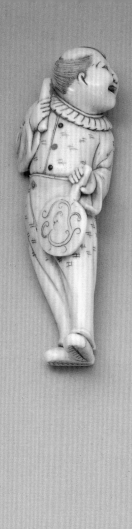

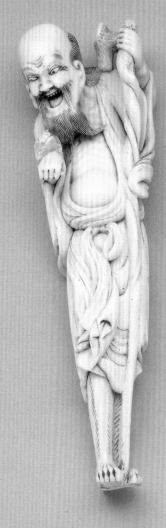

93 *(top left)*
NETSUKE
Carved ivory with inlaid eyes
and staining
Quails on millet
Signed *Okatori*
Kyoto school, late 18th century
Height 2.9 cm
A.975-1910
Salting Bequest

94 *(top right)*
NETSUKE
Carved ivory with inlaid eyes
A herdboy on a buffalo
Signed *Kaigyokusai Masatsugu*
(1813–1892)
Second half of the 19th century
Length 4.5 cm
A.30-1919
Clarke-Thornhill Gift

95 *(centre)*
NETSUKE
Carved ivory with inlaid eyes
and staining
A grazing horse
18th century
Height 5.6 cm
418-1904
Dresden Bequest

96 *(bottom left)*
NETSUKE
Carved ivory with staining
Autumn grasses and the moon
Signed *Kōu*
Later 19th century
Diameter 4.5 cm
A.1016-1910
Salting Bequest

97 *(bottom right)*
NETSUKE
Carved ivory with staining
Three beanpods
Later 18th or 19th century
Length 4.6 cm
A.46-1920
Clarke-Thornhill Gift

98 *(opposite top left)*
NETSUKE
Carved wood with inlaid eyes
A bird
18th or 19th century
Length 6.7 cm
A.69-1915
Fox Gift

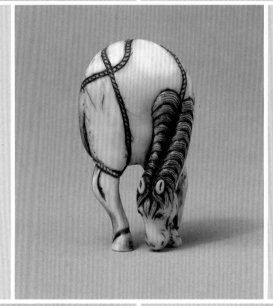

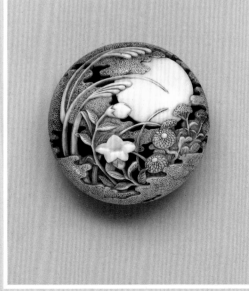

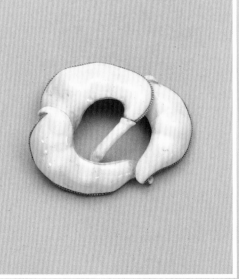

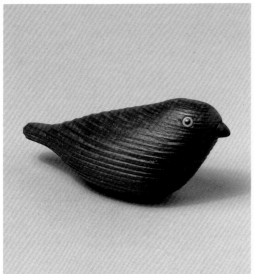

99 *(top right)*

NETSUKE

Carved wood with inlaid eyes
and staining
A wild boar
Signed *Toyomasa*
Tamba school, early 19th
century
Length 6.9 cm
A.53-1915
Fox Gift

100 *(centre left)*

NETSUKE

Carved wood with staining
Mushrooms
Signed *Tadayoshi*
Nagoya school, mid-19th
century
Width 4.2 cm
A.1002-1910
Salting Bequest

101 *(centre right)*

NETSUKE

Carved wood with staining
A fox mask for the *Kyōgen*
comic drama with hinged
lower jaw
Signed *Tenkaichi Deme Uman*
Later 18th century
Height 3.9 cm
A.1011-1910
Salting Bequest

102 *(bottom left)*

NETSUKE

Carved ebony
A frog on a lotus leaf
Signed *carved by Namie
Tomiharu (1733–1811) of Iwami
province*
Later 18th or early 19th century
Length 6.5 cm
A.982-1910
Salting Bequest

103 *(bottom right)*

NETSUKE

Carved wood with eyes inlaid
in shell, and staining
A tiger
Signed *Tōmin*
Tsu school, late 18th or early
19th century
Height 3.5 cm
A.939-1910
Salting Bequest

Armour

THE settlement imposed by Tokugawa Ieyasu (1542–1616, see p.15) after the battle of Sekigahara in 1600 and the fall of Osaka castle in 1615 required the daimyo to excel in the arts both of peace and of war. However, in order to prevent dangerous challenges to Tokugawa authority, Ieyasu took steps to ensure that the standing armies which the daimyo were obliged to maintain could not be used to overthrow him. The daimyo families which were related to the Tokugawa or had taken their side before Sekigahara were given fiefs near the new capital, Edo, while less reliable lords were kept at a safe distance from the centre of power. All daimyo were made to spend alternate years or half-years in Edo and to leave their wives and families as virtual hostages in their domains. This system involved the daimyo in the great expense of keeping large residences at Edo and equipping the hundreds or even thousands of samurai and servants who formed their retinue on the journey to and from the capital. The composition of these processions, which indirectly carried the authority of the shogunal system to every corner of Japan, was strictly regulated by sumptuary laws setting limits on the degree of display according to the status of the daimyo and his fief. Much of the appeal of the arms and armour of the Edo period derives from their expression of a tension between the need to preserve a semblance of utility and restraint, and the client's desire for embellishment and ostentation. In addition, armours, swords and other accessories played an important part as the embodiment, in a period of prolonged peace, of the martial values which had brought about the ascendancy of the samurai class. In the absence of opportunities for real fighting, there was a need for professional scholars to pass on the secrets of martial arts such as swordsmanship and archery, codify the military ideologies and practices of the past as the 'Way of the Samurai' (*bushidō*) and compile histories of arms and armour. In the same way, Edo period armourers perpetuated in an ornate and often impractical form the successive styles of the Heian, Kamakura and Muromachi periods (tenth to sixteenth centuries).

The earliest Japanese armour was made up of horizontal strips of leather or, later, iron fastened together with leather thongs. In the fourth or fifth century this was supplanted by another type, introduced from the mainland, made up of small plates tied together in rows and then laced vertically. This style continued until the tenth century, when it gave way to the *ōyoroi*, 'great armour' (*104*). Like all later armours, the *ōyoroi* combined the skills of the armourer with those of weavers and lacquerers as well as specialists in leatherwork and soft metal decoration. Many of its components were made from small-plates of leather or iron which were tied together in rows before being heavily lacquered all over. This gave greater strength and rigidity and led, in the Edo period, to the manufacture of armours incorporating strips of metal or leather disguised to look as though they were made up of smaller plates. Distinctive features of the *ōyoroi* include the low, rounded helmet with prominent 'stars' or rivets, the broad neck-guard with large

104

SUIT OF ARMOUR IN
ŌYOROI STYLE

Iron helmet-bowl with gilt fittings, signed *made by Myōchin Mondo Ki no Muneharu on a day in the eighth month of the sixth, tsuchinoto-hitsuji, year of Ansei* [= 1859]; iron mask with whiskers of animal hair; gold-lacquered iron and leather small-plates laced with silk; iron chain-mail sleeves and leg-guards; stencilled leather breast-plate, shoulder-strap protectors and other details; patterned silk sleeves; gilt openwork trimmings; red silk cords; stencilled leather, gilt and fur boots
1859
Height as shown: 146 cm
362-1865
Given by Queen Victoria

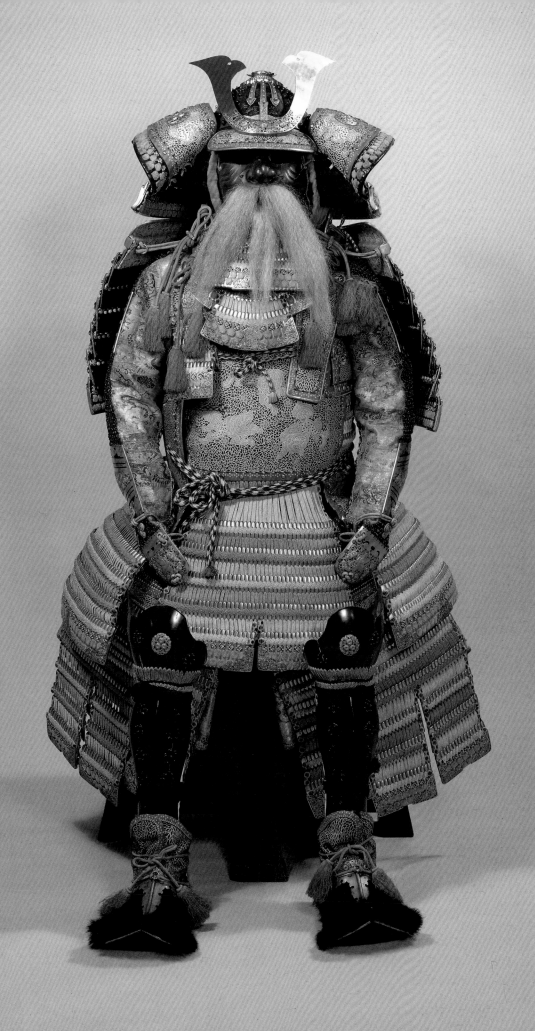

turnbacks, the body armour in two pieces, the extensive areas of stencilled leather decoration and the very large shoulder-guards. By the late Edo period, when this example was made, there was little understanding of the way mediaeval armours had been used, but attention was paid to the detailed reproduction of decorative features. The metal parts of the sleeves, for example, are close imitations of a pair which is said to have belonged to the great hero Yoshitsune (died 1189, see pp.134, 138), and the stencilled leather panel on the front of the armour, decorated with a design of lions on a floral ground, is seen on many early ōyoroi. This armour was presented to Queen Victoria in 1860 by the last but one shogun, Tokugawa Iemochi (reigned 1858–1866, see p.184). The helmet was signed in the preceding year by Muneharu, a late member of the Myōchin line of armourers who probably carried out the whole commission.

The armour opposite (105) is in the dōmaru style. This was first used during the fourteenth century. The chief points of difference from the earlier ōyoroi style are the close-fitting one-piece body armour, the smaller and more numerous thigh-guards and the smaller shoulder-guards. This suit retains the earlier style of protection for the shoulder-straps, flexible on the wearer's right shoulder and rigid on his left shoulder. This is more appropriate to the ōyoroi and was often replaced on dōmaru by two simpler leaf-shaped pieces. In another departure from convention, the peak of the helmet, parts of the shoulder-guards and other details are covered in rayskin which was filled with black lacquer, polished down and then decorated in black lacquer with dragonflies. These areas were more usually trimmed with stencilled leather. During the Momoyama period (1573–1615) there had been a vogue for extraordinary helmets taking the shape of monstrous fish, animal heads or monks' hoods, but Tokugawa convention frowned on such extravagant expressions of power. The horns, as on the ōyoroi, were the most usual helmet decoration, but here the silvered fittings in the form of waves add a discreet touch of ostentation. All the shakudō (see p.132) mounts were made in the work-shops of the Hamano family of sword-fitting makers; the signature of the fourth master, Masanobu, is on the forecrest of the helmet. This crest, a wheel of mallets, is that of the Doi, a middle-ranking daimyo family resident to the northeast of Edo.

The armour was probably assembled, lacquered and decorated at the same date, 1799, as the compilation of a set of certificates which accompanies the suit. These certificates are signed by Munetō, hereditary master of the Myōchin family, who supposedly stood twenty-sixth in succession from Munesuke, the legendary reviver of the family fortunes, himself alleged to be a descendant in the thirty-second generation of the prime minister of the Empress Jingū (traditional dates 201–269). In fact the Myōchin were relative newcomers to the armourers' profession, and no signed Myōchin pieces are known before the sixteenth century. Even if some parts of the armour really were earlier, since the small-plates would have had to be relaced and relacquered many times after damage in battle, the original construction of many of the components of the armour would be virtually impossible to assess and Munetō's attributions to his largely fictitious prede-cessors can be confidently dismissed. The Myōchin were in any case notorious for their practice of crediting their own family with the manufacture of all early armour.

105

SUIT OF ARMOUR IN DŌMARU STYLE

Iron helmet-bowl and peak with gilt and *shakudō* fittings; lacquered iron mask; gold-lacquered iron and leather small-plates laced with silk; iron chain-mail, forearm-guards and leg-guards; patterned silk sleeves and other details; lacquered rayskin on helmet-peak, shoulder-strap guards and body-armour; *shakudō* fittings signed *respectfully carved by Otsuryūken Miboku Masanobu* (active late 18th century); silvered copper horns; red silk cords; lacquered and stencilled leather and fur boots; gold and black lacquered leather-covered box
c. 1800
Height as shown: 142 cm
M.130-1914

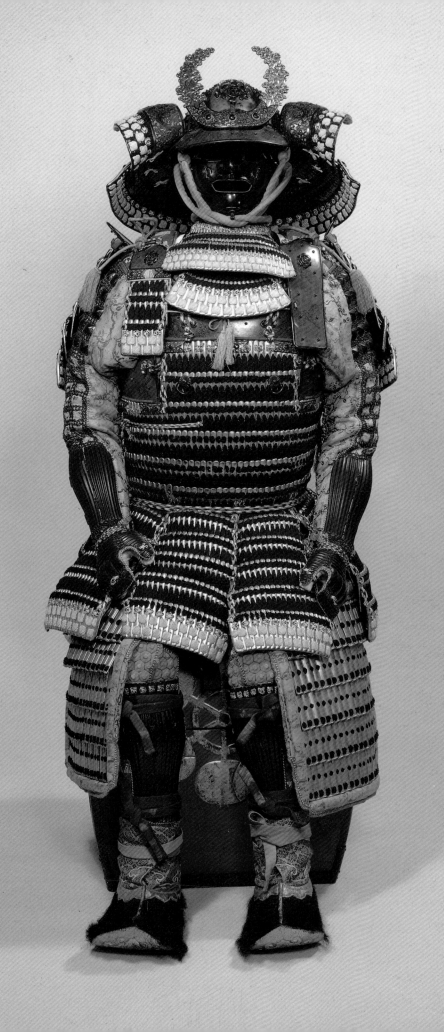

The Myōchin attempt to create an illustrious ancestry, which began in the seventeenth century, should not be seen as a simple fraud. As well as enhancing the prices (detailed in the certificates) of their works, their bogus pedigree responded to the government ideology of the day, which attached great importance to the maintenance of military values and traditions in a time of peace.

In the 1540s muskets were introduced to Japan by the Portuguese and quickly came to play a vital part in the decisive battles of the later sixteenth century. In response to the new weapon, many armourers abandoned the traditional protection of rows of small-plates laced with silk in favour of breast-plates and other components made of solid wrought iron. This iron shoulder-guard (106) and its companion are both signed *made by Nagasone*. They are probably early works of Nagasone Kotetsu (died 1678), who started his career by following the family trade as an armourer but later moved from Echizen province to Edo and became one of the most famous swordsmiths of the seventeenth century.

The shoulder-guard has the russet patination typical of much Japanese armour and is decorated with rivetted details, also in iron. Bamboo and plum blossom, which is here shown attached to a love-letter, are especially associated with winter. Kotetsu has conveyed the seasonal associations of the subject-matter by adding snow in the form of drops of silver splashed in molten state onto the heated surface of the iron, an extraordinarily difficult technical feat.

The squirrel and grape motif on the helmet signed by a recorded Momoyama period armourer (107) is first seen in East Asia on Chinese mirrors of the Tang dynasty (618–906). It was revived in the sixteenth century and used in the decoration of contemporary lacquers from the Ryukyu Islands (see p.172), Korea and Japan, as well as on Japanese textiles and Chinese porcelain made for the Japanese market. The delicate design offsets the rather crude construction of the helmet in a characteristically Momoyama period combination of practicality and display.

The more traditional helmet signed *Myōchin Nobuie* (108) is made up of sixty-two iron plates with upturned flanges. Like many armours and armour accessories of the later Muromachi period (1336–1573) onwards, it retains a number of obsolete features. Originally, the four knobs in the sides diverted rainwater from the silk loops immediately below them by which the helmet was secured in earlier times, while the opening in the top, with its gilt copper mount, was designed to take the warrior's queue of hair. By the sixteenth century hair was worn underneath the helmet and the method of securing the helmet had changed, making both details purely ornamental.

Myōchin Nobuie, whose signature appears on the inside of the helmet, is one of the earliest members of the Myōchin family of whose existence we can be reasonably certain. Nobuie signatures are so common, and so often include dates and other circumstantial details, as here, that one cannot avoid the suspicion that this is another Myōchin attempt to create a pedigree. JE

106 (opposite)
SHOULDER-GUARD (one of a pair)
Iron splashed with silver, trimmed with silk
Fans, hollyhocks, bamboo and plum with letter
Signed *made by Nagasone*
(Nagasone Kotetsu, died 1678)
31 × 29 cm
M.968-1916
Alexander Gift

107 (overleaf left)
HELMET-BOWL
Seven iron plates with gold and silver overlay; silvered iron finial and eyebrow-shaped decorations
Squirrels and grapes
Signed inside *Haruta Yoshihisa, on a lucky day in the eighth month*
Late 16th or early 17th century
Height 15.7 cm
M.93-1955
H.R. Robinson Gift

108 (overleaf right)
HELMET AND NECK-GUARD
Sixty-two iron plates; gilded copper finial and forecrest holder with openwork chrysanthemum design; gilded copper horns; turnbacks of neck-guard faced with stencilled leather; gilded copper badges of the Makino family; neck-guard of four semicircular rows of lacquered small-plates laced together with blue silk braid; blue, red and multicoloured silk lacing
Signed *made by Myōchin Nobuie, guardian of Echizen province, of the Sano manor in Shimotsuke province on a day on the fourth (intercalary) month of the ninth year of Eishō* [= 1512]
Probably 16th century; the mounts probably 19th century
Diameter of neck-guard 42.5 cm; height of helmet-bowl about 16 cm
M.111-1919

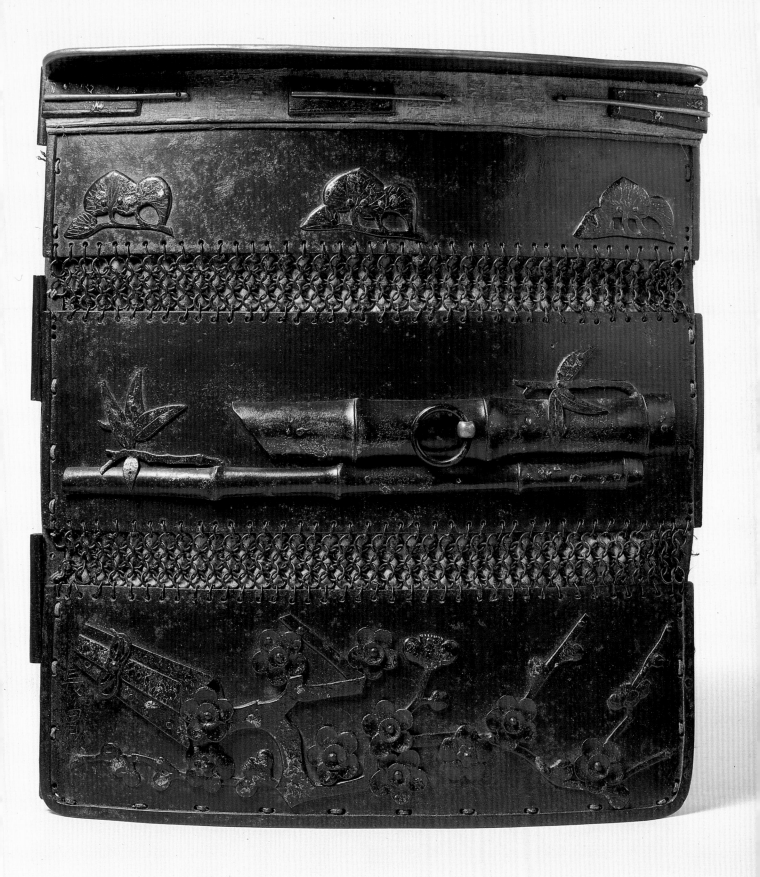

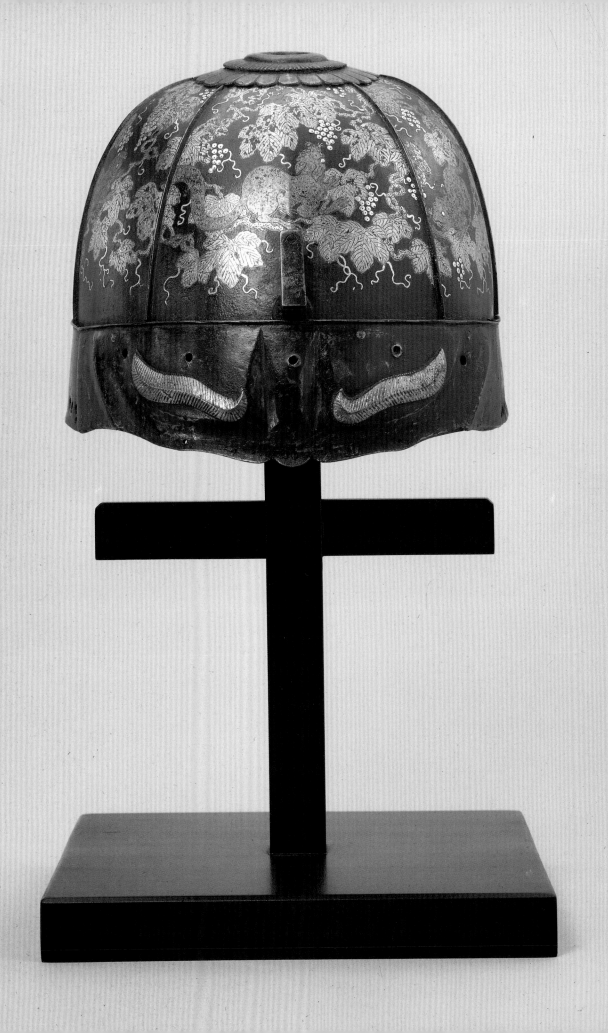

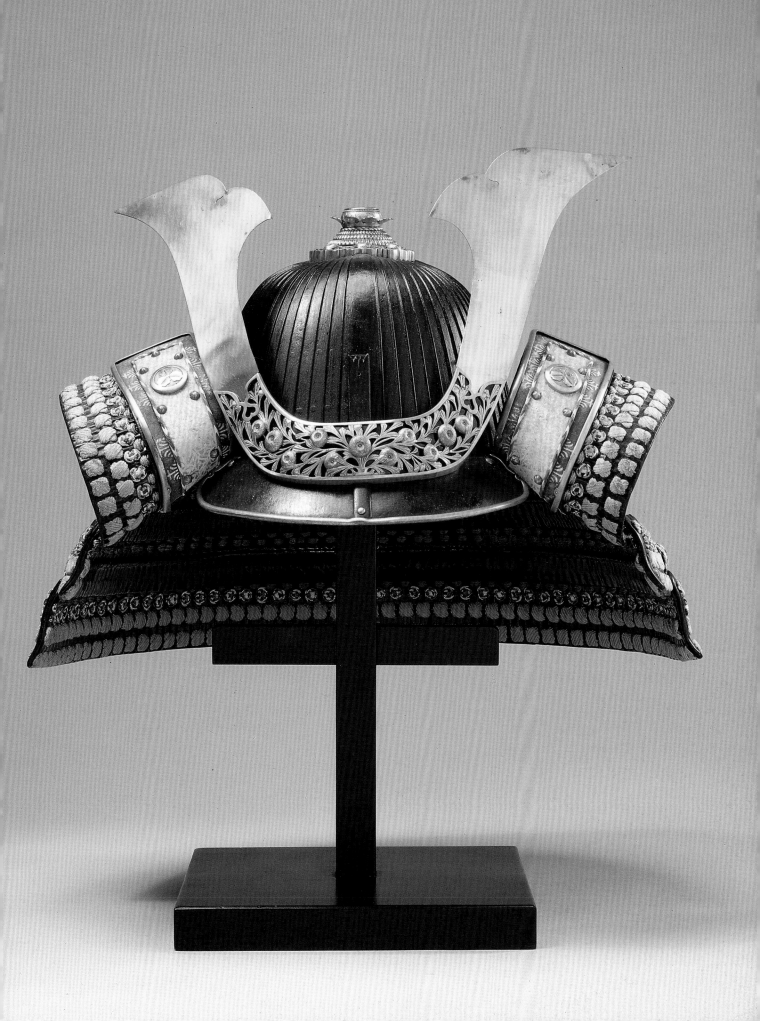

Swords

THE *tachi*, a curved sword about ninety to a hundred centimetres long, worn edge downwards in a scabbard which hangs from the waist, was the standard edged weapon of Japan from the tenth or eleventh century until the fourteenth century. Thereafter the *uchigatana*, worn edge upwards and carried by infantry, gained in importance, but the *tachi* continued to have great prestige among imperial courtiers, daimyo and other senior samurai. The two mountings illustrated here are both conservative in style. The *kazaritachi* (*109*) is a very close copy of a kind of mounting worn at court during the eleventh and twelfth centuries. A similar example was excavated in 1953 from the tomb of the second lord of the Owari branch of the Tokugawa family, who died in 1700.

The 'cord wrapped' (*itomaki*) style (*110*) reached its final form in the Momoyama period. It is so named because the binding is not confined to the hilt but also extends about one third of the way along the scabbard so as to protect it from damage when worn with armour. This example contains a very fine blade from one of Bizen province's great periods of sword manufacture. Old blades were avidly collected by Edo period daimyo and were frequently presented as gifts. This one changed hands for the last time in Japan when it was given by Prince Katsura to Sir Claude Macdonald, Britain's ambassador to Japan at the beginning of the century.

The 'large and small' (*daishō*) is a pair of swords, one (the *katana*) about ninety centimetres long and the other (the *wakizashi*) about sixty centimetres long, mounted in the style shown overleaf (*111*), and worn edge upwards in the belt. The combination came into general use during the sixteenth century. During the peaceful years of the Edo period, when the *daishō* was worn by all samurai, swords retained a certain utility. Their blades, in particular, whether newly forged or handed down from earlier periods, were as deadly as ever. Even so, in the seventeenth century some smiths found it necessary to prove the efficiency of their work by inscribing the tangs of their swords with records of tests carried out on the dead bodies of criminals. Particularly for samurai living in the great urban centres, the sword was more important as an item of personal adornment than as a weapon, and thousands of craftsmen in lacquer and metal lavished their skill on its decoration.

The most important metal fittings of the *daishō* were the *tsuba*, *habaki*, *fuchi-kashira*, *menuki*, *kozuka*, *kōgai*, *kojiri* and *kurikata*. The *tsuba* or guard, pierced with a wedge-shaped opening to take the tang of the sword, protected the wearer's hand from an adversary's blade. Sometimes it is pierced with one or two further holes to admit the ends of the *kozuka* and *kōgai*. The *habaki* is a collar, usually made either from copper or from copper plated with gold, which is fitted round the sword at the point where the polished blade ends and the tang (which fits inside the hilt) begins. The *fuchi-kashira* is a matching set of collar and pommel holding together the two pieces of magnolia wood which form the basis of the hilt. The two *menuki*

109 (*left*)
MOUNTING FOR A SLUNG SWORD (*kazaritachi*)

Wood; scabbard covered in gold *nashiji* lacquer with shell inlay of phoenixes; openwork gilt fittings on solid bases carved with paulownia badges and scrolls; blue enamel studs; leather hanging straps; hilt covered in rayskin, with other fittings as on scabbard; leather cord
Steel blade signed *made by Fujiwara no Masatoshi, Guardian of Echizen Province, to the order of Lord Tsunemitsu of the Upper Second Rank, on the first day of the sixth month of the second year of Tenna* [= 1682]
Mounts 17th or 18th century
Overall length 96.5 cm
M.144-1915
Church and Howarth Gifts through the N.A.C.F.

110 (*right*)
MOUNTING FOR A SLUNG SWORD (*itomaki no tachi*)

Wood; scabbard covered in gold *nashiji* lacquer with gold *hiramaki-e* decoration of paulownia badges and scrolls; metal fittings *shakudō* with gilded paulownia badges; partly wrapped in white silk braid over white and gold silk brocade; leather hanging loops; multicoloured silk braid tying cord; hilt wrapped in white silk braid over white and gold patterned silk; metal fittings as on scabbard
Steel blade signed *Morimitsu of Osafune in Bizen province* (late 14th century)
Mounts 19th century
Overall length 107 cm
M.139-1929
Given by Lady Macdonald

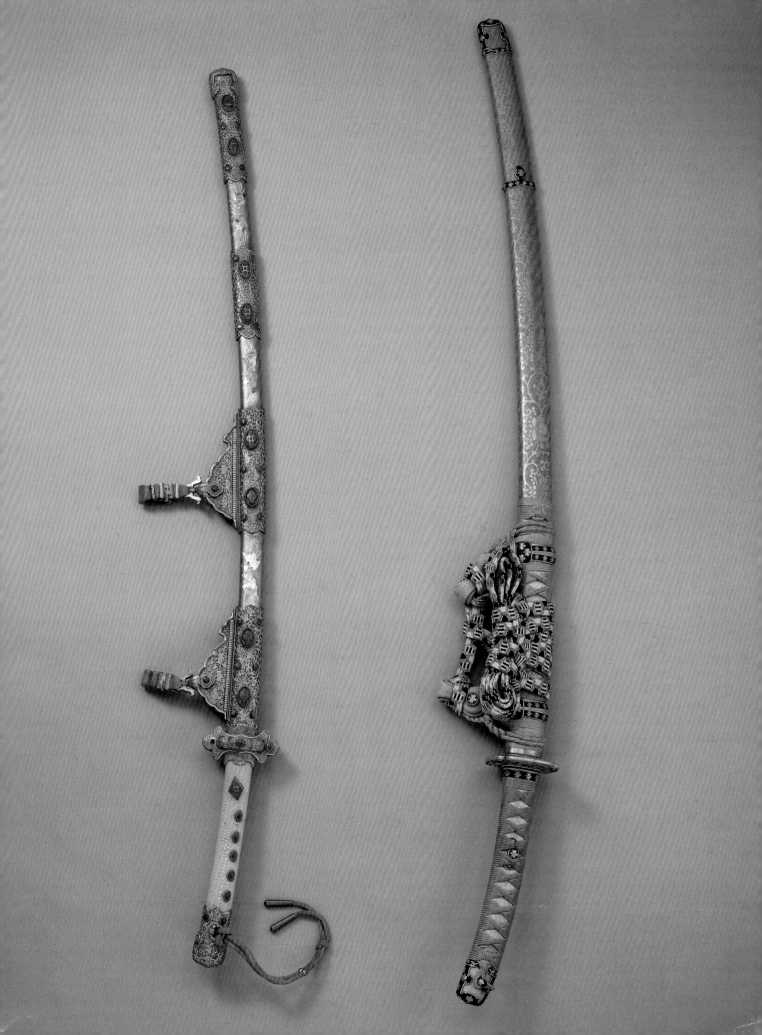

111

PAIR OF MOUNTED SWORDS (*daishō*)

Wood scabbards covered in black lacquer, partly textured and sprinkled with minute particles of colour, with cloud forms reserved in polished lacquer; wood hilts covered in rayskin wrapped with black silk bands; tying cords of grey and brown silk braid
Overall lengths 71.5, 96.5 cm
Mid-19th century
M.20, 21-1949
Alt Bequest

FITTINGS ON THE SMALL SWORD:

a Collar and pommel on the hilt (*fuchi-kashira*):
Shakudō with gold, *shibuichi* and silver
Shōki the demon-queller (on the *kashira*) chasing a demon (on the *fuchi*)
Signed *Shūgensai Hirosada*
Mito school at Edo
First half of the 19th century

b Fittings (*menuki*) under the hilt-wrapping:
Iron
Demon masks and roof-tiles

c Guard (*tsuba*):
Shakudō, with gold, copper and *shibuichi*
Peacock beneath a cherry tree
Signed *Yoshinari* (Ishiguro Yoshinari, first half of the 19th century)

d Attachment (*kurikata*) for the tying-cord:
Shakudō with gold and copper
Persimmons
Signed *Gotō Mitsusada* (first third of the 19th century)

e Butt (*kojiri*) of the scabbard:
Shakudō with gold and copper
Fern fronds and plants
Signed *Mitsuaki* (1816–1856)

f Double collar (*habaki*) between sword blade and sword tang:
Gold on a copper lining, textured with 'cat-scratch' (*nekogaki*) markings

g Knife (*kogatana*) carried in the scabbard:
Steel
Signed *Monju Shirō Kanemori* (mid-17th century)

h Handle (*kozuka*) of the knife carried in the scabbard:
Panel: *shakudō* with silver, *shibuichi* and gold
Frame: gilded copper
A storm-dragon by Mount Fuji
Signed *Sonobe Yoshihide at the foot of Tendai mountain in autumn of the mizunoto-mi year* [= 1833]

FITTINGS ON THE LARGE SWORD:

i Collar and pommel (*fuchi-kashira*) of the hilt:
Shibuichi, with *shakudō*, gold and copper
Oxen and plants
Signed *Shōzui* (Hamano Shōzui, 1696–1769), *aged 63*
c. 1760

j Fittings (*menuki*) under the hilt-wrapping:
Shakudō with gold, silver and copper
Buddhist deities, warrior and demon

k Guard (*tsuba*):
Shibuichi with gold, *shakudō* and silver
A fox disguising itself with plants and admiring its reflection by moonlight; reverse: two wrapped pine trees by a shrine-arch
Hitsu hole plugged with gold
Signed *Iwamoto Konkan* (1744–1801) *in the kanoe-ne year of An'ei* [= 1780]

l Attachment (*kurikata*) for the tying-cord:
Horn with gilded linings

m Butt (*kojiri*) of the scabbard:
Shibuichi with silver and gold
The Chinese emperor Shun helped by an elephant and birds to till the soil
Signed *Yoshimitsu* with a seal (Aoyagi Yoshimitsu, c. 1830–1848)

n Collar (*habaki*) between sword blade and sword tang:
Gold on a copper lining, textured with 'cat-scratch' (*nekogaki*) markings

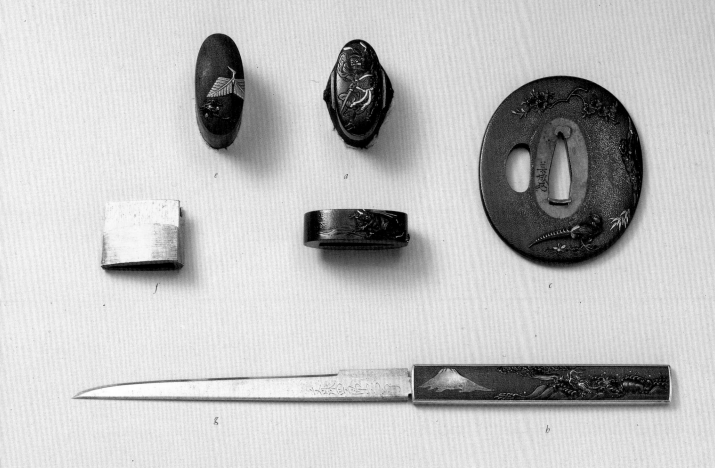

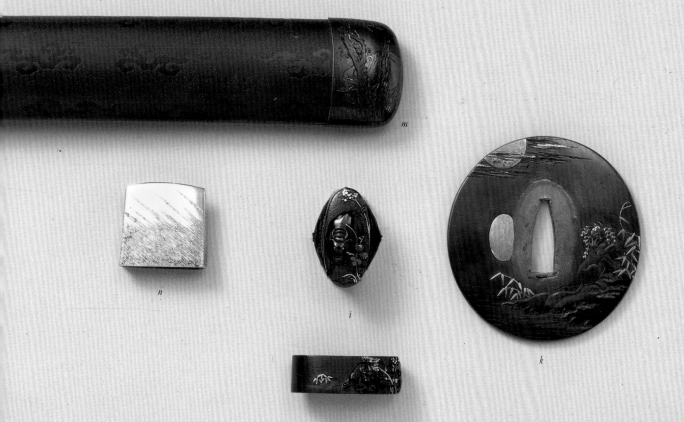

were originally decorative covers for the pegs holding the sword in the hilt. By the later fifteenth century, however, *menuki* and peg had separated. The *menuki* were placed at different points on each side of the hilt, so changing the contours of the silk braid binding and improving the grip. The *kozuka* is the handle of a small knife whose blade is inserted into a slot on the side of the scabbard lying next to the wearer's body; on the other side there is sometimes, but not on these swords, a *kōgai*, a skewer-like implement said to have been used to arrange the hair under the helmet. By the Edo period, neither *kozuka* nor *kōgai* had any real function. The *kojiri*, or butt, corresponds to the *kashira* at the end of the hilt, protecting the wood of the scabbard from damage and holding the two pieces of magnolia together. The *kurikata*, on the outside of the scabbard, takes the silk braid ribbon which ties the whole assembly to the wearer's belt.

The fittings of this *daishō* are all of very high quality and mostly signed by well-known masters of the late Edo period. At first glance, the swords have a deceptive air of sobriety and restraint. This was in part the result of historical circumstances, for they were mounted shortly after the austere Tempō reforms of 1841–1843, which were the shogunate's last attempt to influence the economy by currency revaluation, sumptuary edicts and other traditional methods. The choice of fittings shows a leaning towards fine craftsmanship rather than lavish use of gold and silver, and consistency of overall appearance rather than symbolic continuity between decorative motifs. The fittings of the large sword include a *tsuba* (*111k*) by Iwamoto Konkan, a representative of the townsman class with a reputation as an *habitué* of the licensed quarters. Konkan's *tsuba* shows a fox which has dressed itself up as a beautiful woman admiring its reflection in a pool. This frivolous design appears on the same sword as an improving Confucian fable about the diligence in agriculture of the legendary Chinese emperor Shun. These fine swords attest to the growing convergence of samurai and townsman taste which is a feature of the late Edo period.

Elaborately decorated short swords without guards were worn in conjunction with the *tachi* by important warriors during the Kamakura and Muromachi periods. Their mounts were later applied to *katana* and *wakizashi*, and continued to be widely used throughout the Edo period. Later examples (*112–113*) are something of a puzzle: often their extravagant decoration seems quite inappropriate to the higher echelons of the samurai class, yet it is difficult to believe that such weapons were permitted to non-samurai in the large numbers suggested by the quantity of these daggers which have been handed down in western collections. The dagger with red, gold and silver lacquer, at any rate, is decorated with the highly traditional motifs of autumn plants and insects, but the sea-creatures which cover the larger dagger seem to belong very much to the world of the nineteenth-century townsman, with his taste for the exaggerated and curious. The *wakizashi* with the blue-green lacquering (*114*) is in an altogether more sober style. All-over decoration in a colour other than black, red, gold or silver is relatively rare in the Edo period except on small objects, since there are few pigments which can be dissolved in lacquer without either making it unworkable through some chemical alteration or themselves changing colour. Like the *daishō* (*111*) the *wakizashi* is mounted with a carefully selected range of works by different masters, and in this case there is complete consistency in the motifs.

112 (*left*)
MOUNTING FOR A
DAGGER
Wood scabbard covered in red lacquer, with gold and silver *hiramaki-e* decoration of autumn plants; wood hilt covered in rayskin wrapped with whalebone; tying cord of purple and white silk braid
All metal fittings except *menuki* engraved silver with *shakudō* and gold: autumn plants; *shibuichi* and gold fittings (*menuki*) under the hilt wrapping: cicadas
Signed in several places *Taisen Yoshiteru* (mid-19th century)
Overall length 43 cm
FE.3-1974
Crawshay Gift

113 (*centre*)
MOUNTING FOR A
DAGGER
Wood scabbard covered in black and silver lacquer, the silver lacquer modelled as waves, the black lacquer with gold *hiramaki-e* decoration of waves; wood hilt covered in rayskin wrapped with whalebone
All metal fittings silver with gold and *shibuichi* in the form of sea-creatures
Handle (*kozuka*) of the knife carried in the scabbard signed *Jukōdō Tomoyoshi*; *c.* 1860
Overall length 55 cm
M.1335-1926
Books Gift

114 (*right*)
MOUNTING FOR A
COMPANION SWORD
Wood scabbard covered in blue-green lacquer with gold *hiramaki-e* decoration of bamboo-grass; wood hilt covered in rayskin wrapped with faded brown and white silk bands
Metal fittings *shibuichi*, gold, silver and *shakudo*; tigers, rocks and bamboo grass; handle (*kozuka*) of the knife carried in the scabbard: dragonflies
Metal fittings signed by various artists
Overall length 69 cm; *c.* 1860
M.25-1912
Dobree Gift

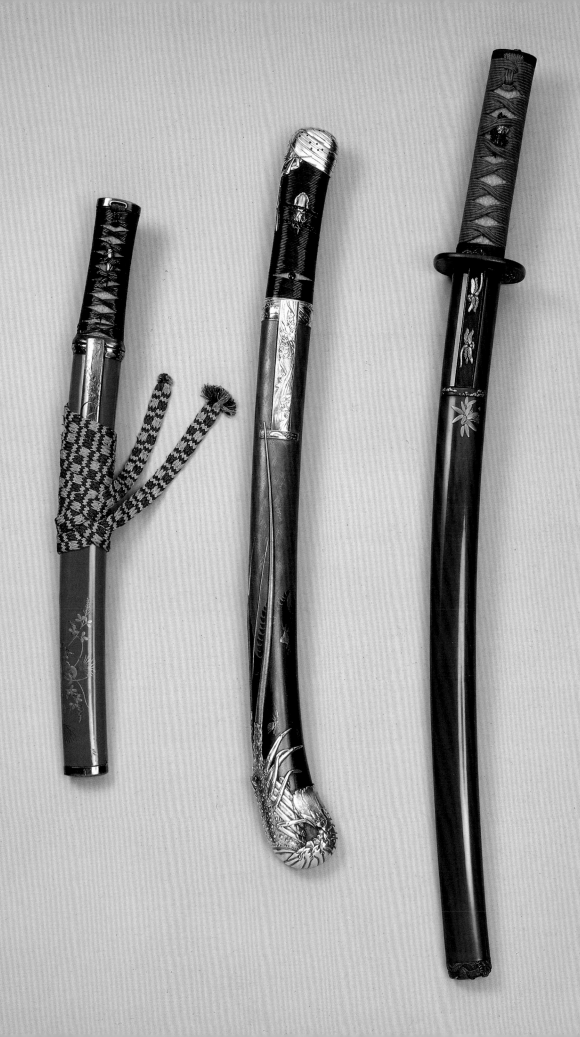

Sword-fittings attracted even more interest among late nineteenth-century British collectors than the other miniature art forms of Japan. The chronological span is longer, the range of materials and subject-matter is wider and, unlike *netsuke* and *inrō*, the manufacture of sword-fittings was not confined to a few areas of production. Sword-guards in particular were made in almost every province and domain, from Akita and Dewa in the far north of Hokkaido to Satsuma in the south of Kyushu. In addition, the vast number of pieces with detailed signatures provide an irresistible if ultimately unrewarding field for taxonomic study. The fittings reproduced here attest to dramatic changes both in function and in market and range from simple and practical early iron guards to elaborately encrusted miniatures by the late masters. The date of the first use of iron guards (*115–120*) is disputed but it is generally accepted that they were intended as mounts for the 'striking sword' (*uchigatana*) worn edge upwards in the belt and carried by infantry, which evolved during the fourteenth and fifteenth centuries from the earlier *tachi* (see p.122). These early guards are traditionally believed to have been made by armourers and swordsmiths as a sideline. Especially in 'armourers'' guards the piercings often carry a symbolic auspicious meaning. In one of the 'armourers'' guards reproduced here (*118*), the tumbler toys recall the form of Daruma, the reputed founder of Zen Buddhism whose legs are said to have atrophied after prolonged meditation. The weighted toys always return to an upright position and thus stand for resilience. The cherry blossom pierced in the larger 'armourers'' guard (*119*), a frequent motif in these early pieces, is a perennial symbol of impermanence in Japanese literature and had a special significance for warriors in the very unstable conditions of the late fifteenth and sixteenth centuries.

During the sixteenth century, a number of groups of specialist sword-guard makers came into being. In their work there is a shift away from the limited range of subject-matter in the early guards towards a wider decorative repertoire which shares motifs with other crafts such as lacquer and textiles. The new style spread from the capital region to Higo province in Kyushu (*116*) and the new city of Edo, where the Akasaka district (*115*) became a centre of mass-production during the eighteenth century. The most influential group of all was the Shōami (*135*), which originated in Kyoto but was dispersed to domains throughout Honshu and Shikoku at the beginning of the Edo period.

Decoration of guards with a second metal first appears in the sixteenth century (*124*). The anonymous craftsmen of the Heianjō-zōgan (*123*) group conceived a style of brass inlay which soon found followers in other provinces. The name of Umetada Myōju (1558–1631, *126*) is associated with the earliest guards to be made from a ground metal other than iron; like the Kōdaiji lacquerers (p.52) he was able to convey a richly polychromatic effect with limited resources.

115 (*top left*)

TSUBA

Pierced iron
Reeds, dewdrops and crescent moon
Signed *made by Tadatoki*
Akasaka school, 18th century
Greatest diameter 7.7 cm
M.64-1914
Church Gift

116 (*top right*)

TSUBA

Pierced iron
Pine trees with a bridge for a *koto*
Higo province, Nishigaki style, 18th century
Greatest diameter 7.5 cm
M.60-1919

117 (*centre left*)

TSUBA

Pierced iron
Fungus and young ferns
Probably made by a swordsmith; 16th century
Greatest diameter 8.4 cm
M.211-1921

118 (*centre right*)

TSUBA

Pierced iron
Conch shell and tumbler toys
Probably made by an armourer; 15th or 16th century
Greatest diameter 9.1 cm
M.20-1931
Hildburgh Gift

119 (*bottom left*)

TSUBA

Pierced iron
Incense symbol (*Genjikō*), cloud, cherry blossom and arabesque
Probably made by an armourer, 15th or 16th century
Greatest diameter 10.3 cm
M.148-1913
Church Gift

120 (*bottom right*)

TSUBA

Pierced iron
Irises and dewdrops
Kyō-sukashi style, 16th century
Greatest diameter 8.1 cm
M.190-1914
Church Gift

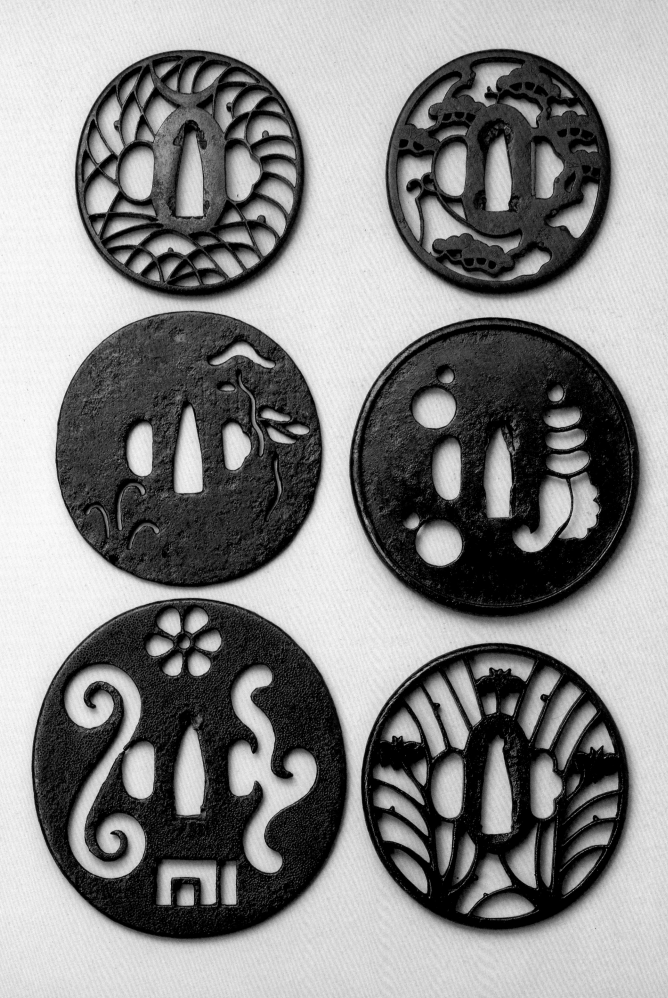

121 *(top left)*
TSUBA

Iron with *sahari*, an alloy of copper
with tin and lead
A broken umbrella
Signed *Hazama*
Ise province, 18th century
Greatest diameter 7.1 cm
M.1640-1931
Hildburgh Gift

122 *(top right)*
TSUBA

Iron with brass
A phoenix
The *hitsu* hole plugged with
pewter
Heianjō-zōgan style, late
16th–early 17th century
Greatest diameter 7.9 cm
M.358-1940
Somerville Gift

123 *(centre left)*
TSUBA

Iron with brass, silver and copper
Buddhist Guardian Kings *(Niō)*
Heianjō-zōgan style, 17th century
Greatest diameter 7.4 cm
M.126-1931
Hildburgh Gift

124 *(centre right)*
TSUBA

Pierced iron with brass
Bridge-post and iris flower
Ōnin style, 16th century
Greatest diameter 8.2 cm
M.201-1921

125 *(bottom left)*
TSUBA

Iron with brass
Heraldic badges and waterweed
Signed *made by Hakamaya Saburōdayū*
of Okayama in Bizen province
Yoshirō-zōgan style, first half of
the 17th century
Greatest diameter 8.3 cm
M.203-1921

126 *(bottom right)*
TSUBA

Copper with *shakudō* and gold
Oak leaves and dewdrops
Signed *Umetada* and *Myōju*
Umetada school, 17th century
Greatest diameter 8.4 cm
M.5-1920

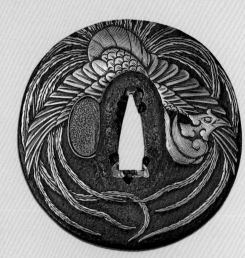
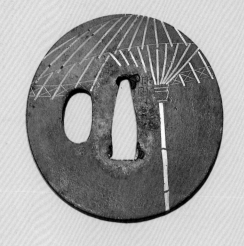
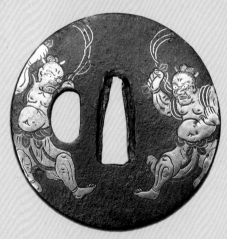
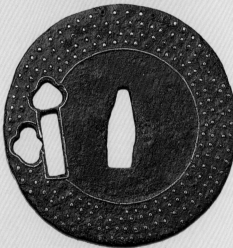
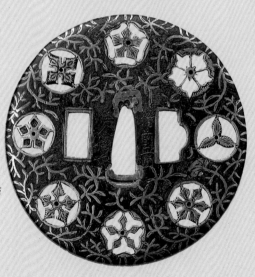
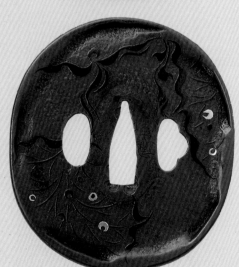

127
KOZUKA
Shibuichi with gold, silver, copper
and *shakudō*
An actor of the Ichikawa Danjūrō
line in the play *Shibaraku*
Inscribed on the back with a
poem by Kikaku (1661–1707):
*Now that Danjūrō is in, the devils are
out!*
Signed *Miboku* with a seal *Shōzui*
(Hamano Shōzui, 1696–1769)
Height 9.7 cm
M.111-1928

128
PAIR OF MENUKI
Shakudō with gold and silver
Bow, arrows and quiver
Signed *Gotō, Mitsuyo* (Gotō Jōha,
died 1724)
Length 7.0 cm
M.138-1924
Marcus Gift

129
PAIR OF MENUKI
Gold with *shakudō* and silver
The *bodhisattvas* (see p.24) Fūgen
riding an elephant and Monju
riding a lion
Each signed *Morinaga*
(c. 1837–1896)
Mito school, later 19th century
Heights 3.1, 2.9 cm
M.476-1916
Alexander Gift

130
FUCHI-KASHIRA
Shakudō with gold, shell and
copper
Butterflies
Signed *Nobutatsu*
Murakami school, 19th century
Width of *fuchi* 3.0 cm
M.63-1957

131
KOZUKA
Shakudō with gold
Three carp with waterweed
Signed *Ishiguro Masatsune*
(1760–1829)
Length 9.8 cm
M.1414-1931
Hildburgh Gift

See overleaf for 132–134

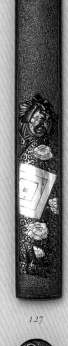

127

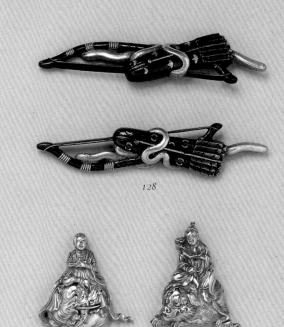

128

129

130

131

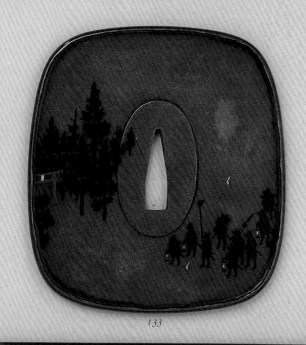

132

133

134

The creation of an elaborate pictorial style using a combination of *shakudō*, gold, silver and, later, other metals (*127–140*) is traditionally ascribed to Gotō Yūjō (1440–1512), a craftsman in the entourage of Ashikaga Yoshimasa (see p.60). The Gotō style, originally intended for the decoration of daggers carried by leading daimyo and aristocrats, was not applied to guards until the Momoyama period. At the beginning of the Edo period the Gotō craftsmen moved to Edo, where they were the predominant exponents of decoration in soft metals until the end of the seventeenth century. From their workshops came the founders of many of the families of craftsmen which were active in Edo during the following two centuries. Although the Gotō school continued, and enjoyed a revival under Ichijō (1791–1876), its work had only a limited appeal for the urban samurai class and the townsmen who were occasionally permitted to bear arms or could form collections of fittings without buying swords. Their tastes were better served by more innovative ateliers, drawing on a wider range of decoration partly shared with the makers of *inrō* and *netsuke*, and often influenced by contemporary developments in painting. The 'town carving' (*machibori*) craftsmen combined the discipline of the Gotō workshops with an inventiveness which has had a compelling appeal both in Japan and in the West.

Among the metals used the most important are iron, copper, brass, gold, silver and the alloys *shibuichi* and *shakudō*. According to forging technique and surface treatment, iron can acquire a number of patinas including red, black and brown. Copper, too, can vary in colour. Slight additions of other metals to copper can produce a brown, red or purple tint. Brass is used in two forms. The first is close to the western alloy of copper and zinc, while the second, *sentoku*, contains a proportion of lead and tin. Pure gold is rarely used. Small proportions of copper and silver are added and these affect the tint. *Shakudō* is an alloy of variable composition made up of over 90 percent copper with a percentage of gold and a small quantity of *shirome*, a compound usually containing antimony and arsenic. *Shibuichi*, also called *rōgin*, is basically a compound of copper with approximately 25–40 percent silver. Both *shakudō* and *shibuichi*, as well as many of the other metals, are 'pickled' in acidic solutions, *shakudō* producing a rich blue-black patina and *shibuichi* a variety of tones ranging from dark grey through brown-grey to light grey depending to some extent on the proportion of copper to silver.

In terms of techniques actually visible in the finished product, sword-fittings exhibit an even greater variety than lacquers. Surfaces can be hammered directly, given the appearance of stone with a small chisel, polished, filled or treated with a pattern of minute granulations called 'fish-roe' (*nanako*) using a cup-shaped punch. Decoration can be pierced or chiselled in the main metal of the fitting or added in other metals as inlay or overlay. The inlay techniques correspond roughly to *togidashi-e* and *takamaki-e* in lacquer: flat inlay is inserted into hollows cut in the ground of the main metal and polished flat, while high relief inlay is inserted either into built-up areas of the main metal or into hollows like flat inlay, and then worked with the chisel. JE

Previous page

132

FUCHI-KASHIRA

Shakudō with gold, copper and *shibuichi*

Horses

Signed *Tsuki Mitsuoki* (1766–1834) with a gold inlaid seal *Ryūsai*

Width of *fuchi* 3.8 cm

M.624-1911

133

TSUBA

Shibuichi with *shakudō*, gold and copper

The foxes' wedding procession

Tsuji school, 19th century

Height 8.3 cm

M.33-1920

134

KOZUKA

Shibuichi with *shakudō* and copper

The foxes' wedding procession

Tsuji school, 19th century

Length 9.8 cm

M.34-1920

Opposite page

135 (*top left*)

TSUBA

Copper with *shakudō*; *hitsu* holes with gilded linings

A plum branch

Signed *Shōami Tōji Nobushige*

Aizu Shōami school, first half of the 18th century

Greatest diameter 7.7 cm

M.236-1923

Guest Gift

136 (*top right*)

TSUBA

Copper with *shibuichi*, gold and silver

Sailing boats and Mount Fuji

One of the *hitsu* holes plugged with *shakudō*

Signed *Tōryū Hōgen* (Tanaka Kiyotoshi, 1804–1876), *not until they laughed at me did I know that I had hit on a living style*

Greatest diameter 7.1 cm

M.952-1910

Salting Bequest

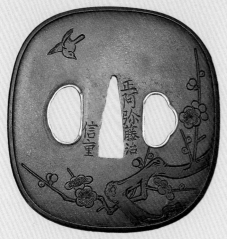

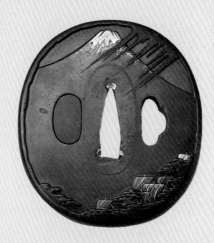

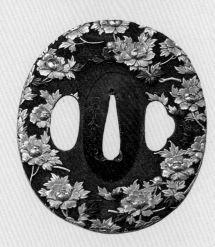

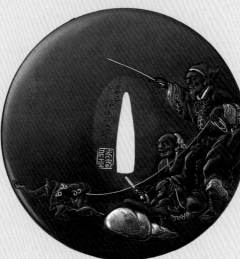

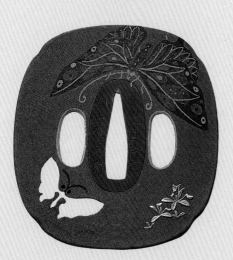

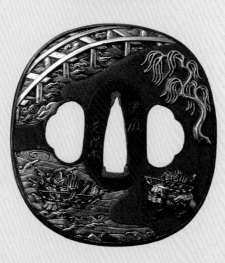

137 (*centre left*)

TSUBA

Shakudō with gold and *shibuichi*
Peony sprays
Signed *Hitotsuyanagi Tomoyoshi*
Early 19th century
Greatest diameter 7.1 cm
M.180-1914
Church Gift

138 (*centre right*)

TSUBA

Shibuichi with gold, silver and
copper
Monkey trainers
Signed *drawn at Tokyo with the iron
brush by Sadamoto Usō* (1828–c. 1900)
and with an inlaid gold seal
Late 19th century
Greatest diameter 8.6 cm
M.1338-1931
Hildburgh Gift

139 (*bottom left*)

TSUBA

Pierced copper with *shakudō,
shibuichi* and gold
Butterflies and plants
Signed *made to order by Wada Isshin
Bizan Kakuō* (1814–1882) *in the
spring of the fourth year of Ansei
[=1857] as part of a complete set*
Greatest diameter 7.4 cm
M.32-1920

140 (*bottom right*)

TSUBA

Shakudō with gold, silver and
shakudō
Rival generals of the Minamoto
clan racing to the Uji river in
1184 AD
Signed *Gotō Mitsumasa*
(1695–1742)
Greatest diameter 7.3 cm
M.79-1919

Woodblock Prints

FROM the moment when Japan opened her doors to the outside world in the mid-nineteenth century, westerners were struck by the extraordinary richness of her woodblock printing traditions. Arriving in the 1850s and 1860s, they found a highly active publishing business as thriving as ever it had been in its two hundred-year-long history. Older work was available alongside a seemingly endless succession of new designs for a large and voracious contemporary public. Prints and printed books soon made their way to Europe and America where they were gathered into the first of many private and public collections. The collection at the South Kensington Museum (now the V&A) came into its own when over ten thousand prints were bought in 1886. Later acquisitions, of which the Alexander Gift of 1916 was the largest, have doubled that figure to make the collection one of the most extensive in the world. To the connoisseur attuned to seventeenth- and eighteenth-century works the Museum has less of interest perhaps than certain other institutions. For enthusiasts of the nineteenth century, on the other hand, there is an immense resource of very exciting material which even now offers much scope for fresh exploration.

The actor portrait by Toyokuni (*141*) is in a dramatic style reminiscent of his pupil Kunimasa (1773–1810). The distinctive hairstyle with its wing-like protuberances indicates a villainous role, in this case Kudō Suketsune in the famous tale of the Soga brothers' revenge. The story goes that in 1177 Suketsune murdered the father of two young boys Jurō and Gorō, then aged five and three. Their mother remarried and the boys received their step-father's family name of Soga (see also p.154). As they grew up single-mindedly preparing themselves to avenge their father's death, Suketsune rose in prominence to become a close retainer of Yoritomo, the new military leader of Japan. The brothers had to wait until 1193 before a suitable opportunity presented itself. One rainy night on the occasion of a hunting party organized by Yoritomo they managed to enter Suketsune's tent and kill him. In the ensuing struggle, however, Jurō was struck down and Gorō captured and later beheaded. The concern shown in the story with issues of revenge and filial piety struck a deep chord in a society dominated by a military elite and governed according to Confucian principles. Plays on the theme were written by numerous authors and performed with great frequency, making the Soga brothers two of the most widely familiar characters in the theatrical repertoire.

The incident depicted in the diptych by Kunimasu (*142*) also occurred in the late twelfth century, a period renowned for its episodes of heroism and military glory. Benkei, a warrior monk of great physical strength, had decided to collect a thousand swords by challenging each of their owners in single combat. One night, prowling the streets of Kyoto in search of the one last sword he needed, he came across Minamoto Ushiwakamaru on Gojō bridge. Ushiwakamaru, later called

141 (*opposite*)
UTAGAWA TOYOKUNI
(1769–1825)
Portrait of the actor Onoe Matsusuke I as the villain Kudō Suketsune in the production of the play *Saihai Soga* performed at the Nakamura theatre in the first month of the twelfth year of Kansei [= 1799–1800]
Signed *Toyokuni ga*
Published by Tsuruya Kinsuke
Publisher's seal
Colour print from wood blocks
1800
Ōban; 37.2 × 24.6 cm
E.994-1914

142 (*overleaf*)
UTAGAWA KUNIMASU
(active 1834–1852)
The actors Nakamura Utaemon IV and Nakamura Shikan III playing Benkei and Minamoto Ushiwakamaru as they engage in combat on Gojō bridge, from a performance which took place at the Naka theatre in Osaka in the third month of Tempō 8 [= 1837]
Signed *Gochōtei Sadamasu ga*
Artist's seal
Published by Honsei
Publisher's seal
Colour print from wood blocks
1837
Ōban diptych; 37.4 × 50.8 cm
E.12268-1886

Yoshitsune (see also p.116), was the youngest brother of Yoritomo and a brilliant swordsman. Benkei did not know of Ushiwakamaru and was taken in by his youthful looks. He attacked with confidence, but much to his surprise soon found himself hopelessly outskilled. Struck with awe and admiration he had no choice but to surrender. Then, asking to become a retainer, he swore eternal allegiance to Ushiwakamaru. This was the beginning of a close and eventful relationship which soon became the subject of popular legend.

In the case of both prints the actors depicted are taken from the well-known Kabuki theatre. Tradition relates that Kabuki was originated at the beginning of the seventeenth century by a young girl called O-Kuni and her samurai husband Nagoya Sanzaburō. The dubious virtues of the women who made up the troupes of performers brought reproof from government officials, and in 1629 female artists were banned from the stage altogether. Their place was taken by groups of boy actors, but in 1652 they too went the way of their predecessors for not dissimilar reasons. Mature Kabuki developed in the mid-seventeenth century with male actors playing both male and female roles. Its success was primarily due to the efforts of the great actor families which provided the stage with successive generations of talented performers. In spite of repeated harassment from the authorities, which in 1842 almost resulted in the complete closure of all theatres, Kabuki continued, and still continues, to attract large and appreciative audiences. In Edo, Kyoto and Osaka, the three main urban and also theatrical centres of pre-modern Japan, Kabuki actors enjoyed the same degree of fame as popular entertainers do today. The demand for pictures of these cult figures was enormous, and, as attested to by the vast numbers of actor prints which survive, was a prime source of stimulation to publishers and their artists.

A second no less potent object of popular interest was the licensed pleasure quarter and the activities of the women who worked there. The triptych by Kunisada illustrated (144) shows the interior of a restaurant on the banks of the Tamagawa, a river flowing westwards into Edo whose lower reaches were well-known as a place from which to view the autumn moon. The river is just discernible through the top of the staircase in the centre of the print. The scene shows women servants bustling about their business of catering to customers who had no doubt come to combine observation of the moon with certain of the less contemplative pursuits which were available to them. With its closely observed depiction of architectural and ornamental detail, and above all of women's dress, the print ranks with others of its kind as an invaluable record of prevailing styles and taste. At the time of this particular print's publication, it was generally the case that the characterization of personality found in the better portraits of the late eighteenth century had been lost in an excess of concern with contemporary fashion. Here the artist has placed the women in a variety of highly stylized poses for the express purpose of showing their costumes to best advantage, treating them more as clothes-horses than as human individuals.

The depiction of actors and women was the overriding concern of the print business during the seventeenth and eighteenth centuries. As the examples discussed so far have shown, these interests continued to inspire much important work during the nineteenth century as well. In this latter period, however, fresh demands from the public and the pressure of official censorship against the representation of what were seen as disreputable aspects of popular culture

143 (*opposite*)
UTAGAWA HIROSHIGE
(1797–1858)
White heron landing behind irises
Signed *Hiroshige hitsu*
Artist's seal *Hiroshige*
Colour print from wood blocks
Early 1830s
Hosoban (panel print);
37.8 × 17.0 cm
E.2382-1912

144 (*overleaf*)
UTAGAWA KUNISADA
(1786–1864)
Tamagawa han'ei no zu, interior view of a restaurant in the pleasure quarters along the banks of the Tamagawa, showing fashionably dressed women servants going about their business
Signed *Gototei Kunisada ga*
Published by Yamamotoya Heikichi
Publisher's seal
Censor's seal *kiwame*
Colour print from wood blocks
1820s
Ōban triptych; 37.8 × 75.8 cm
E.5560-1886

encouraged publishers and artists to experiment with new kinds of subject matter. Naturalistic studies of birds, flowers, insects and fish began to appear both in book form and as single sheet prints. They reflected an interest also seen in painting which was to some extent the result of a growing familiarity with European naturalistic studies introduced by way of imported books and prints. The best examples are characterized by a restrained palette of colours combined with boldly conceived designs. In the example by Hiroshige (143) the possibilities of the medium have been further exploited through the use of blind printing to depict the heron's wings and feathers.

More than naturalistic subjects, however, it was landscapes and views, both rural and urban, which particularly fired the imagination of nineteenth-century print artists. The print by Kuniyoshi (145) captures with magical effect the atmosphere of Mount Fuji rising in the distance as dusk gathers over the shadowy outlines of the village of Sekiya. The use of chiaroscuro to give depth to the foreground elements, the sides of the embankment and the tree trunk in particular, reflects the artist's understanding of western techniques. His mastery of pictorial composition is shown in the placement of the tree and the rising cone of the mountain on the far left hand side of an image dominated by strongly horizontal features. As with most landscape prints the human element is firmly present, in this case principally in the form of two rather comical looking characters admiring the view. In the print by Hirokage (146) the human and in this case genuinely hilarious content is more important than the view itself. The gusting wind sweeping through the city throws travellers on a bridge into complete disarray. Hats and umbrellas fly away as women try desperately to hold down their skirts. The swaying boughs of the trees on the far bank of the river take on a disconcerting aspect as heavy clouds rushing across the fading blue of the sky tell ominously of an approaching typhoon. The particular colour used to depict sky and river is characteristic of landscape prints of the mid-nineteenth century. It derives from a synthetic dye said to have been introduced from Europe at the end of the 1820s and widely used by the 1830s. It was both more stable than traditional blues made from vegetable pigments, and could be applied with greater intensity and vibrancy of hue. Because of this it also offered greater scope for the printer to experiment with tonal grading, a technique which in this print has been masterfully employed in the representation of the stormy sky.

The second major new genre of prints to emerge in the nineteenth century were illustrations of famous incidents in history, literature and legend. While landscape prints seem to have evolved naturally as part of growing public involvement and interest in travel, the stimulus for producing this kind of print came from the need to compensate for the increasingly repressive attitude of the authorities towards actor and women prints, and, given the stagnant nature of much mid-nineteenth-century work on these themes, from the need on the part of artists for a new expressive medium.

The triptych by Yoshitsuya (147) illustrates a well-known legendary episode in which the hero Minamoto Yorimitsu (948–1021), also known as Raikō, slays the giant ogre Shutendōji. The tale, which is a mythified version of what was probably a true incident involving one of the many bandit chieftains who harassed the country at the time, relates that Shutendōji, literally 'Great Drunkard Boy', had built a stronghold in the mountains of Ōeyama in the province of Tamba, to the

145 (previous pages)
UTAGAWA KUNIYOSHI
(1797–1861)
Sumida tsutsumi no yū Fuji, 'Mount Fuji at dusk from the Sumida embankment', from the series Tōto Fuji-mi sanjūrokkei, 'Thirty-six views of Mount Fuji seen from the eastern capital (Edo)'
Signed Ichiyūsai Kuniyoshi ga
Published by Murataya Jirobei
Two publisher's seals
Censor's seal Mura
Colour print from wood blocks
1843–1844
Ōban; 23.4 × 34.9 cm
E.2265-1909

146 (opposite)
UTAGAWA HIROKAGE
(active 1850s–1860s)
Atarashibashi no taifū, 'Typhoon on Atarashi bridge', seventh in a series of thirty-one prints entitled Edo meishō dōke zukushi, 'A complete collection of playful events at famous places in Edo'
Signed Hirokage ga
Published by Tsujiokaya Bunsuke
Publisher's seal
Engraver's seal
Censor's seal
Colour print from wood blocks
1859
Ōban; 31.5 × 21.9 cm
E.2969-1886

west of the capital, Kyoto. With his retinue of demonic attendants he descended from his lair to terrorise the neighbourhood, ravishing the local women and devouring human flesh. The emperor, unable to stop this devastation, called upon Yorimitsu and his four retainers to destroy the ogre. By disguising themselves as Buddhist monks, the band of five gained access into Ōeyama, where they were welcomed by Shutendōji. A great feast began and Shutendōji, true to his name, consumed vast quantities of *sake*. As the revelry reached its height, Yorimitsu brought out some of his own *sake* and offered it to the assembled company. It was a specially prepared brew which quickly put them all to sleep. At that point Yorimitsu and his men donned their armour and set about killing Shutendōji and putting his followers to flight. This final climactic scene is illustrated in the triptych by Yoshitsuya. As with many such prints the design is rather busy, with much emphasis on the detailed rendering of the warriors' armour and, in this case, the wildly flung hair of the ogre. In terms of sheer technical achievement the print is a *tour de force*, a point which is reflected in the inclusion in the central panel of the blockcutter's name. Prints of this kind have frequently been scorned for their vulgarity, and until recently have been treated with a rather dismissive attitude. There is no doubt, however, that their immense energy and often fantastical coloration is both exciting and unique, and that at their best they are no less creatively and imaginatively conceived than their earlier and traditionally praised counterparts.

The vertical triptych by Yoshitoshi (*148*) dates from the end of the historical period of Japanese woodblock print production. It illustrates a scene from the highly popular novel *Nansō Satomi Hakkenden* by Takizawa Bakin (1767–1848), which was published in no less than one hundred and six volumes between 1814 and 1841. The bulk of the novel revolves around the extraordinary adventures of eight brothers born, in a fashion typical of the work as a whole, of the daughter of a feudal lord and a dog. The fight on the roof of the Hōryūkaku was a favourite theme among artists and their public, and there is a famous triptych by Kuniyoshi dating from 1836–1837 on which Yoshitoshi clearly based his print. The Kuniyoshi triptych shows the whole length of the roof swarming on either side with Inukai Kempachi's men. Yoshitoshi has taken the right hand panel of Kuniyoshi's print and has elongated it with striking effect into vertical diptych format. He has further increased the dramatic content by ridding the picture of all other human figures and presenting the two main characters in direct conflict with each other. The print has a peculiarly remote and eerie quality typical of much of Yoshitoshi's late work. This results not only from the composition itself but from the extreme fineness of the block-cutting and from the almost excessively controlled printing. The startling red which dominates the image is an aniline-based dye of the type introduced from Europe in the 1860s and widely used thereafter. Although aniline colours resulted in images of sometimes shocking garishness, sensitive artists like Yoshitoshi exploited them to new and often quite remarkable effect. RF

147 (*previous pages*)
UTAGAWA YOSHITSUYA
(1822–1866)
Ōeyama Shutendōji, Minamoto Yorimitsu (Raikō), accompanied by his four retainers, slaying the giant ogre Shutendōji at his mountainous lair on Ōeyama
Signed *Ichieisai Yoshitsuya ga*
Published by Kiya Sōjirō
Publisher's seal
Engraver's seal *Horikane*
Censor's seal
Colour print from wood blocks
1858
Ōban triptych; 35.7 × 73.9 cm
E.14254-1886

148 (*opposite*)
TSUKIOKA YOSHITOSHI
(1839–1892)
Hōryūkaku ryōyū no ugoki, Inuzuka Shino Moritaka defending himself against Inukai Kempachi Nobumichi, the chief of police, on the roof of the Hōryūkaku, from an episode in the novel *Hakkenden* by Takizawa Bakin (1767–1848)
Signed *ōju Yoshitoshi sha*
Artist's seal *Taiso*
Published by Hasegawa Jūjirō
Colour print from wood blocks
1887
Vertical *ōban* diptych;
71.0 × 24.6 cm
E.1031-1914
Noguchi Gift

Lacquer for Export

THE eastward spread of Portuguese exploration reached Japan in the early 1540s. The Jesuit missionary St Francis Xavier (1506–1552) arrived in 1549 and by the end of the sixteenth century the Roman Catholic church could claim several hundred thousand Japanese converts. In the early years of the seventeenth century Japan also attracted the mercantile interest of the English and the Dutch. One result of the contact between Japan and Europe during this period was the development in lacquer of an international style. This style, called 'Southern Barbarian' (*Namban*) by the Japanese, has received enthusiastic attention in Japan during the last twenty-five years for its expression of the outward-looking and experimental spirit of Momoyama period culture.

There are two varieties of *Namban* lacquer: the decoration of one type, destined for the domestic market, features exotic subjects such as Portuguese figures dressed in enormous breeches and outsize hats. The other type, intended for Europe, incorporates elements from several cultures. There is internal evidence that many of the *Namban* pieces were produced in the same Kyoto workshops as the Kōdaiji wares (see p.52), since both make use of some innovative time-saving methods. The geometric borders and other motifs which decorate so much *Namban* lacquer may reflect the influence of inlaid caskets in the Indo-Portuguese style, itself drawing inspiration from contemporary Spanish furniture in the Hispano-Moresque *mudejar* manner, with its distinctive roundels of geometric ornament. The idea of shell inlay in black lacquer may have come from Korea or China. Contact with Korea, where a bold style of shell decoration was current, was renewed during the two attempted invasions by Toyotomi Hideyoshi (1536–1598) in 1592 and 1597–8, while Chinese shell-inlaid lacquers had been known in Japan for two centuries.

The forms of Namban lacquers are almost all western. The commonest secular types are the small secretaire fitted with drawers and a hinged or drop front, and the domed coffer. *Namban* export lacquer chests may have been in production as early as 1569. In that year the missionary Luis Frois, writing of his interview with Oda Nobunaga (1534–1582, see p.15), records that the great warlord had 'twelve or fifteen chests like those of Portugal'. They were certainly being made before 1596, when a Japanese lacquer cabinet which survives to this day was inventoried as being in the possession of the Archduke Ferdinand of the Tyrol.

The coffer reproduced here (*149*) is one of a very small group which is covered almost entirely in pieces of shell, with lacquered decoration confined to the borders and the gaps between the shell. Inside the lid is a design, in simplified *hiramaki-e* lacquer techniques, of phoenixes and vine tendrils; such designs are also found on the interiors of more conventional *Namban* lacquer coffers.

Until 1919 the coffer was at Rushbrooke Hall, the residence of Henry Jermyn, Lord St Albans (died 1684), a favourite of Charles I's widow Henrietta Maria. It is included in an inventory taken in 1759, when the Hall still contained the bulk

149
COFFER
Wood covered with plates of shell held by gilded copper rivets, and black and gold *hiramaki-e* lacquer
Gilt metal fittings
The interior of the lid decorated with phoenixes and tendrils
Late 16th or early 17th century
The stand English, 17th century
55 × 110 × 45 cm
FE.33-1983
Purchased with the assistance of the Garner Fund

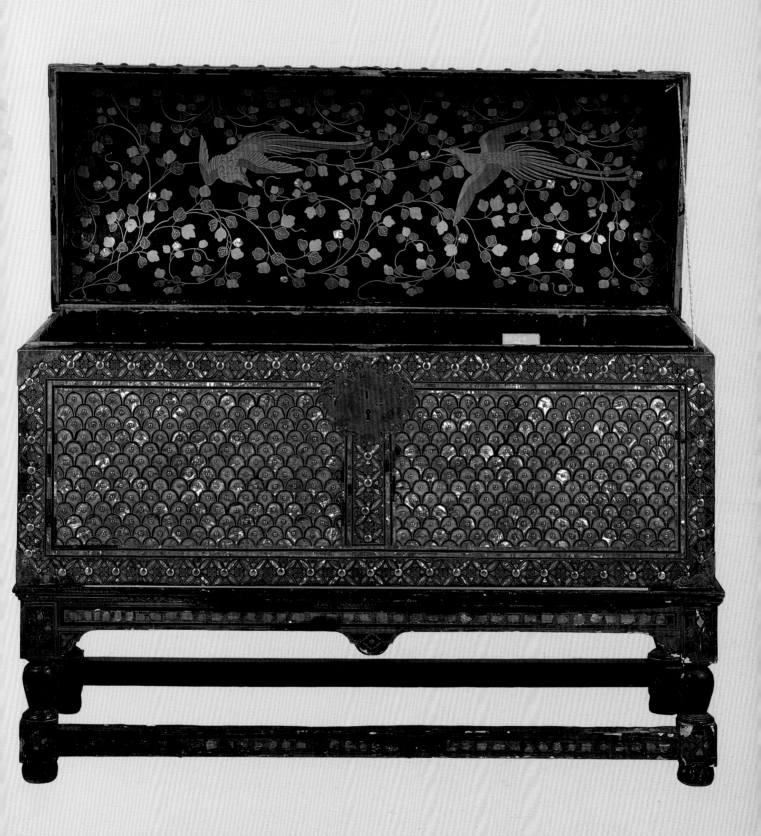

of Jermyn's collection. The Rushbrooke Hall furniture also included English pieces bearing Henrietta Maria's monogram, presumably gifts to Jermyn. Shell-decorated furniture was fashionable at the late sixteenth-century Parisian court and Henrietta Maria owned examples at the time of her death in 1669. It is perhaps not unreasonable, then, to speculate that this coffer may have been another gift from her to Jermyn.

Following the severe treatment of Christianity in the early seventeenth century, Portuguese influence in Japan waned. The more pragmatic Dutch came to dominate the European export trade, and in 1639 they became the only European nation permitted to maintain a trading post in Japan. A clear distinction can be drawn between the 'Iberian' and 'Northern' phases of the export lacquer style. The later, 'Northern', lacquers make progressively less use of shell inlay, relying instead on pictorial motifs in *maki-e*. There is a wider variety of forms, but the most typical are the chest with a flat lid (*152*) and the secretaire with two hinged doors (*154*), usually seen on a European-made stand.

Most of these lacquers made for foreigners were mass-produced and they are often of rather poor quality. There is, however, a small group of export lacquers, apparently made during the 1630s, which are conspicuous for their very high standard of craftsmanship and for their use of motifs drawn from the *Tale of Genji* (see below). Three of these are in the Museum. The earliest of the three is a casket (*150*) which retains some 'Iberian' elements, in particular the intricate strips of geometric and floral ornament at the base of both box and lid. These are reminiscent of the so-called *shima* ('striped') lacquers of the later Momoyama period, thought to derive their inspiration from imported textiles. Another backward-looking feature of this casket is its deliberately exotic combination of disparate materials and techniques: ivory columns with lacquer decoration, and carved and lacquered wood resembling ebony, brought together in the decoration of a form based on European caskets of the later sixteenth century.

More typical of the 'Northern' phase is the pictorial decoration on the interior of the lid. Although less directly based on the *Tale of Genji* than the export lacquers in the following plates, it includes the motif of baskets of stones used to reinforce the banks of rivers. These baskets are particularly associated with the Uji river, itself the setting for the last ten chapters of the *Tale*.

The Van Diemen box (*151*) stands out from other export lacquers of the period by virtue of its shape, which is Japanese rather than European. The *ryōshibako*, a rectangular box measuring about 45 by 30 centimetres and used to hold writing paper, is one of a number of practical new forms devised during the Momoyama period. The decoration of the lid departs from standard Japanese practice, however, in that its orientation is horizontal rather than vertical. Most of the surfaces are covered with scenes from the *Tale of Genji*. This eleventh-century literary masterpiece had enjoyed a revival of interest in the fifteenth century, and by the early Edo period a number of distinct traditions of Genji-painting were established. The lid of the Van Diemen box combines clearly identifiable scenes from two chapters of the *Tale*. In Chapter 1, the young Prince Genji's coming-of-age ceremony is described, and the depiction here, showing him about to mount the steps of a palace where the Emperor sits with his ministers, corresponds closely to the same scene in contemporary screen paintings. The two figures with swords standing near the steps are drawn from Chapter 7, where Genji and a

150

CASKET

Exterior panels of carved wood covered in black lacquer: river scene with cranes and a bridge; borders in gold and silver *hiramaki-e* lacquer with shell: geometric and floral ornament; gilt metal lockplate; ivory feet and ivory columns with gold and red *hiramaki-e* lacquer decoration of dragons
Interior of lid covered in black lacquer with gold and silver *hiramaki-e* and *takamaki-e* lacquer, and gold and silver details: moonlit landscape with pagoda, buildings and galleries; gold and silver *hiramaki-e* lacquer frame
Early 1630s
20.1 × 28.4 × 19.6 cm
628-1868

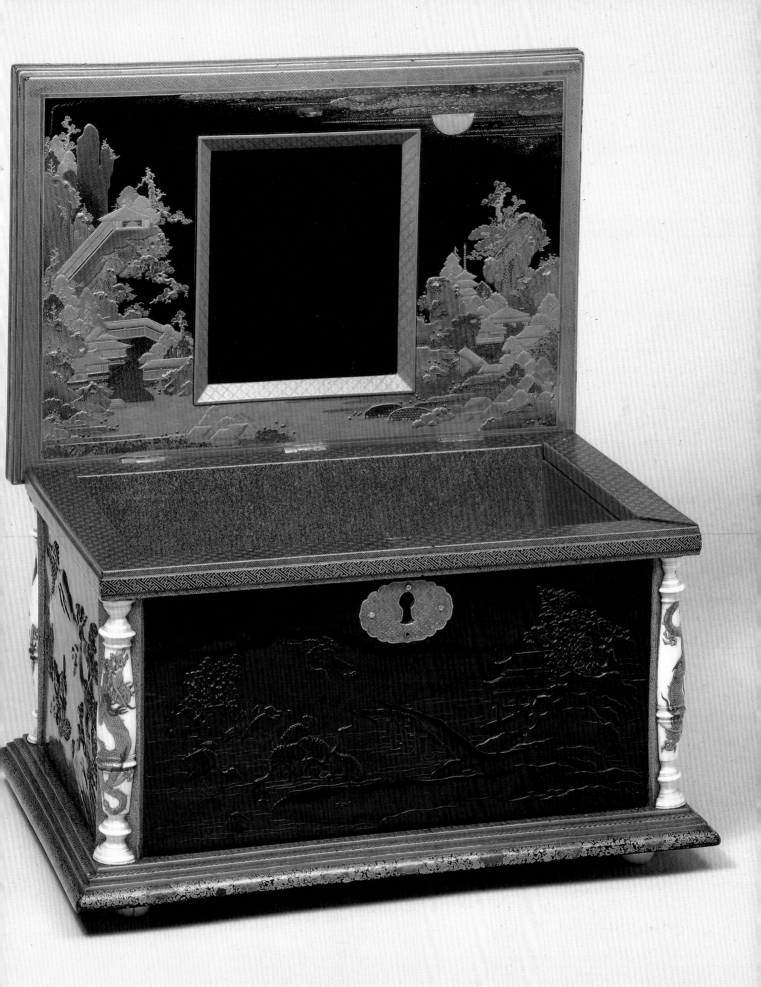

friend, Tō no Chūjō, perform a dance on the occasion of the Emperor's autumn maple-viewing expedition.

The scene is surrounded by a stylized floral border, a design concept which is not usually seen in lacquers intended for the domestic Japanese market but was second nature to the Chinese decorator of the Ming dynasty (1368–1644). It seems probable that this border, like the Chinese-style architecture on the right and the intrusion of geometric patterns into some of the buildings, reflects the Japanese lacquerer's desire to meet the wishes of a foreign client. Being unfamiliar with European decoration, he responded by producing a version of Ming Chinese lacquer, the alien style he knew best.

The back of the lid was inscribed at the time of manufacture with the name of Maria Van Diemen, the wife of Anton Van Diemen, Governor-General of the Dutch East Indies from 1636 to 1645. Another box in an English house, of the same shape, size and quality and also with Genji decoration, is inscribed with the name of the wife of Van Diemen's second-in-command. A combination of biographical details enables us to date both boxes to the period 1636–1639.

The Mazarin chest (152) is the largest of this group and combines themes from several chapters of *Genji* with a wealth of other pictorial allusions. On the front of the chest, Prince Genji, at the right, visits Suetsumuhana, a long-neglected love living in obscurity, accompanied by Koremitsu holding an umbrella. The two dragon- and phoenix-headed boats and the pavilion built out over the water belong to Chapter 24 where a boating expedition is organized by Genji. The ladies gathering flowers at the left of the design are drawn from a chapter which describes how, after a storm, the lady Akikonomu's servants are sent to put out insect cages and gather flowers. The insect cages are omitted, but the figures are very close in style to those on a painted screen devoted to this chapter in a Japanese collection. The bridge in the centre, with female figures at one end and male figures at the other, may allude in a general way to the courtship of the Eighth Prince's daughters by Princes Kaoru and Niou.

Most of these *Genji* export lacquers use figures to tell their story, unlike the subtly allusive pieces made for Japanese clients (34). The left-hand end of the Mazarin chest, however, is exceptional in relying solely on non-figural means. The chapter alluded to relates Genji's journey to the Sumiyoshi shrine. At the left we see the shrine buildings and the *torii*, a form of arch closely associated with the Shinto religion. The ox-cart, the elegant conveyance of eleventh-century courtiers, belongs to Genji. This design is more 'Japanese' in another respect: the plants in the foreground are carefully chosen for their close association with autumn, the season of the chapter.

The right-hand end shows a scene not from Genji but from the *Tale of the Soga* (see p.134), a Kamakura period romance telling of the revenge of the Soga brothers on their father's murderer. The final act of the *Tale* is preceded by a boar-hunt during which the brothers raid the murderer's tent. Again there are close parallels between the lacquer design and contemporary paintings of the episode.

In spite of overall similarities between the front of the chest and the two sides of the lid, the latter are not directly related to Genji painting. They present an extraordinarily rich fantasy which draws freely on the artistic traditions of both China and Japan. Within dragon and phoenix borders inspired by Ming lacquers, Heian period palace buildings are shown alongside Zen Buddhist monasteries

151

DOCUMENT BOX WITH SUSPENDED INNER TRAY, KNOWN AS THE VAN DIEMEN BOX

Wood, covered in black lacquer, with gold, silver and red *hiramaki-e* and *takamaki-e* lacquer, and gold and silver details
1636–1639
16.0 × 48.0 × 26.7 cm
W.49-1916
Given by the children of Sir Trevor Lawrence, Bart.

Exterior of lid, showing scenes from Chapters 1 and 7 of the Tale of Genji
Interior of lid, inscribed in gold foil with the name of Maria Van Diemen

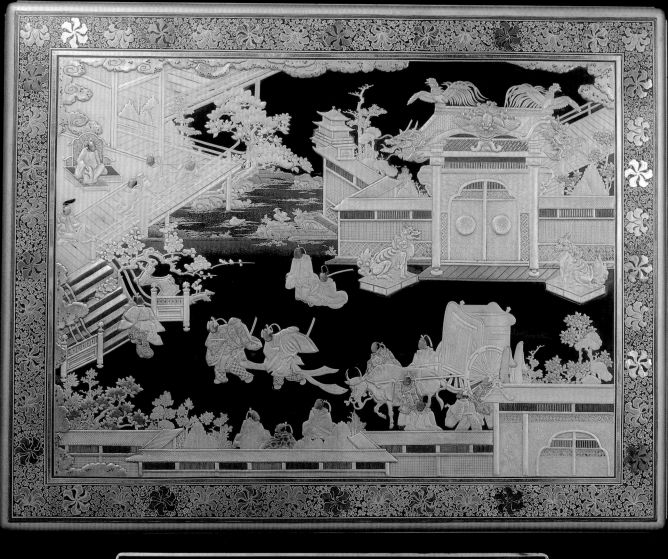

MARIA.UAN.DIEMEN

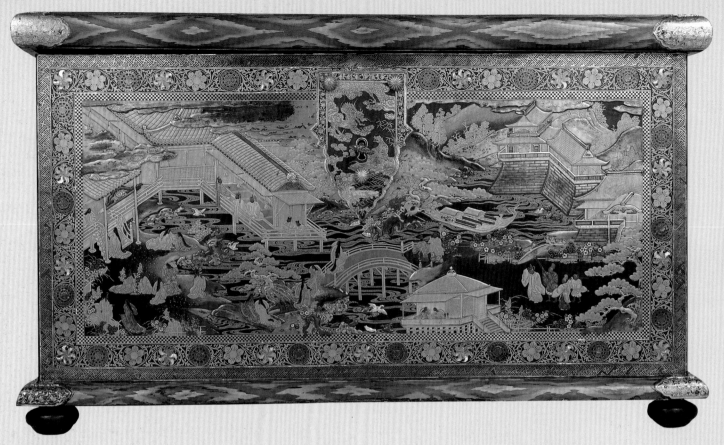

152

Chest with hinged lid, known as the Mazarin chest

Wood, covered in black lacquer with gold and silver *hiramaki-e* and *takamaki-e* lacquer; details in gold, silver, and *shibuichi*; border inlaid with shell; gilded *shakudō* fittings; French steel key

c. 1640

56.5 × 100.3 × 63.5 cm

412-1882

Front, with various scenes from the Tale of Genji

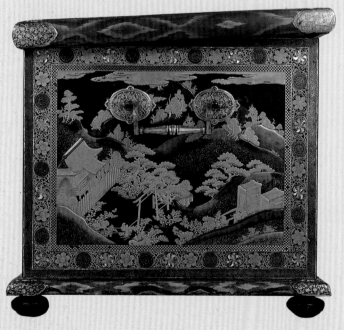

Left hand side, with a scene from Chapter 14 of the Tale of Genji

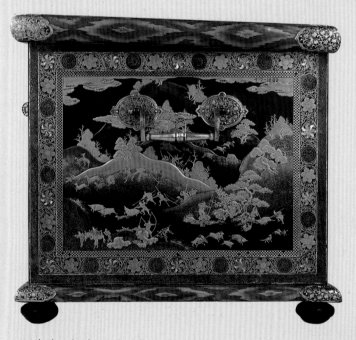

Right hand side, with a scene from the Tale of the Soga Brothers

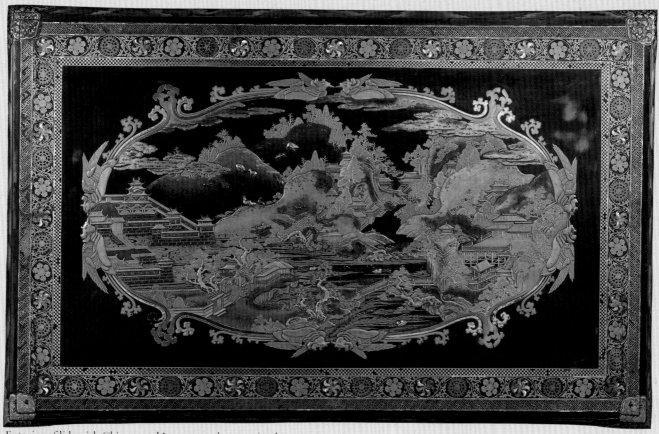

Exterior of lid, with Chinese and Japanese palaces; animals
applied in gold and *shibuichi*

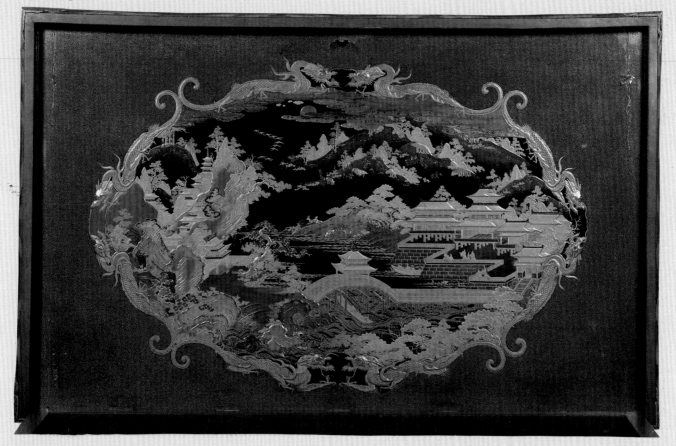

Interior of lid, with palaces and forests by a lake; animals
applied in gold and *shibuichi*

from Muromachi period ink paintings and castle architecture of the early seventeenth century, while sinuous waves in Rimpa style (see p.57) break on shores executed in the most conservative *takamaki-e*. The lacquerer's awareness of his client's ignorance allowed him a latitude which he could never enjoy when working on conventional commissions.

Both sides of the lid are decorated with small animals applied in *shibuichi* alloy and gold. These give us a valuable clue to the Mazarin chest's possible place of manufacture. Its scale and quality make it likely that it was made in one of the foremost lacquer workshops of the day, and it is significant that the *Hatsune no chōdo*, a set of wedding furniture made for the Owari province branch of the Tokugawa family in 1637–1639, is embellished with very similar metal animals. The set was made in the workshop of Nagashige (1599–1651), head of the Kōami family who had been famous lacquerers since the fifteenth century, and the metal animals are traditionally ascribed to Kenjō (1586–1663), seventh master of the Gotō family (see p.132). Considered alongside the clear evidence in the chest's decoration of influence from the Kanō school of painters, who are known to have been important in Nagashige's work, the metal animals offer grounds for an attribution of the chest to the workshops of some of the most distinguished craftsmen of the early seventeenth century.

The French key carries the arms of the Mazarin-La Meilleraye family, but it is not clear when the chest came into their possession. Both the Mazarin chest and the Van Diemen box were acquired in France by William Beckford (1760–1844), the author of *Vathek*. Aside from his fame as a Gothic novelist, he may be accounted the greatest ever non-Japanese collector of Japanese lacquer.

After 1693, no lacquerwork is included in the lists of Japanese goods sold by the Dutch East India Company in the Netherlands. Although a few pieces continued to reach Europe by means of private trade, at the beginning of the eighteenth century most Far Eastern lacquer imported into Europe was Chinese rather than Japanese. In the last quarter of the century, however, new kinds of objects began to be ordered and made. The best known of these are the small portrait plaques copied from European books, of which an example is reproduced above (*153*). The Japanese lacquerer has faithfully copied the stippling on the original engraving, based on a portrait by Sir Godfrey Kneller (1646–1723).

Also in the later eighteenth century there developed a style of export lacquer furniture decorated with extremely thin pieces of pearl shell selected for their striking coloration (*154*). This could be enhanced by painting the back of the shell before it was inlaid. The designs usually incorporate Chinese elements, in this case bird and flower designs and key-fret borders. Such furniture is often seen in English country houses.

This cabinet was said by the donor to have been brought back from the Far East by George Burn, an officer in the Royal Navy. Burn's life is well documented in naval records and he is not definitely known to have been in the Far East until 1856. It is probable that the cabinet is two or three decades earlier. If so, it must have been bought second-hand; alternatively, it may have belonged to Burn's father John, who was in the Canton area of China in 1802. The quality of its workmanship is not high and it has required extensive conservation; it is nevertheless another magnificent instance of the Japanese lacquerer's response to his estimation of foreign taste. JE

153

PLAQUE

Metal, covered in black lacquer with gold *hiramaki-e* lacquer decoration and gold details
Portrait of John Locke, after Dreux du Radier, *L'Europe illustré*, Paris, 1777
The reverse inscribed *Philosophe: ne en 1632, mort en 1704*
Last quarter of the 18th century
12.2 × 9.3 cm
FE.29-1985

154

CABINET

Wood, covered in black lacquer with coloured shell inlay; tinned copper mounts
Birds and flowers
Probably *c.* 1800–1830
54.4 × 60.0 × 33.1 cm
W.11-1936
Adderley Gift

Folk Craft

THE notion of 'folk craft' is a phenomenon of modern urban societies where stabilising links with past community life are sought. Often it results in the attachment of a high degree of value to traditionally manufactured objects which in their original context were appreciated primarily for their practical functions. Folk crafts were first discussed in Japan by Yanagi Sōetsu (1889–1961), the founder of the *Mingei* or Japanese Folk Craft movement, during the 1920s. Yanagi's thought combines two main elements. One derives from the social and moral concerns expressed in the writings of William Morris and other thinkers whose views contributed to the British Arts and Crafts movement of the late nineteenth century. The other, an essentially mystical attitude towards perception and aesthetic appraisal, derives from Yanagi's experience of various forms of oriental philosophy. Like its British counterpart, the Mingei movement evolved in reaction to the problems of rapid industrialisation. In the years after the Second World War it also became a means towards the preservation of a sense of national identity in the face of intense americanisation, a high-point of interest being reached in the middle to late 1950s. Since then support for the movement has gradually declined. Objections have been expressed not only by its critics but also by many of its erstwhile followers on the grounds that its ideals are impossible to maintain under the complex conditions of modern living.

Regardless of the validity of the views put forward by Yanagi and his successors, the existence of folk craft as a discrete and identifiable entity within Japanese culture is now widely accepted in both Japan and the West. Generally speaking, the types of artefact taken up by folk craft devotees are rural products of a practical nature intended for use by the common people. The qualities of beauty found in these objects are idealistically seen to derive from their having been made by craftsmen working close to nature, using simple techniques and traditional styles, and living within a small and harmonious community without concern for capitalistic gain and the assertion of individuality. In this respect folk crafts can be distinguished both from mass-produced objects and from those produced essentially to elitist taste. In the case of the former, the maker is felt to be too far removed from the process to contribute to the 'inner' quality of the product. Elite crafts, on the other hand, are valued for their decorative rather than their functional characteristics, or for the way they reflect the self-consciously directed creativity of their maker. The objects reproduced in this section have been grouped together on the basis that they all have the anonymous and rustic qualities which distinguish them from other artefacts produced at the same period and treated elsewhere in the book. The pots reproduced on these pages (*155–158*) have been chosen from a small selection of folk ceramics recently brought together by the Museum. Except for the striped green and white jar they all come from the Tōhoku region in the northeastern part of the main island of Honshu, historically one of the most remote areas of Japan. It is only recently, in fact, that adequate

155
JAR
Stoneware with bluish-white and olive brown glazes
Yamanokami ware
19th century
Height 61.8 cm
FE.15-1985

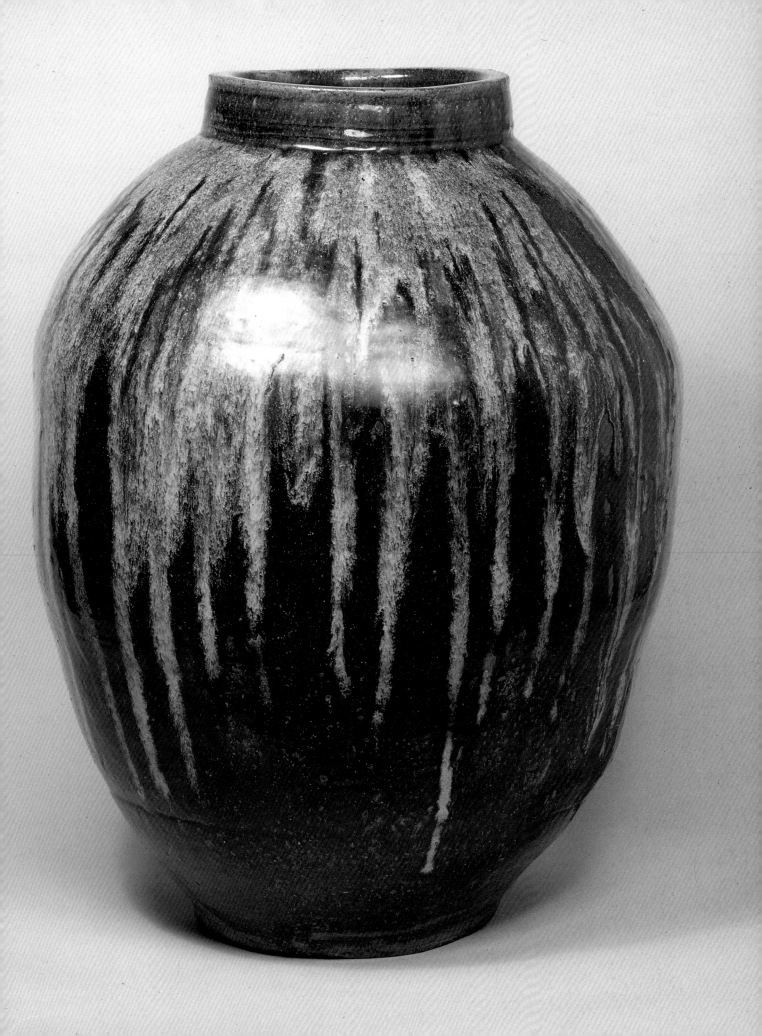

transport facilities have made the area properly accessible. The relative isolation of the Tōhoku has been an attraction to folk craft enthusiasts, and it is still possible to find traditional practices which have survived relatively unaffected by modernising influences. The kilns where the three pots were made were all founded in the early nineteenth century at the start of a general boom in ceramic production which took place throughout the country and particularly in the provinces. In contrast to these three pieces, the striped green and white jar (*158*) was made at Shigaraki in the central part of Japan, not far from Kyoto. The Shigaraki kilns had a long history dating back to the mediaeval period (see p.36), and from the seventeenth century onwards had been actively engaged in producing functional glazed pottery. The formula seen on the two wide-mouthed jars of applying light glaze over dark was frequently employed on nineteenth- and early twentieth-century country pots as an irregular though pleasingly spontaneous form of decoration. The white and green combination on the Shigaraki jar is also widely found. It is thought that the technique was introduced in the late eighteenth century from Seto. The spread of technology from one area to another was a particularly distinctive feature of the early to middle nineteenth century, and gave rise to a situation in which ceramics of closely similar types were made all over the country. This is one of the reasons why the identification of place of manufacture of many nineteenth-century ceramics is so difficult. The blue and white bottle from Kirigome could easily be confused, for example, with wares from many of the other regional porcelain kilns newly founded on the basis of technology learnt from large and established manufacturing centres like Kyoto, Arita and Seto.

156 (*left*)
JAR
Stoneware with brown and white glazes
Tsutsumi ware
19th century
Height 24.4 cm
FE.7-1985

157 (*centre*)
BOTTLE
Porcelain with underglaze blue decoration
Vine leaves
Kirigome ware
19th century
Height 28.0 cm
FE.17-1985

158 (*right*)
JAR WITH TAPHOLE
Stoneware with green and white glazes over shallow fluting
Shigaraki ware
19th century
Height 40.8 cm
FE.10-1985

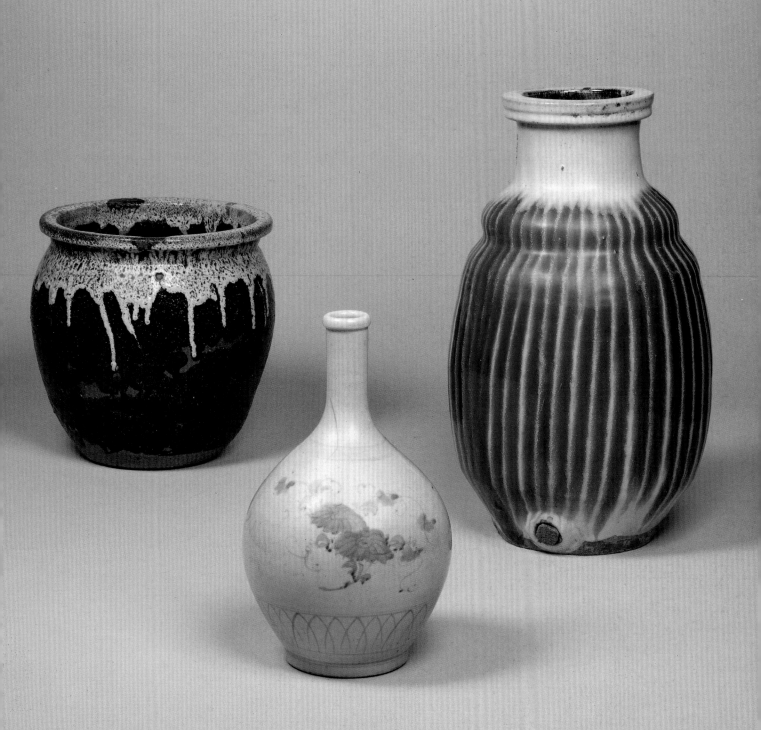

The merchant's chest reproduced opposite (*159*) belongs to another category of artefact falling under the general heading of folk craft. It is thought to come from Kanazawa, an important provincial town on the Japan Sea coast and one of numerous regional centres of storage chest (*tansu*) production which flourished during the latter part of the nineteenth and the beginning of the twentieth century. It has a combination of different sized drawers, two sections with sliding doors, and in the bottom right hand corner a lockable compartment containing several small drawers. Chests of this configuration were generally used by merchants to hold sales ledgers and other equipment necessary for the day to day running of a shop. The chest is constructed of deal and zelkova wood. The zelkova for the fronts of the panels and doors was selected with particular attention to its grain, while an overall coating of clear lacquer has brought out the natural qualities of the material and has given the chest a uniform reddish brown tone. The rather simple treatment of the metal fittings gives the piece its final characteristic look. RF

159
MERCHANT'S SHOP
CHEST (*chōba-dansu*)
Zelkova and deal with clear lacquer finish, iron fittings and copper alloy door-pulls
Probably from Kanazawa
Late 19th century
122 × 97 × 46 cm
FE.7-1986

Baskets of split and woven bamboo, essentially practical items used from early times for the transport or storage of foodstuffs and other materials, became from the Muromachi period closely associated with the display of flowers for the tea ceremony and in other contexts. The closeness to the natural state of the woven bamboo strips and the visual immediacy of the process of making fitted in well with the tea aesthetic. The involvement of sophisticated urban consumers with the anonymous craft producers of rural Japan was under way well before the conscious formation in the 1920s of thinking about 'folk craft', an aesthetic in which baskets continue to hold a prominent place.

These baskets (*160–162*) form part of a large group purchased for the Museum in 1886 and 1888 in Arima, a hot spring resort situated a short distance to the north of Kobe city, from 1868 one of the first centres in Japan to have a resident foreign population. Famous as a basket making centre since at least the eighteenth century, Arima was able to build on a long history as a scenic spot patronised by the court in Kyoto to develop a tourist industry which has flourished to the present day.

In contrast to China, where a craft of bamboo carving performed by named artisans developed, in Japan the weaving of flower baskets grew directly out of the manufacture of less ambitious pieces for daily use. Flower baskets such as these were designed to stand, or in many cases to hang, in the *tokonoma* alcove (see p.42) of a tea room or reception room and were used in conjunction with an internal watertight container made from a section of bamboo. Their shapes continued to allude to their humble origins. In many cases they are miniature versions of coarser items employed in farming or fishing. CC

160 (*top*)
HANGING FLOWER-BASKET
Split and woven bamboo
In the form of a basket for carrying fish
Purchased at Arima
1880s
Height 26 cm
87-1886

161 (*bottom left*)
HANGING FLOWER-BASKET
Open weave bamboo
Purchased at Arima
1880s
Height 25.8 cm
691-1888

162 (*bottom right*)
FLOWER-BASKET
Split, woven and lacquered bamboo
Purchased at Arima
1880s
Height 17.5 cm
66-1886

From its inception the folk craft ideology of Japan has embraced the concept of technical simplicity. In the case of textiles, however, while tools might be rudimentary the methods of patterning employed could be complex and time-consuming. The folk textiles reproduced on the following pages (*163–168*) belong to a significant group which is woven with pre-dyed and patterned yarn, a process commonly known by its Indonesian name of *ikat* but called *kasuri* in Japan. This involves completion of the resist-dyeing before the actual weaving takes place. Bundles of accurately measured natural-coloured yarn are bound at certain points so tightly as to resist the colour when the skein is immersed in the dye bath. When dry, the bindings are released to leave areas of white against a coloured ground. The prepared pattern-making yarns, possessing a parti-coloured beauty in their own right, serve as both warp (longitudinal threads) and weft (transverse threads). The design then emerges as weaving proceeds. Fabrics so patterned are made into garments and household furnishings, notably covers for quilts. Covers like the one reproduced (*168*) were used to cover both the under-*futon*, the padded sleeping mat, and the over-*futon*, which served as a blanket. Cotton, a sixteenth-century introduction into Japan, is mostly used for quilts, but several linen-like native fibres as well as cotton are used for clothing. Despite their rustic origins, *kasuri*-dyed garments gained wide popularity among fashionably dressed towns-people.

FOUR TEXTILE LENGTHS PATTERNED BY SELEC-TIVELY RESIST-DYEING THE YARNS BEFORE WEAVING (*kasuri*)

163 (*top left*)
Hemp
Carp among waves
Fukuoka prefecture
Late 19th century
Width 33 cm
T.99-1957

164 (*top right*)
Cotton
Tiger, bamboo and birds
Tottori prefecture
Late 19th century
63 × 31 cm
T.101-1957

165 (*bottom left*)
Cotton
Three-comma motifs and characters meaning 'longevity'
Tottori prefecture
Late 19th century
72 × 33 cm
T.127-1968

166 (*bottom right*)
Cotton
Tiger and bamboos
Fukuoka prefecture
Late 19th century
112 × 33 cm
T.128-1968

167 *(above)*

KIMONO

Hemp patterned by selectively
resist-dyeing the yarns before
weaving *(kasuri)*
Chrysanthemums and geometric
shapes
Niigata prefecture
19th century
142 × 127 cm
T.329-1960

168 *(right)*

QUILT COVER

Cotton patterned by selectively
resist-dyeing the yarns before
weaving *(kasuri)*
Repeating design of an immortal
riding a carp
Fukuoka prefecture
19th century
170 × 136 cm
T.325-1960

Other folk textiles represented in the Museum's collection received their design after the cloth was woven. The chrysanthemum quilt cover (169) was patterned by the cone-drawing resist technique. First the flowers and waves were drawn freehand onto the cotton. Next a glutinous paste contained in a paper cone like an icing bag was squeezed out along the lines of the pattern. A spatula was probably used to spread the paste over the large areas. When the paste hardened, the entire surface of the cloth was brushed with soya bean broth to ensure the fixing of both paste and dye. Repeated dipping in the dye bath achieved the desired depth of colour. The light blue areas received a second paste application at an early stage of dyeing, and some of the flower petals and centres may have been painted directly with a brush. The door-curtain's (170) resist-dyed central crest and surname prominently advertise the shop where it was hung. It is made from three lengths of cloth, each the width of the bolt as it came off the loom, and these are joined only at the top, so allowing passage through the doorway.

Few folk textiles are enriched with needlework but plain fabrics were sometimes quilted both as a practical expedient and as a decorative feature (171–173). In the course of fighting a fire the fireman who wore the coat and hood reproduced here (171) would have belted the coat and closed the hood flaps. He would then have been hosed down with water to protect him from the flames.

Another method of patterning textiles, commonly used in Japan, was that of applying resist paste through the cut-out parts of strong paper stencils. The areas not covered by the paste could be coloured by brushing or by immersion in dye. When the paste was washed away the resulting design was sharply defined, in contrast to the more blurred effects obtained by some of the other techniques. Elaborate use of stencils is found on Okinawa, the largest island in the Ryukyu chain to the south of Japan. Today, these Pacific islands are part of Japan, but from the seventeenth to the nineteenth centuries they formed a separate kingdom paying tribute both to China and to the Satsuma fief in southern Kyushu. Their distinctive artistic traditions were thus open to influences from China and southeast Asia as well as Japan.

169
QUILT COVER
Cotton dyed in cone-drawing resist technique
Chrysanthemums, foaming waves and four crests
Fukuoka prefecture
19th century
160 × 124 cm
T.331-1960

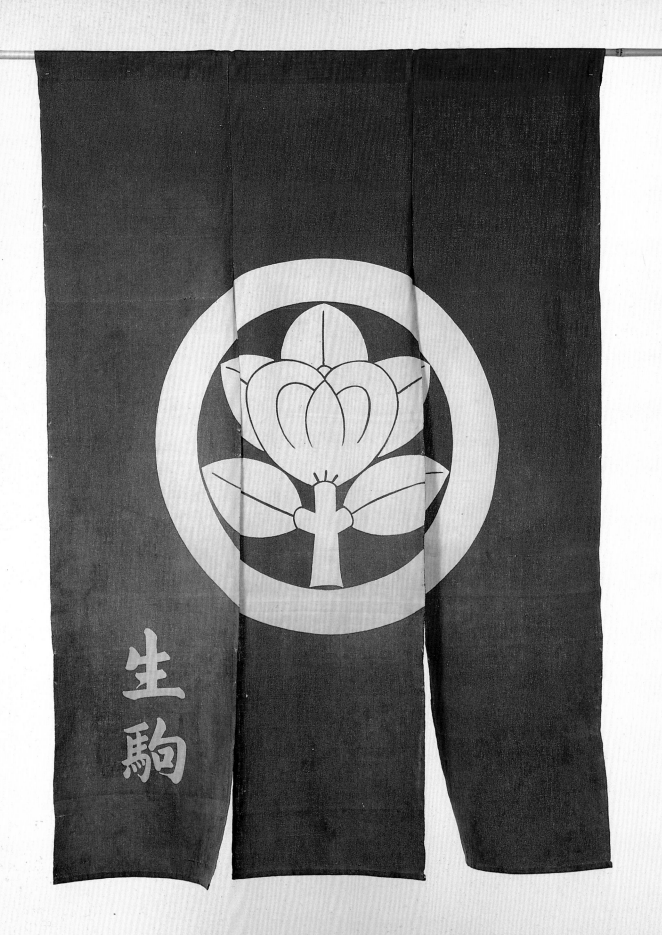

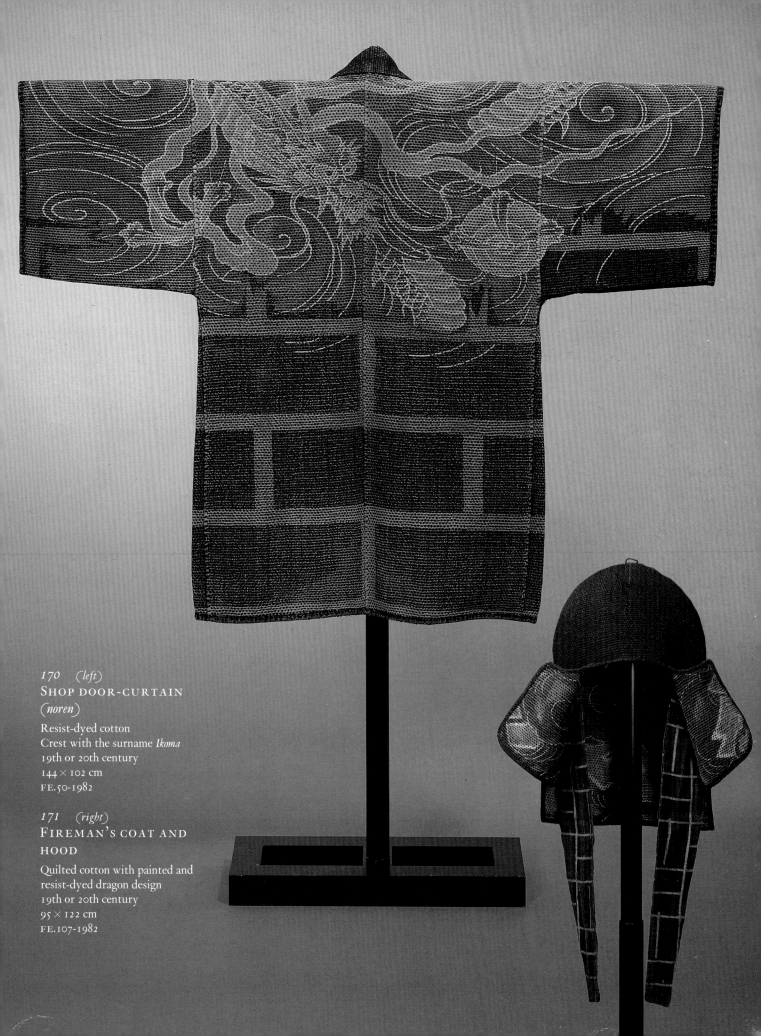

170 (*left*)
SHOP DOOR-CURTAIN
(*noren*)

Resist-dyed cotton
Crest with the surname *Ikoma*
19th or 20th century
144 × 102 cm
FE.50-1982

171 (*right*)
FIREMAN'S COAT AND
HOOD

Quilted cotton with painted and
resist-dyed dragon design
19th or 20th century
95 × 122 cm
FE.107-1982

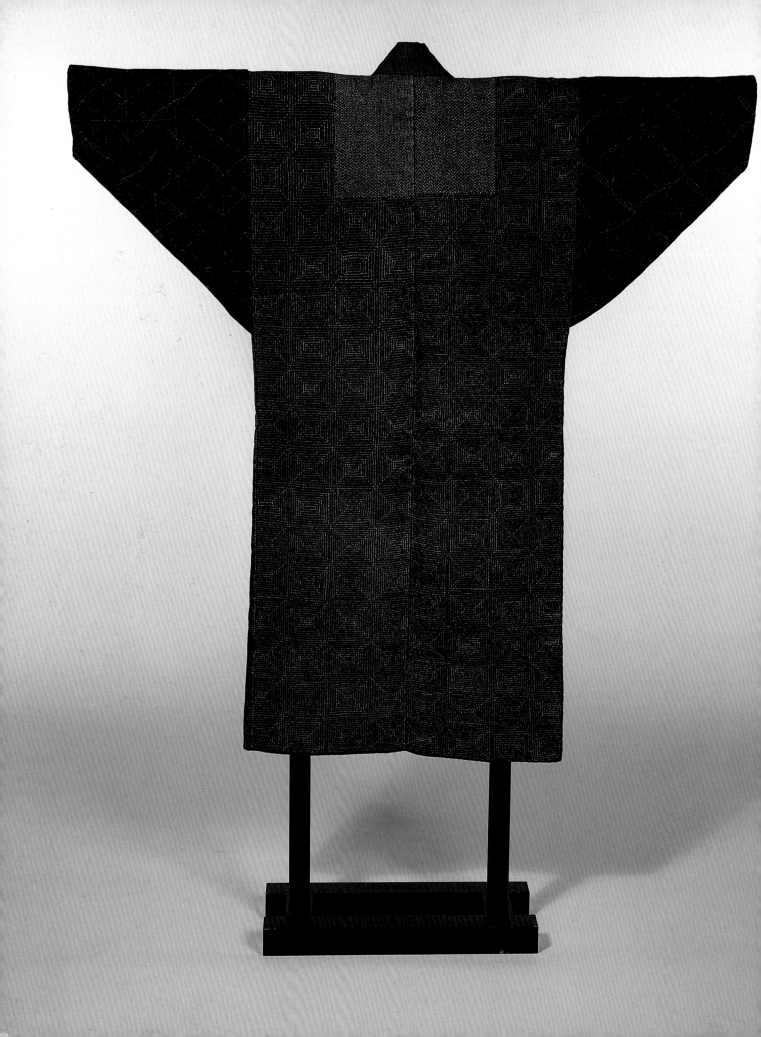

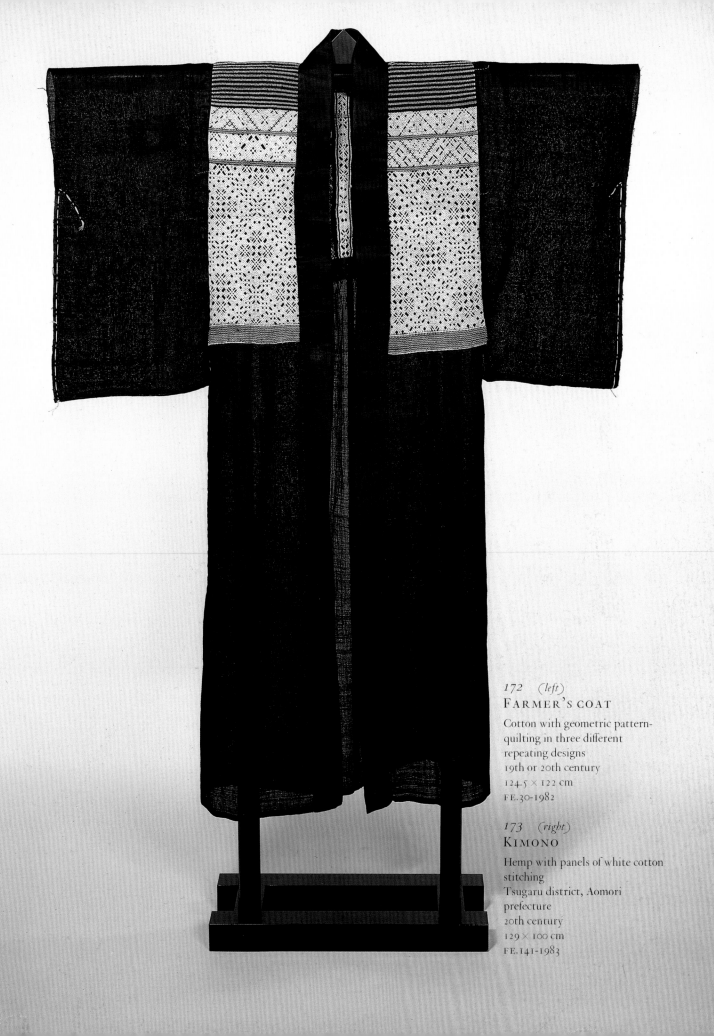

172 *(left)*
FARMER'S COAT
Cotton with geometric pattern-
quilting in three different
repeating designs
19th or 20th century
124.5 × 122 cm
FE.30-1982

173 *(right)*
KIMONO
Hemp with panels of white cotton
stitching
Tsugaru district, Aomori
prefecture
20th century
129 × 100 cm
FE.141-1983

The child's *kimono* on the right (*174*) is a product of this little-known country and shows the rich variety of colours and shades characteristic of Ryukyuan dyework. The name for both the technique and the finished textiles is *bingata*, a reference to the red colour. *Bingata* may prove to be a link between the painted and mordant-dyed cottons of India and the dyed silks of Japan proper. In the seventeenth and eighteenth centuries these Indian cottons travelled not only westwards to Europe where they were known as chintz, but also to southeast Asia, the Ryukyu Islands and subsequently Japan; in each country they exerted an influence on native textile technologies. Stencils for *bingata* may be classified according to the size of their patterns. Those designs which extend over an entire garment without a repeat require large differently cut stencils for each segment of the composition. With smaller designs the stencils can be used repetitively until the cloth is suitably covered. The Museum's example has such a repeat pattern, and because the tailoring method involved using one length of cloth extending from front to back with no shoulder seams, the stencil was turned at the shoulder to ensure that the motifs always appeared the right way up. The white ground and lines on this *kimono* represent the cut-away parts of the stencil which received the resisting paste. If both the figure and the ground were to be coloured the whole process would be repeated in reverse, with the dyed patterns being covered with paste while the ground was subjected to the dye bath or brush. Where the units of the design were smaller than on the example illustrated and were spread evenly over the surface of the cloth – the Museum has several such pieces – it was usual to stencil the resist, then paint the pattern and the ground in a single process. VW

174
KIMONO FOR A CHILD
Cotton patterned by resist-stencilling (*bingata*)
Water plants and ducks beside a stream
Shuri, Okinawa, Ryukyu Islands
18th or 19th century
93 × 79 cm
T.19-1963

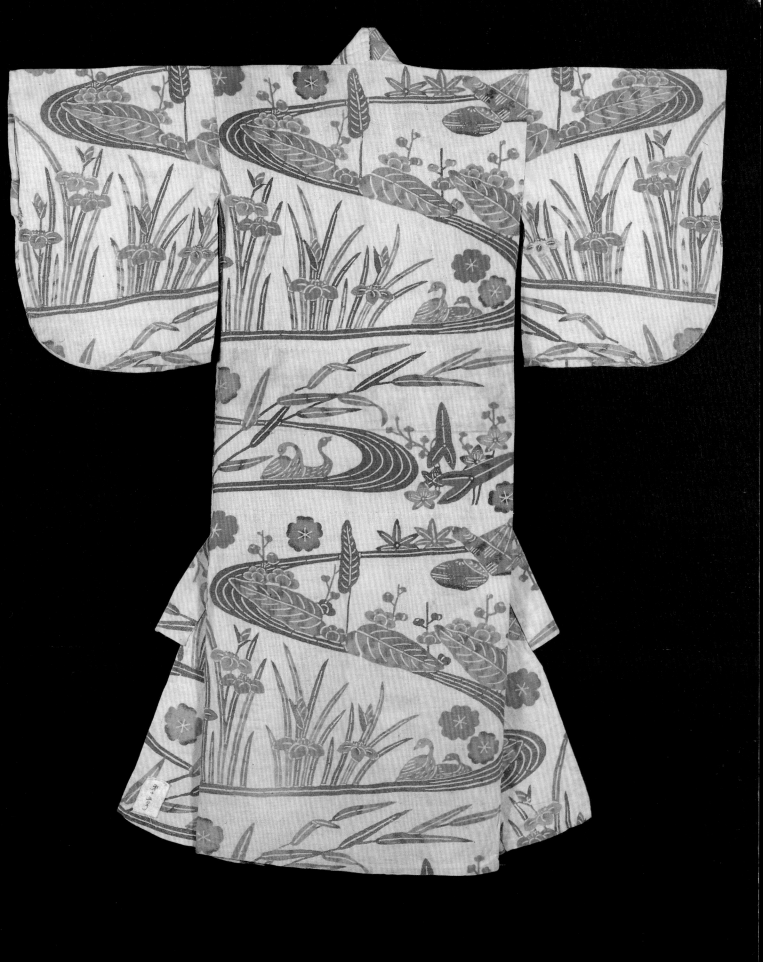

The Meiji Period

DURING the early to middle nineteenth century a rapid spread of technology from established manufacturing centres gave rise to a proliferation of new kilns around the country and stimulated a nationwide expansion in ceramic production. This was part of a general growth in commercial and economic activity which took place during the last decades of the Edo period. These developments occurred in spite of inconsistent and discouraging policies adopted by the Tokugawa government, which contributed indirectly to its final downfall in 1868. The Meiji Restoration set the stage for further growth, generated by increasing domestic demand as well as by efforts on the part of the new government to build the country into an industrial power of international standing. The Meiji period saw not only the active production of ceramics for domestic consumption but the rise of many new factories producing a wide variety of wares for export to foreign countries. Japan's zest for competition with the industrialised nations of the West can be gauged from the decision, taken as early as 1870, to employ the German chemist Gottfried Wagner (1831–1892, see also p.200) to introduce European ceramic techniques at the large porcelain manufacturing centre of Arita. The government's ambitious attitude is also reflected in the encouragement given to workshops and factories to submit work to the great international exhibitions taking place in Europe and America at the time.

The large jar (175) was probably new when it was purchased by the Museum in 1879. Its technical brilliance and decorative extravagance are equalled only by its vulgarity, and one is made to wonder whether a degree of jibing humour was not involved in such overt catering to Victorian taste. The early Meiji period was one of immense adulation of the West, however, and one when the Japanese rejected many aspects of their traditional culture in favour of what was foreign and in their eyes superior. It may be, then, that wares like this jar were as much admired in Japan as they were in Europe. It is interesting in this respect to compare the different prices paid for a group of ceramics collected under the auspices of the Japanese Government with funds from the South Kensington Museum (the former name of the V&A) and exhibited at the 1876 Philadelphia Exhibition before coming to London. The selection of two hundred and sixteen pieces, which was rather grandly intended to represent the full range of Japanese ceramics from historical to modern times, contained both antique and contemporary wares. One pattern to emerge is that contemporary pieces generally fetched much higher prices than antiques. The second is that delicate and highly decorated ceramics were much more expensive than what must have been viewed as crude and unrefined pieces of stoneware. From the standpoint of values prevailing a little over a hundred years later, it is staggering to find that the Satsuma incense burner (178) was bought for nearly eight times as much as the Raku teabowl by Kōetsu (19), and over twenty times as much as the Bizen fresh-water jar (22). No

175 (*opposite*)
JAR
Earthenware with crackled cream glaze, overglaze enamel and gilt decoration, and high relief model of a hawk on a flowering bough
Possibly Yokohama, Miyagawa Kōzan workshop
1870s
Height 58.4 cm
308-1879

176 (*overleaf left*)
TIERED FOOD BOX
Porcelain with underglaze blue decoration
Auspicious plants and creatures
Seto ware
c. 1860
Height 37.5 cm
307-1865
Given by Queen Victoria

177 (*overleaf right*)
VASE WITH TRUMPET-SHAPED MOUTH
Porcelain with decoration in underglaze blue and low relief design of a coiling dragon
Hirado ware
c. 1860–1880
Height 37.2 cm
FE.19-1985

matter how we judge such enamelled pieces today, however, it is easy to understand why they were so sought after in the West during the late nineteenth and early twentieth centuries. The exquisitely painted detail and lavish coloration of the vase and bowl (*179–180*) show that by the beginning of the twentieth century the already considerable virtuosity seen in earlier works had been raised to a level of almost unbelievable perfection.

The tiered box (*176*) was originally presented to Queen Victoria by the fourteenth shogun, Tokugawa Iemochi (reigned 1858–1866, see also *104*), and entered the Museum in 1865 as part of a large group of mainly modern artefacts which constitutes a useful document about the state of Japanese manufacturing immediately prior to the Meiji Restoration. It is notable that not only the tiered box but all the other twenty-one pieces of ceramics included in the gift were examples of blue and white porcelain. At this date Seto was a large manufacturing centre catering very much to plebeian taste. It is not surprising, therefore, to find that the box is a genuinely native product. It is in a traditional shape and painted with motifs which, although immediately recognisable to any Japanese, would have been totally lost on the British of that time.

The rather crude, if naively charming, qualities of the Seto box contrast strikingly with the formality of the Hirado vase (*177*). The shape is rigorously conceived, the relief design masterfully executed, and the painting both delicate and careful. The vase was made a few miles from the large porcelain centre of Arita at the village of Mikawachi where a small group of kilns had developed in the mid-eighteenth century under the direct patronage of the Matsuura daimyo family, rulers over the local Hirado fief. It was through the requirements of making high quality porcelain for the military elite that the Hirado potters initially developed their skills, and a peak of sophistication was reached with the manufacture of highly ornate presentation pieces in the 1830s. The commercial possibilities of Hirado porcelain were first realised during the last decades of the Edo period, and were fully exploited under the more opportunistic conditions of the Meiji period.

The vase and bowl (*181, 182*) were both made by Miyagawa Kōzan, one of the more remarkable figures in Meiji period ceramic history. He was born in Kyoto in 1842 and succeeded to the headship of his family in 1860. Twelve years later, in 1872, he was invited to set up a factory near Yokohama. The products of this factory, known as Makuzu or Ōta wares, were aimed at the burgeoning export market. At first, clay was especially imported to make accurate imitations of Satsuma wares, and it is possible that the large jar (*175*) is an early example of this kind. The factory subsequently began to make porcelain as well. In his later years Kōzan handed over the running of the business to his son, and until his death in 1916 experimented as a kind of studio potter in a wide variety of styles. Both of these pieces date from his final period and demonstrate the immense virtuosity and also playfulness for which he was so well known. R F

178 (*left*)

INCENSE BURNER WITH COVER IN THE SHAPE OF A LION-DOG

Earthenware with crackled cream glaze and decoration in overglaze enamels and gilt
Satsuma ware
Mid-19th century
Height 19.7 cm
292-1877

179 (*right*)

VASE

Earthenware with crackled cream glaze, overglaze enamels and gilt
Landscape decoration
Marks *Yabu Meizan* in gilt and *Meizan* as impressed seal on base
Osaka, Yabu Meizan workshop
c. 1900–1910
Height 15.2 cm
C.225-1910
Dingwall Gift

180 (*centre*)

BOWL

Earthenware with crackled cream glaze and decoration of floral bands in overglaze enamels and gilt
Mark *Seifūzan* on base in gilt
Kyoto, Seifū workshop
Late 19th century
Diameter 10.8 cm
C.1248-1917
Florence Bequest

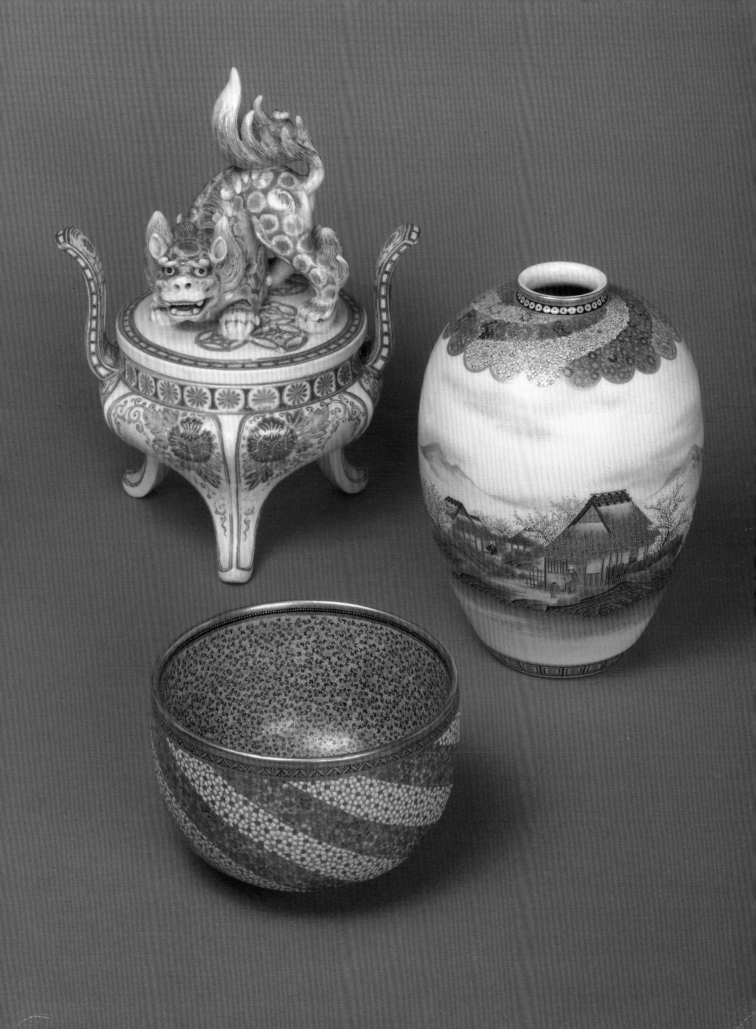

181 *(left)*
VASE IN THE FORM OF TWO POLAR BEARS INSIDE AN ICY CAVE

Porcelain with decoration in
underglaze turquoise and brown
Mark *Makuzu* impressed on base
By Miyagawa Kōzan (1842–1916)
c. 1900–1910
Height 22.2 cm
C.244-1910
Dingwall Gift

182 *(below)*
BOWL

Porcelain with decoration in
underglaze blue and black
Flying cranes
Mark *Makuzu Kōzan sei* on base in
underglaze blue
By Miyagawa Kōzan (1842–1916)
c. 1900–1910
Diameter 31.1 cm
C.250-1910
Dingwall Gift

Like the ceramic industry, textile manufacturing underwent rapid changes at the beginning of the Meiji period. After an initial decline, the important Nishijin weaving district of Kyoto revived thanks to modern production techniques introduced by the energetic governor of the city, Makimura Masanao (1834–1896). It was Makimura who welcomed Christopher Dresser (1834–1904, see also p.88) to Kyoto in 1876, arranging for him an exhibition of Kyoto products in the House of Commerce. This was to enable Dresser, as an official representative of the South Kensington Museum, to achieve the two-fold purpose of giving information about European taste in order to promote Anglo-Japanese trade and advising on new industrial developments. Prior to this visit, Nishijin craftsmen had been sent to the great silk-weaving centre of Lyon and had returned in 1871 with modern equipment, notably the semi-automated Jacquard loom. They also attended the Vienna World Exhibition in 1873 and remained in Europe for another two years to further their knowledge of mechanized textile production. It seems strange that Dresser, in his influential published account of his fruitful visit to Japan, remarks on the persistence of the drawloom and the absence of the Jacquard device.

A group of sample sheets and albums containing woven silks similar to those described and illustrated by Dresser forms a valuable part of the Museum's Japanese textile collection. Although a detailed study of them has still to be completed, their importance in the hitherto neglected field of Meiji textiles is becoming apparent. It is unclear what these woven silks were used for apart from sashes, pocket book covers and pouches. Dresser confessed himself baffled on this issue. 'All I can say is,' he writes, 'that during my stay in Japan I never saw, either in the palace of the Mikado, the residence of a minister, the house of a merchant, or the cottage of an artisan, any of their richly coloured fabrics used, either as dress materials or in any other way.' In an article in *The Studio* written in 1910, the products of the Nishijin looms are praised and some are described as curtaining material, presumably for European houses. Even at this date the drawloom was still thought to be in regular use, less expensive mixtures of silk and cotton being woven on the Jacquard looms.

The *kimono* opposite (*183*), although not directly a part of the Nishijin revival, is nonetheless an unmistakably Meiji garment. It probably contains some synthetic dye colours, and the pronounced wavy texture of the silk crepe used for the ground was very likely made possible by some form of mechanical yarn twisting process. All the motifs were first resist-dyed. A variety of techniques – embroidery, dye-painting and stencilling to imitate tie-dye – were then used to outline or fill in the designs in colour.

While it is uncertain how far Japanese textiles, after the mid-nineteenth century, were adapted to suit the tastes of western customers, it is true to say that many items made for Japanese consumers also appealed to foreigners. An English woman, Miss Hubbert, who made a trip to Japan in the 1890s, bought two *kimono*, one very similar to the Museum's blue crepe example (*183*), from Kuhn & Co., billing themselves as a 'Fine Art Depot' of 57 Main Street, Yokohama. Miss Hubbert's invoice for these and other items calls the garments 'antique', but they could not have been more than thirty years old at the time the purchase was made. Of course, it was not necessary to visit Japan personally in order to acquire Japanese artefacts. So great was their appeal and so closely were they linked to the

183 (*opposite*)
KIMONO FOR A WOMAN
Blue silk crepe with embroidery and resist-dyeing
Billowing waves, rocks and long-tailed tortoises on the lower section; cranes, trees and flowers above
Late 19th century
165 × 128 cm
FE.14-1983

184 (*overleaf left*)
HANGING SCROLL
Painted, ribbed and cut velvet
Peonies and rocks with birds on a fruiting bough
Late 19th century
195 × 74 cm
T.712-1888

185 (*overleaf right*)
VELVET PICTURE
The Yōmei-mon gate of the shrine at Nikkō
Late 19th or early 20th century
66 × 61 cm
T.104-1971

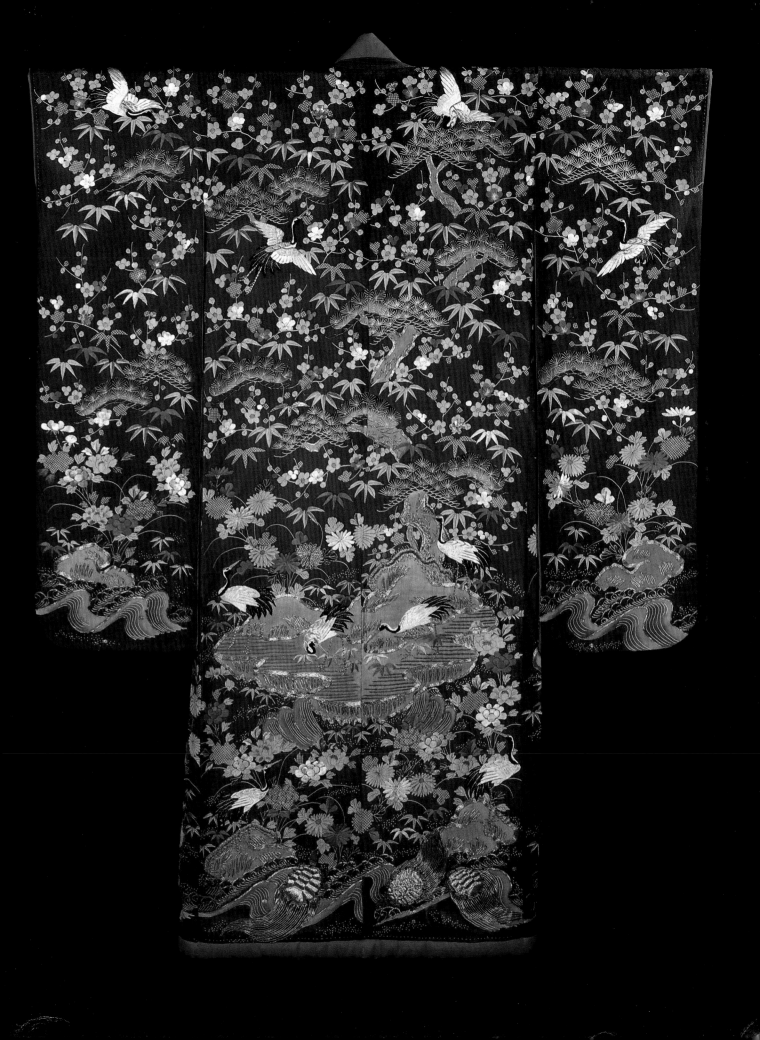

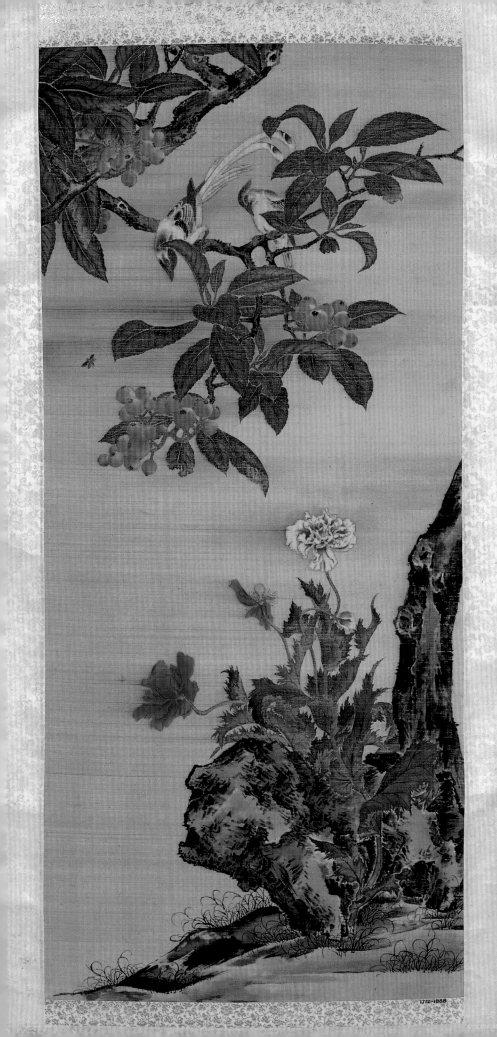

Art Nouveau movement that even a local shopping expedition could yield a textile from Japan. Jones Brothers, a department store situated in the heart of a late Victorian villa development in Holloway, north London, possessed an 'Oriental Bazaar' where such items were sold.

Although pictorial velvet scrolls (*184*) would have been recognisable to and usable by Japanese clients, their manufacture received great stimulus from the demands of the European market. The Museum acquired this example along with three others from a general dealer in London Wall in 1888. The unmounted velvet picture (*185*) with its very deliberate virtuoso display of technical accomplishment in matters of detail and depth of field, depicts the Tōshōgū shrine at Nikkō, 120 kilometres to the north of Tokyo, erected after his death in 1616 to the memory of Tokugawa Ieyasu (see p.15) and extensively refurbished during the 1630s. Souvenirs such as this testify to the shrine's enduring popularity as a tourist attraction. That adventurous Englishwoman Isabella Bird found her visit there in the 1880s inspirational, despite two earth tremors. She regretted that the impressions of the buildings so quickly faded from her memory but we can imagine that such a serious-minded traveller would have scorned souvenir buying. It is recorded that similar pictures depicting temples and beauty spots were exhibited by the Kyoto weaving firms of Takashimaya and Tanaka in London in 1910 (see p.194). Their manufacture involved painting the coloured scene on to a ready-woven but uncut velvet. Some areas of the velvet were then cut, producing a tufted pile, while other areas were left as horizontal ridges according to the dictates of the design.

The silk crepe length opposite (*186*) is an example of the resist-dyeing technique known as *Yūzen*. The painstaking process of building up thin walls of paste along the already drafted outlines of the design and then brushing on the colours within these walls was revolutionised during the Meiji period by the Kyoto master Hirose Jisuke (1822–1896). Hirose promoted the use of synthetic dyes and in 1879 devised a method of directly applying pre-coloured paste, instead of resist, through stencils, eliminating several production stages and making it possible to produce less expensive textiles which were within the reach of a wider section of consumers. This is the type of *Yūzen* dyeing most widely practised to this day.
VW

186
LENGTH OF RESIST-
DYED SILK CREPE
Flowers against bamboo fences
Late 19th or early 20th century
86 × 41 cm
T.429-1912
Strange Gift

At the beginning of the Meiji period, the gradual abandonment of traditional Japanese dress, with the pouch hanging from the waist replaced by the western pocket, dealt a blow to the trade of the *netsuke* carvers (see p.110). Like other craftsmen, they were obliged to seek new markets for their skills. The first Domestic Industrial Exposition of 1877 included a number of high quality ivory carvings and in the following few years there was a growing demand for ivories from foreigners. Chinese ivory carvings had been prized in Europe at least since the eighteenth century for their intricate workmanship, and the earliest Japanese export ivories laid similar stress on technical virtuosity. This study of *rakan* (188), made in Yokohama, is one of a group of seven ivories acquired by the Museum in 1883 for the high price of £300.

The sixteen, eighteen or five hundred *rakan*, 'worthy of respect', are enlightened beings, depicted as the disciples of the Buddha and patrons and guardians of the faith, who became widely known in Japan during the Muromachi period from imported Chinese paintings. These paintings expressed Chinese reaction to foreign facial types. Their style, usually bordering on exaggeration and caricature, appealed to the tastes of the sometimes irreverent Edo period towndwellers. As a result, *rakan* were often depicted in *netsuke* and would have already been a familiar subject to the carver of this piece. There is considerable iconographic variation in both the Chinese and the Japanese treatment of *rakan*, but elongated earlobes and grotesque expressions are standard. More specifically, among the seven featured here, Handaka can be identified by his attendant dragon, and Rakora by the small shrine he carries. This excellent piece of tourist art is a hybrid, combining Chinese caricature with a technical brilliance which satisfied European stereotypes of oriental fictile ingenuity.

The early popularity of ivory carvings was followed by a decline which was counteracted, as part of the more general effort to preserve Japanese art and craft traditions, by the foundation of sculpture societies in 1881 and 1886. An active and influential figure in the ivory carving movement was Ishikawa Kōmei (1852–1913). Kōmei is said to have had hundreds of pupils, and his style is represented here by a work from the hand of an unknown follower, Eizan (187). Kōmei himself started life as a carver of images and ornaments for temples and shrines. Probably around 1880, he started to produce naturalistic figures of the type shown here, combining precise observation with a certain expressionism in the chiselwork and reflecting the influence of contemporary French genre sculptors such as Jules Dalou (1838–1902). Although bordering sometimes on sentimentality, these little sculptures stand out from the huge quantity of tawdry work in ivory which was turned out for a normally uncritical western market.

The group of two bears (189), hammered from a single piece of iron, was exhibited at the great Japan-British Exhibition of 1910, which featured displays of 'Japanese Old Fine Arts' and 'Japanese Modern Fine Arts'. The show coincided with a shift in British scholarly and curatorial interest from Japanese to Chinese art and its cultural and artistic aspects did not make much of a mark. As well as the present group, its attractions included a spectacular pair of lions over four feet high by the same artist, Muneyoshi, and in the same technique. This late manifestation of the Japanese armourer's skill, signed by a member of the Myōchin family (see p.116), is one of the very few pieces from the exhibition to have found its way into a British national museum.

187 (*opposite left*)
MAN FEEDING A GOOSE WITH WORMS
Carved ivory with staining
Signed *Eizan*
c. 1900
Height 25.7 cm
A.22-1941
Read Gift

188 (*opposite right*)
GROUP OF DISCIPLES OF THE BUDDHA (*rakan*)
Carved ivory with staining
Signed *Hōshinsai* (Hōshinsai Uemura Masanobu)
c. 1880
Height 22.1 cm
942-1883

189 (*overleaf left*)
TWO BEAR CUBS AT PLAY
Hammered iron
Signed *made by Muneyoshi* (Yamada Chōzaburō)
c. 1909
Height 19.3 cm
M.47-1919
Hildburgh Gift

190 (*overleaf right*)
CABINET WITH DRAWERS
Wood covered in black lacquer with gold *nashiji* lacquer; cocks in carved shell, stained ivory and horn; silver fittings
The exterior signed *Shinsō*; the interior signed *Shinsei* with a seal; the base with a silver plaque signed *made by Ōzeki*
c. 1900
22.3 × 23.1 × 17.6 cm
W.23-1969
Margary Gift

Decorated lacquerware, laborious in technique and unsuited to mass-production, probably suffered more than any other craft from the social and economic upheavals of the early Meiji period. Vast quantities of fine Edo period lacquer were sold abroad by impoverished daimyo and samurai, and over-responsiveness to insatiable foreign demand had two unfortunate results. In order to meet the requirement to combine elaborate decoration with cheapness, it was necessary to produce goods of very low quality. The increased need for sap to supply the burgeoning export industry led to the widespread use of destructive lacquer-tapping techniques which killed the trees in a single year and made Japan a major importer of lacquer from China by the end of the century. Nevertheless, the favourable reception accorded to Japanese crafts at the Vienna World Exhibition of 1873 alerted the Government to the urgency of protecting and developing traditional workshops. Companies such as the Kiritsu Kōshō Kaisha (see p.200) were set up, the Tokyo Art School was opened in 1889, and posts of Craftsman to the Imperial Household were established in 1890, in each case to the particular benefit of lacquerers.

While 'eccentric' styles of lacquering associated with such Tokyo artists as Shibata Zeshin (76–87) and Ikeda Taishin (42) continued to flourish, much Meiji period lacquering is very conservative. The small writing box from the workshop of Nakayama Komin (41), though included in an earlier section of this book, could perhaps date from as late as the 1870s or 1880s. The long box reproduced here (191) has the very traditional function of holding the specially shaped sheets of decorated paper used for writing poems. Touches typical of the renaissance of *maki-e* in the middle Meiji period include the artfully semi-transparent silver *hiramaki-e* near the base of the waterfall and the skilful manipulation of the relative heights of river and bank at the top. Both these features are the result of an effort to emulate the effects of ink-painting which is a common theme of much craft of this period.

The Meiji period saw the revival, or at least the recognition, of several regional lacquer traditions. The bowl opposite (192) was probably made in Wakasa province on the Japan Sea north of Kyoto. Wakasa became known during the eighteenth century for the production of some special forms of 'odd lacquering' (*kawari-nuri*). These techniques were at first mostly used on sword scabbards but later applied to other objects as well. The bowl, acquired in 1869, was lacquered in the normal way and then treated with a mixture of egg-white and water brushed on to a semi-dry layer of lacquer. This caused uneven drying with wrinkles and fissures. Gold foil was then applied, followed by further layers of yellowish lacquer until the wrinkles were covered. The lacquer was then polished until the foil had been rubbed away from the highest wrinkles. The use of a water and egg-white treatment gives the resulting design an accidental character which is prized in other crafts but far removed from the deliberate, mannered style apparent in so many nineteenth-century lacquers.

In the sphere of tourist and export lacquer there were many variations in quality. Like the metal vase (198) the lacquer cabinet on the preceding page (190) is a deliberate combination of diverse techniques, including the Shibayama style of high relief incrustation of shell, ivory and horn so popular in Victorian drawing rooms, as well as traditional *maki-e* lacquering.

191 (*left*)
POEM-CARD BOX
Wood covered in black lacquer with gold and silver *takamaki-e* lacquer and foil; sides gold *nashiji* lacquer; *shakudō* and gilded mounts
Waterfall and maples
c. 1870s–1880s
Length 39.5 cm
W.264-1916
Alexander Gift

192 (*right*)
BOWL
Wood covered in yellow lacquer over gold foil
Probably made in Wakasa province
1860s
Height 12.3 cm; diameter 24.4 cm
287-1869

Apart from two very early pieces of disputed origin, no definitely Japanese enamels are known before the Momoyama period, when Hirata Dōnin (1591–1646) is credited with the foundation of a tradition of enamel decoration on small metal objects such as sword fittings and door handles. While huge quantities of porcelain were decorated in enamels from the seventeenth century (46–52), enamelling on metal remained a small scale affair, restricted in its range of colours and often closely based on Chinese models.

The craft was revived by Kaji Tsunekichi (1803–1883), who made a study of imported European examples in the 1830s, and substantial, free-standing objects in the technique were first manufactured in the mid-nineteenth century. In the early Meiji period, technical improvements were assisted by the experiments of the German chemist Gottfried Wagner (see p.180): they included the development of a more lustrous enamel which could take a high polish, and better adhesion between the enamel and the metal base, permitting broad areas of uninterrupted colour and greater freedom of design.

From the start of the Meiji period, enamelling was predominantly an export-oriented craft. The first pieces were probably sent abroad in the 1860s; the V&A acquired its first examples in 1869. The best enamels date from about 1880 onwards. The leading exponent of the traditional type of cloisonné enamelling on metal, using soldered wires to separate different areas of colour, was Namikawa Yasuyuki (1845–1927) of Kyoto (193–195). His finely worked vases were often very small, allowing high-quality enamels to be purchased by people of limited means in preference to the mass-produced trash which has until recently given this very untraditional craft a bad name among western scholars and curators.

The small vases from the Kyoto Namikawa workshop, although dating from the later Meiji period, reflect earlier western expectations of the East in the exotic elaboration of their detail, but other enamels, like the vase (197), seem responsive to a more advanced taste. During the Meiji period there was a complex interaction between European artefacts in a japanizing style and subsequent Japanese artefacts, especially those for the export market or for international exhibitions, made by craftsmen aware of the vogue for *japonisme* in Europe.

Just as the adoption of western dress dealt a death blow to the *netsuke*, the abolition in 1876 of the samurai practice of wearing two swords made it necessary for the makers of sword-fittings to find new outlets for their skills. The metal, enamel and lacquer vase (198) acquired in 1892 from Samuel Bing (1838–1906), the German-born Parisian art-dealer, publisher and high-priest of *japonisme*, is a demonstration piece, bringing together on its surface most of the Japanese techniques of decorative metalwork without regard for consistency of design.

The impressive bronze vase (196) combines a variety of influences. Its decorative technique derives from the later sword fitting tradition; its naturalism from painting in the Shijō style; its composition from the Rimpa style (see p.57) which also influenced the lacquerer Ikeda Taishin (42); its patination and lappet borders from Chinese bronzes. The vase was purchased in 1886 from the Kiritsu Kōshō Kaisha, 'Company for the Establishment of Industry and Commerce'. The Company was founded in 1874 after the experience of the 1873 Vienna World Exhibition with the intention of encouraging and developing the traditional craft industries of Japan. It commissioned many of the most famous craftsmen of the day including the bronzecaster Suzuki Chōkichi (1848–1919) who, according to the Museum's records, made this piece. JE

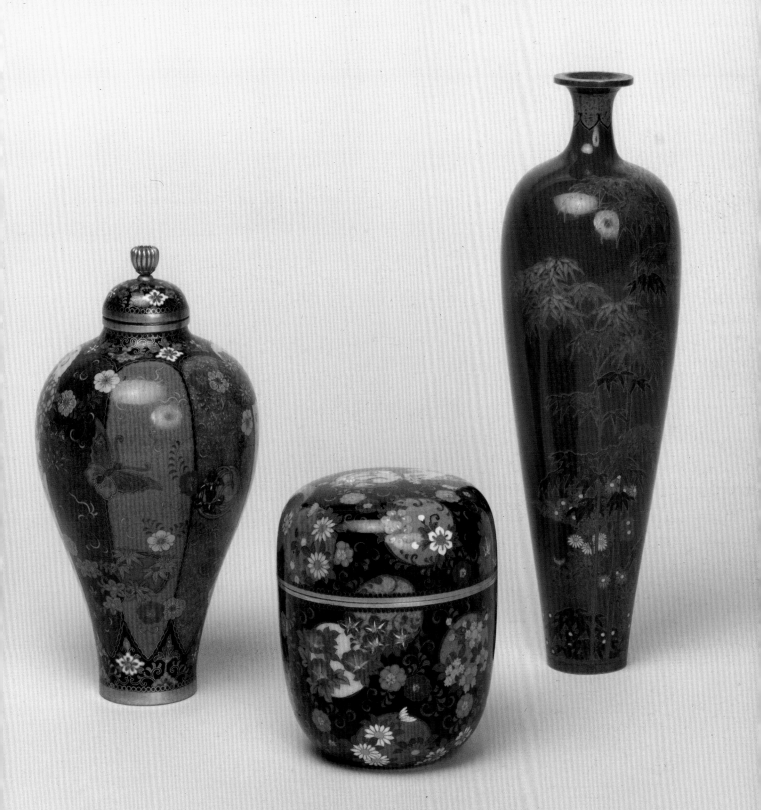

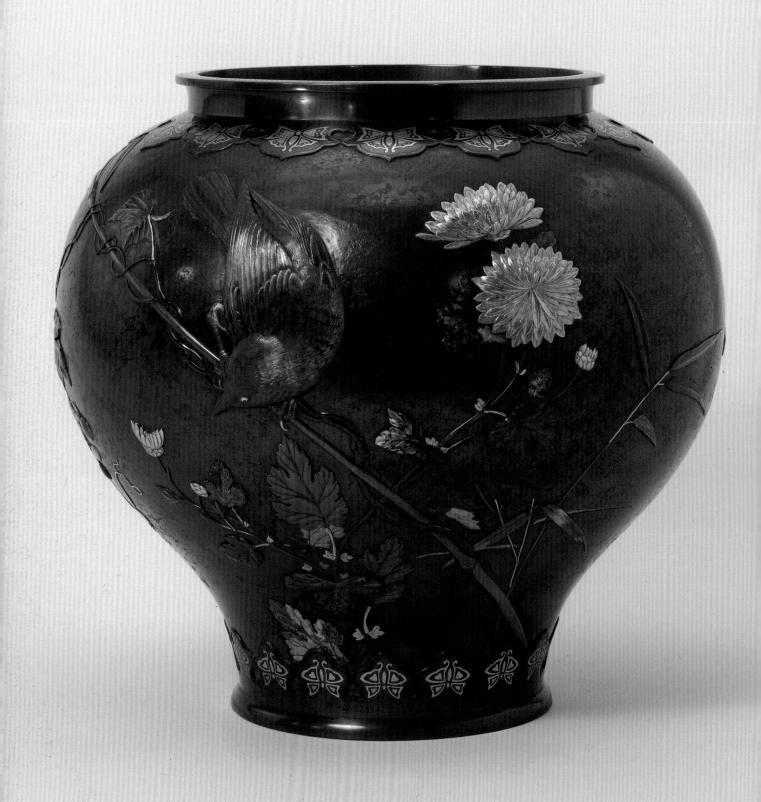

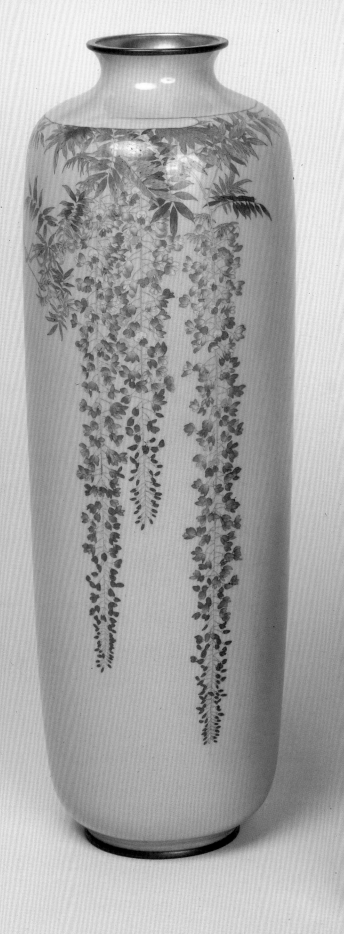

The Twentieth Century

THIS six-panel screen was executed by one of Japan's foremost textile artists, Serizawa Keisuke, in the late 1930s. The son of a textile merchant, he subsequently trained as an artist and designer. He became an active member and defender of the Folk Craft movement after meeting its founder, Yanagi Sōetsu (see p.160), in 1926. Later in the same decade his discovery of the tropical colours and bold designs of textiles from Okinawa in the Ryukyu Islands (see p.172) inspired him to learn the resist-stencilling technique of *bingata* practised there. This six-panel screen utilises the *bingata* method and depicts stages in the traditional manufacture of paper at the village of Ogawamachi in Saitama Prefecture. The six stages are, from right to left: (opposite) boiling the branches of paper mulberry and washing the boiled paper mulberry fibres in running water; (pp.207–206) softening the fibres by beating them with mallets, moulding the paper in a frame, removing excess water in a press and drying the sheets of paper on boards in the sun. Handcrafted Japanese paper made by the same process is used to back the screen. V W

199 (*opposite and overleaf*)
SIX-PANEL SCREEN

Cream silk stencilled with the stages of paper-making
Serizawa Keisuke (1895–1984)
c. 1938
81 × 214 cm
FE.20-1985

The present affluence of Japan and the consistently high level of interest shown by a large and well-informed public ensure that Japan enjoys a prominent place in the world of contemporary art ceramics. Indeed, one might suggest that Japan is the leader in the field in terms of the large number of active potters, the high prices which they can command, and the wide variety of styles in which they work. This very dynamism, however, leads to a complexity whose essence is not easy to grasp. A multiplicity of styles and traditions is coupled with the existence of numerous artistic groupings with widely different declarations of intention. Diversity if not confusion of values is also caused by the highly pressurised marketing of ceramics involving not only individuals and organizations in the commercial world, but others who might be expected to take a more objective and dispassionate stand. The commitment by the Museum to collect contemporary Japanese ceramics is therefore not an easy one to fulfil. The pieces illustrated here have been chosen as examples of four different facets of recent production and should be understood as representing part rather than the whole of the diverse repertoire which exists.

The large octagonal dish by Imaizumi Imaemon XIII (*200*) derives from the decorative porcelain tradition which began in Arita in the seventeenth century (see p.78). Imaemon is the thirteenth generation of a family whose members have worked in Arita as porcelain decorators since that time. The precisely controlled shading of the underglaze blue, the stiff geometry of the pattern, and the particular hue of turquoise enamel echo features of earlier Nabeshima porcelains but combine with elements drawn from Turkish ceramic decoration to give a distinctly modern flavour. There are several families in western Japan which have been involved in ceramic manufacture since their founding in the seventeenth century and are now in their thirteenth or fourteenth generation. Most of them run small factories producing traditional styles of functional ware aimed at the middle range of the market. In each case, however, the head of the family devotes much of his time to making individual works which are sold at very high prices. Like the Imaemon example shown here, they are often accomplished pieces, using traditional elements in creative and original ways. There are instances, however, of individuals who react to the weight of the traditions they feel obliged to uphold by moving off in unexpected directions. Equally there are potters whose long-established name appears to be the main explanation for the acclaim which their classical but often less than imaginative work receives.

200
OCTAGONAL DISH
Porcelain with decoration in underglaze blue and overglaze enamels
Interlinked chrysanthemums
Mark *Imaemon* incised on base
Imaizumi Imaemon XIII (born 1926)
c. 1980
Greatest diameter 41.2 cm
FE.43-1981

The large size of the dish by Imaemon and the stoneware piece by Shimaoka Tatsuzō (*201*) suggest that they were both intended as display pieces. Enormous dishes and large globular jars have been the staple shapes in recent years for potters working in traditional non-sculptural modes when they show in major exhibitions at which many artists show one piece of work each. The essentially non-functional nature of Shimaoka's dish reflects the disruption of values which is found in the world of modern folk craft ceramics. As Hamada Shōji's (1894–1978) student and successor, Shimaoka is generally regarded as Japan's leading folk craft potter. It would be expected, therefore, that he would try to uphold the ideals set forth by Yanagi, Hamada and the other founders of the Japanese Folk Craft movement (see p.160), and observe their demands for functionality, anonymity and low prices. Regardless of the contradictions which arise from a failure to fulfil such requirements, contradictions which are perhaps inevitable in a system where ideals of innocence are made the basis of a conscious search for artistic originality, Shimaoka's work is both accomplished and consistent. This is reflected, for example, in the way in which over many years he has gradually perfected the effects of rope-impressed decoration. In this dish, where the impressed marks are filled with white slip, he has combined three different patterns with leaf-like splashes of underglaze iron painting to give a remarkable feeling of vitality to what is an extremely large and challenging pot.

201
DISH
Stoneware with underglaze iron painting over rope-impressed and slip-filled ground
Maker's mark impressed on base
Shimaoka Tatsuzō (born 1919)
1985
Diameter 57.4 cm
FE.30-1985

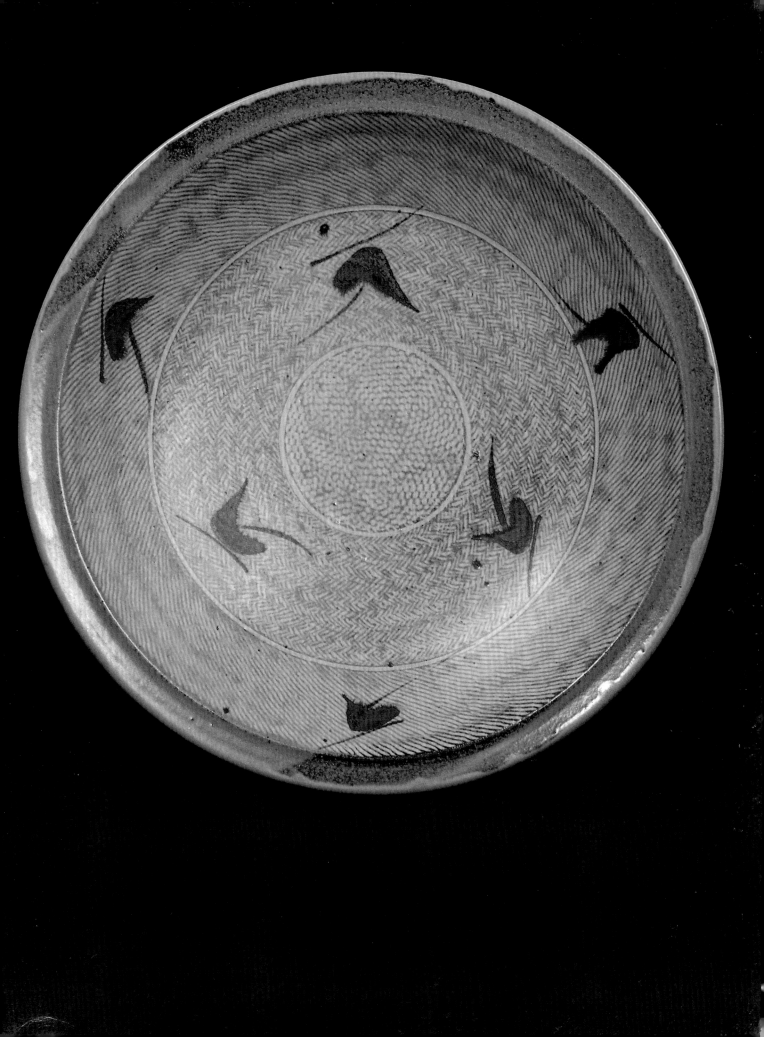

212 · THE TWENTIETH CENTURY

The celadon bowl (*202*) represents the modern aspect of the long-standing interest of the Japanese in Chinese ceramics. Kawase Shinobu, the maker of this bowl, is the third generation of a distinguished family of potters who live and work near Tokyo and have long been known for their ceramics in Chinese styles. Since the early 1970s Shinobu has specialised in celadon glazed wares, drawing much of his inspiration from Southern Song dynasty (1128–1279) celadons of the type traditionally admired in Japan. Until recently he has tended to use small and rather delicate shapes as vehicles for the exquisite glazes which he has succeeded in creating. This bowl reflects a new departure of his into larger and bolder forms. He has purposely used a smooth rather than a crackled glaze to add tension to a highly wrought shape, which draws its principal effect from two small cusps to the thin everted rim.

202
BOWL WITH CUSPED RIM

Porcelain with celadon glaze
Kawase Shinobu (born 1950)
1984
Diameter 29.1 cm
FE.42-1985

Kamoda Shōji (203) studied at the Kyoto College of Fine Arts, where he was exposed both to traditional ceramic techniques and to the philosophical stirrings among young potters which led to the formation of the avant-garde Sōdeisha group in the early 1950s. Until his untimely death in 1983 he was regarded as a leader among artists working in contemporary styles. He followed what by Japanese standards was a remarkably independent career in that he refused to affiliate himself to any artistic group, including the influential and dynamic Sōdeisha. It is interesting too that from 1959 onwards he worked in Mashiko, a place which is normally associated with folk craft potters like Hamada and Shimaoka. Kamoda was mainly concerned with issues of sculptural form and surface decoration. In this vase he has successfully combined a severely angular shape with sensitively modulated surface qualities resulting from the overlaying of a faint resist pattern on a roughly textured unglazed body. Made in 1968, the vase predates a later series of experiments in which Kamoda inlaid sheets of white porcelain into similarly angular stoneware forms. RF

203
VASE
Stoneware with resist decoration
Maker's mark incised on base
Kamoda Shōji (1933–1983)
1968
Height 28.5 cm
FE.31-1985

Burdened by a technique which is resistant to spontaneity, some twentieth-century lacquerers have attempted to revive their art by introducing designs and methods whose use is justified by their importance during much earlier periods, both Chinese and Japanese. The simple foliate forms of the Chinese Song dynasty (960–1279), first copied in Japan during the Muromachi period, have inspired many craftsmen. Others have transferred to the manufacture of trays and vessels the *kanshitsu* technique used in some of the earliest Japanese Buddhist sculpture, in which cloth previously soaked in raw lacquer is shaped before it hardens, giving a freedom impossible when working with lacquer on a preformed wooden base. The Museum's small collection of contemporary lacquers does not yet include any pieces to illustrate this very successful use of ancient styles and techniques. However, it does have an example of the innovations which can be achieved through awareness of the many regional traditions flourishing in Japan during the mediaeval and early modern periods.

Either for economic reasons or from a consciousness of the modern movement in western design, twentieth-century Japanese lacquers are often less highly decorated than their Edo period counterparts, and this has led to a still greater stress on the quality of the background surface, its lustre and polish, achieved by many hours of patient work. This feature has reinforced the image of the craft as one in which no concession is made to the pace of modern industrial production methods. Some lacquerers have reacted against the absence of opportunities for variation and risk involved in the creation of highly polished uniform surfaces. Kado Isaburō (*204*) is one of several artists with a more spontaneous approach who have been influenced by the bowls and other simple wares made and used throughout much of mediaeval Japan and in some instances continuing to be manufactured almost down to the present. These are very often undecorated, being simply lacquered all over either black or red. Kado has evidently been attracted by their subtle variations in colour and depth which are expressions of an aesthetic, conscious or otherwise, which seems closer to pottery than to traditional metropolitan lacquerware. His tray is in essence a native form, alluding to the wide variety of footed trays and stands used for serving food, but reflects his experience of Burmese architecture in the extravagant geometry of its profile.

Kado is a native of the town of Wajima, on the Noto peninsula in the north of Ishikawa prefecture, where there has been an important lacquer industry since the eighteenth century. Several thousand lacquerers are still active there, some of them with the status of independent craftsmen and others working in factories employing considerable numbers organized into several specialist departments.

204
TRAY
Wood covered in red lacquer
Kado Isaburō
1985
Width 60.5 cm
FE.2-1986

Elaborate technique and intricate design have been the hallmark of some Japanese lacquer produced during the present century. The restraint which is evident in even the most ornate late Edo and Meiji period work has tended to disappear with the invention of a whole range of new pigments which will neither discolour on contact with lacquer nor affect the setting qualities of the medium. Combined with the introduction or development of Chinese and Burmese inlay techniques, these technical advances have given lacquerers great expressive freedom. The results can appear unfortunate to western eyes, even in the work of acknowledged masters, possibly because of an unwillingness on our part to recognise that the work of Japanese lacquerers need not necessarily look 'Japanese'. The vessel reproduced opposite is the work of the present master of a long-standing family of Kyoto lacquermasters. While it quite clearly does not date from the Edo period, it retains the technical simplicity and decorative panache of the Rimpa style (see p.57) as well the textural delicacy of the best *maki-e*, reassuring qualities which we continue to expect from lacquer. Water-carriers of this type are used in the tea ceremony to carry fresh water into the tearoom. The strong market for tea utensils which exists in present-day Kyoto extends both to antiques and to contemporary pieces in a more or less conservative style, and guarantees the continuing economic well-being of the city's traditional lacquerers. The motif is particularly appropriate, since the scouring rush, *tokusa*, is a kind of natural sandpaper much used by lacquerers in their painstaking work. JE

205
PORTABLE WATER
CONTAINER FOR THE
TEA CEREMONY
Wood covered in black lacquer
with gold *hiramaki-e* lacquer
Scouring rushes (*tokusa*)
Suzuki Mutsumi (born 1942)
c. 1979
Height 24.8 cm
FE.14-1982

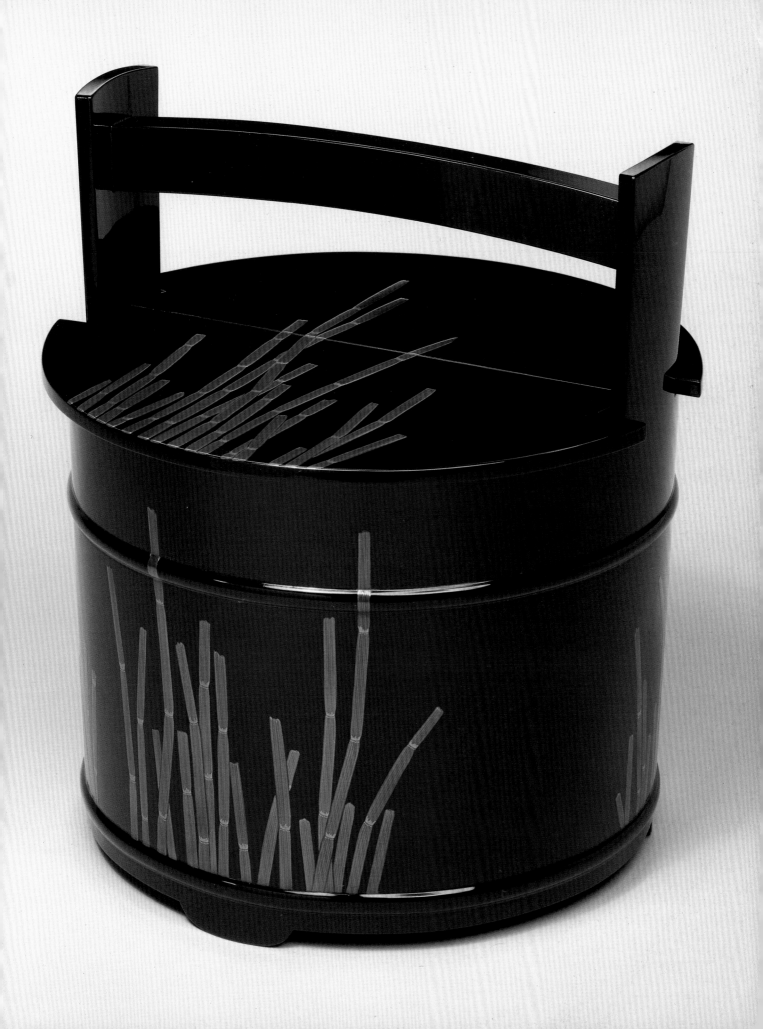

Glossary

Buddha
The principal deity of the Buddhist religion, since the tenth century most often worshipped in Japan as Amida, the Lord of the Western Paradise

celadon
Term of French origin used to describe any green, blue or grey-green coloured ceramic glaze achieved by reduction firing of a glaze mixture containing a small proportion of iron oxide

chanoyu
The tea ceremony, a formal gathering for the drinking of tea and the aesthetic appreciation of tea utensils

Chōsen-garatsu
Type of Karatsu ware in Korean (Chōsen) style characterized by the combination of white and brown glazes

daimyō
Regional feudal lord

daishō
'Large and small', the *katana* and *wakizashi* swords worn in combination

earthenware
Ceramic with body made from clay fired to between 800 and 1100 degrees celsius which is unvitrified and permeable by water

e-nashiji
Nashiji used to highlight areas of the design instead of as an overall background

feldspathic glaze
Clear to semi-opaque glaze deriving from a mixture containing a high proportion of feldspar

fuchi-kashira
Matching collar and pommel fitted to either end of the sword-hilt

habaki
Metal collar fitted to the sword blade next to the *tsuba*

haiku
Poem of seventeen syllables, developed from *waka*; the most important verse form during the Edo period

hiramaki-e
Basic form of *maki-e*, in which metal dust is sprinkled on to still-wet lacquer and then covered with a further layer of lacquer

hitsu
Hole in a *tsuba* to admit the end of the *kozuka* or *kōgai*

hosoban
One of the standard sizes of woodblock print; about 33 × 14 cm in vertical format

inrō
'Seal basket', small decorative container worn hanging from the belt, often lacquered

Kabuki
The popular drama of the Edo period

kana
Phonetic symbols used for writing Japanese in conjunction with *kanji*, Chinese characters

kasuri
Resist-dyeing technique in which warp and/or weft threads are pre-dyed so as to form patterns when the cloth is woven

katana
Same as *uchigatana*, a term used when the *katana* (about 90 cm long) is contrasted with the shorter *wakizashi*

kazaritachi
Decorative style of *tachi* mounting

kimono
'The thing worn', the traditional Japanese garment for men and women

kirikane
'Cut metal', small squares of gold and silver used in lacquer decoration

Kōdaiji maki-e
Simplified form of *maki-e* associated with the Kōdaiji temple in Kyoto

kōgai
Skewer which fits into the scabbard of a sword

kojiri
Fitting at the end of a sword scabbard, often metal

Kokinshū
Anthology of *waka* poems compiled by imperial order about 905 AD

koto
Plucked musical instrument with thirteen strings

kozuka
Handle of a small knife which fits into the scabbard of a sword

maki-e
'Sprinkled picture', a technique of lacquer decoration. See *hiramaki-e*, *takamaki-e* and *togidashi-e*

Meiji Restoration
The restoration of political power to the Emperor in 1868

menuki
Small metal ornaments fitted under the wrapping of the sword-hilt

Namban
'Southern Barbarian', term used by the Japanese to describe European visitors during the sixteenth and seventeenth centuries, and applied to artefacts produced for Europeans or under European influence

nanako
Pattern of small granulations used to decorate metal surfaces

nashiji
Irregularly shaped flakes of gold suspended in clear or yellowish lacquer

netsuke
Decorative toggle worn with *inrō*

Nō
Aristocratic drama originating in the fourteenth century

ōban
One of the standard sizes of woodblock print; about 33 × 27 cm in either vertical or horizontal format

ojime
Bead used with *inrō* and *netsuke*

overglaze
Ceramic decoration, usually painted, which is applied over the glaze after the first high temperature firing

oxidation firing
Firing technique in which sufficient air is allowed into the kiln for complete combustion of the fuel; chemically reactive parts of the ceramic material emerge from the firing in an oxidized state

porcelain
Ceramic with body made from china stone (crushed volcanic rock in Arita) containing kaolin (a pure form of clay) and fired to between 1250 and 1350 degrees celsius; translucent, white, vitrified and impermeable by water

reduction firing
Firing technique in which the flow of air into the kiln is restricted; the burning fuel draws chemically bonded oxygen from the reactive parts of the ceramic material, leaving them in a reduced state

renga
'Linked verse', a mode of verse composition by more than one person, in which *waka* are linked to form long poems

resist-dyeing
Patterning of fabric or yarn by protecting selected areas from dye

Rimpa
Style of decoration founded by Hon'ami Kōetsu and Tawaraya Sōtatsu in the seventeenth century

sake
Rice wine

samurai
Warrior; an armed retainer of the *shōgun* or a *daimyō*, during the Edo period exclusively permitted to wear the *daishō*

shakudō
Alloy of copper with a small quantity of gold, pickled in a solution to produce a blue-black surface colour

shibuichi
Alloy of silver with a varying proportion of silver, pickled in a solution to produce a range of greyish surface colours

Shintō
The indigenous religion of Japan, originally based on the veneration of natural phenomena and largely merged with Buddhism by the end of the Heian period

shōgun
Military ruler of Japan from the end of the twelfth century, in theory exercising his power with the consent of the Emperor

slip
Liquid clay used in ceramic decoration

stoneware
Ceramic with body made from clay and fired to between 1200 and 1300 degrees celsius which is vitrified and impermeable to water

sutra
Buddhist scripture

suzuribako
'Inkstone box', a box containing an inkstone for grinding solid ink with water, a waterdropper, brushes and other writing utensils

tachi
Curved sword worn in a scabbard slung from the belt

takamaki-e
Form of *maki-e* in which lacquer is built up in relief with powdered clay or charcoal

Tale of Genji
In Japanese *Genji monogatari*, a long prose romance written by the court lady Murasaki Shikibu in the early years of the eleventh century

Taoist
Pertaining to Taoism, a Chinese philosophy which developed into a popular religion

tapestry weaving
Weaving technique in which individual areas of the design are created by passing the weft threads back and forth only where a particular colour is needed

tatami
Mats woven from rice straw

tea ceremony
Standard English translation of *chanoyu*

tebako
'Handy box', any small box with an overhanging lid

tie-dyeing
Resist-dyeing technique in which certain parts of the fabric are tightly tied to prevent penetration by the dye

togidashi-e, togidashi maki-e
'Polished-out picture', a form of lacquer decoration in which a *maki-e* design is covered over with several layers of lacquer of the same colour as the background. These layers are then polished down until the original design reappears, flush with the new background

tokonoma
Alcove forming the focal point of tearooms and other formal rooms and used for the display of scrolls, flowers, etc.

Tokugawa
Family name of the dynasty of shoguns ruling during the Edo period

tsuba
Sword-guard, a pierced disc of metal fitted to the sword blade at the point where the sharpened edge begins

uchigatana
Curved sword worn in a scabbard thrust edge upwards through the belt

underglaze
Ceramic decoration, usually painted, which is applied to the body of a pot before it is glazed and fired

waka
A poem of thirty-one syllables, the principal verse form before the Edo period

wakizashi
Sword like the *katana* but about 60 cm long